Gardens for Gloriana

Gardens for Gloriana

Wealth, Splendour and Design in the Elizabethan Garden

Jane Whitaker

BLOOMSBURY ACADEMIC
LONDON • NEW YORK • OXFORD • NEW DELHI • SYDNEY

BLOOMSBURY ACADEMIC
Bloomsbury Publishing Plc
50 Bedford Square, London, WC1B 3DP, UK
1385 Broadway, New York, NY 10018, USA

BLOOMSBURY, BLOOMSBURY ACADEMIC and the Diana logo are
trademarks of Bloomsbury Publishing Plc

First published in Great Britain 2019

For legal purposes the Acknowledgements on pp. xxi–xxii constitute
an extension of this copyright page.

Jane Whitaker has asserted her right under the Copyright, Designs and
Patents Act, 1988, to be identified as Author of this work.

Front cover image: *Queen Elizabeth I, The Welbeck or Wanstead Portrait,*
c. 1580, Gheeraerts, Marcus, the Elder/The Portland Collection, Harley Gallery,
Welbeck Estate, Nottinghamshire/Bridgeman Images

Back cover image: *Queen Elizabeth I,* Nicholas Hilliard, 1572,
© National Portrait Gallery, London

Bloomsbury Publishing Plc does not have any control over, or responsibility for, any
third-party websites referred to or in this book. All internet addresses given in this
book were correct at the time of going to press. The author and publisher regret
any inconvenience caused if addresses have changed or sites have ceased to
exist, but can accept no responsibility for any such changes.

A catalogue record for this book is available from the British Library.

ISBN: HB: 978-1-7883-1119-9
 ePDF: 978-1-7867-3610-9
 eBook: 978-1-7867-2604-9

Typeset by RefineCatch Limited, Bungay, Suffolk
Printed and bound in Great Britain

To find out more about our authors and books visit www.bloomsbury.com
and sign up for our newsletters.

For Jonathan, Laura and Annabel

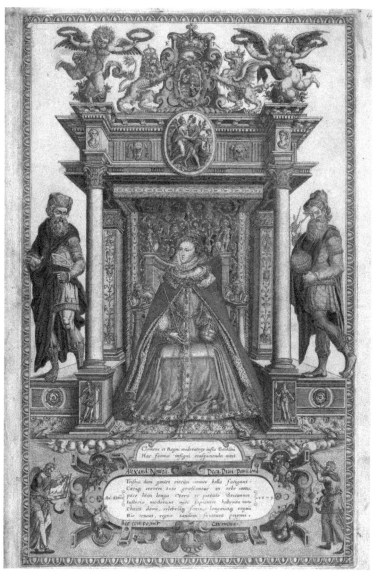

Portrait of Elizabeth I, Christopher Saxton, 1579, from Atlas of the Counties of England and Wales *(London, 1580).*

Fairer and nobler liveth none this howre,
Ne like in grace, ne like in learned skill;
Therefore they Glorian *call that glorious flowre,*
Long mayst thou Glorian *live, in glory and great powre.*

EDMUND SPENSER, *THE FAERIE QUEENE DISPOSED INTO TWELVE BOOKES, FASHIONING XII. MORALL VERTUES,* 1596.[1]

Contents

Illustrations

Colour plates

Figures

Acknowledgements

The origins of this book lie in the research I undertook for my PhD thesis at the University of Bristol. The subject of Elizabethan gardens and their place in contemporary culture has been little researched, unlike the literature, art and architecture of the period, which has made my journey over the past eight years both rewarding and filled with discoveries. So first and foremost, I would like to thank my supervisor and friend, Professor Timothy Mowl, for his unswerving support. Always generous with his time, Tim's extensive knowledge, helpful advice and stream of questions made my studies a pleasure, as well as a challenge to develop my thinking and ideas. Subsequently, Tim has unfailingly continued his support, encouragement and advice in the writing of this book, and I am deeply grateful to him for his patience and wise counsel. I would also like to thank Dr Stuart Prior of the University of Bristol, who undertook the role of internal supervisor for my PhD when Tim became an Emeritus Professor.

Of the many research sources I have used, I would particularly like to acknowledge the assistance and advice I have received from the teams at the county record offices of Berkshire, Gloucestershire, Wiltshire, Northamptonshire, Hertfordshire and West Sussex, especially, at the latter, Alison McCann. I must further extend my very real appreciation to Gaye Morgan at the Codrington Library, All Souls College, Oxford; and to Dr Lynsey Darby at the College of Arms,

London. Also, the staff at Cambridge University Library were notable for their courtesy and helpfulness. I would also like to extend my thanks to Christopher Hunwick at Northumberland Estates and to Louise Vincent at Wilton House for her kind assistance in providing access to private areas of the gardens there.

I would further like to thank my editors for their input and encouragement in writing this book, both David Stonestreet and Joanna Godfrey.

Finally, my grateful thanks go to my family, especially to my husband Alistair, and to my children, Jonathan, Laura and Annabel, for their continuing interest, suggestions and unceasing support, both in the writing of this book and in the years of research which went before. I could not possibly have completed it without them.

Preface

Gardens are a living art form, constantly evolving in a natural cycle of growth and decay, governed by the climate and the changing seasons. Over time, their propensity is to expand beyond the limits of the walls built to encompass and separate them from the landscape beyond: thus to look for complete physical survivals of Elizabethan gardens will invariably lead to disappointment, as in most respects they have been overtaken by the decay of time or overlain by gardens of later fashions. However, the excitement of taking a map of a sixteenth-century garden and tracing its features on the ground can be a rewarding experience, as can analysing the gardens through the perspective of rich contemporary art and literature. This can provide tantalizing glimpses into the past, giving hints as to how these magnificent gardens would once have appeared.

In writing this book, I wanted to go much further and explore a fascinating period of garden history in depth, interweaving the social, cultural and horticultural sources with the evidence surviving on the ground, to produce a vision of these lost Elizabethan gardens. The book is deliberately centred on the royal gardens and those of leading courtiers, as these were the most important of the period in England. Like the grand houses they complemented, the gardens of the educated and privileged Tudor elite were designed in a style influenced by some of the central ideas of the Renaissance. They were expressions of

Classical knowledge, reflecting a desire for a return to the Golden Age or the romantic ideal of pastoral life, as well as being social spaces devised to accommodate large numbers of people. Above all, these gardens were expressions of the aspirations of their owners, whose greatest desire was to achieve success at Court and to delight the Queen.

When Elizabeth I visited, her ceremonial advance from the countryside towards the house was, in a sense, a progress from Nature towards Art. At the extremes of the estate lay woods and groves, populated by wild men or savages, waiting to be tamed. Closer to the house, where woodland gave way to meadows, Pan and shepherds inhabited the landscape. Around the house itself, the formal gardens were intricate living art forms, designed to stimulate all the senses. The Queen herself, given the status of a goddess, ruled over a mythological world. This provided an extraordinary backdrop to the outdoor entertainments staged to greet and amuse her. Parallel to this interest in the Classical world, there was an increasing fascination with Nature. The Elizabethan period was the era of the birth of modern botany and many new plants were introduced, both from the East and from the recently discovered New World of the Americas.

There are many surviving Elizabethan houses, which are, even today, impressive in their scale and architectural presence. When they were first created, their gardens certainly rivalled, for magnificence, the houses themselves. They were places of spectacular display, of pleasure, of surprise and of sensory delight. This book is an exploration of such glorious gardens.

1

Introduction

Empresse of flowers, tell where a way
Lies your sweet Court this merry May,
In Greenewich garden Allies:
Since there the heavenly powers do play,
And haunt no other Vallies.

SIR JOHN DAVIES, *Hymnes of Astraea in acrosticke verse*, 1599.[1]

The desire to create beautiful gardens has long been one of the defining elements of a civilized culture, an expression of humanity's appreciation of art and its relation to the natural world. Gardens offer a timeless sense of peace and seclusion, as green retreats, forming oases of calm, even whilst constantly changing with the seasons and the passing years. In the words of Henry James, they can be 'places to lie down on the grass in forever, in the happy belief that the world is all an English garden and time a fine old English afternoon.'[2]

One of the greatest pleasures of life in Elizabethan England was the tranquillity of a peaceful, enchanting garden, away from the noise and bustle of a busy house. Elizabethan gardens were a profound and complex expression of the Renaissance mind, being representations of humanity's conquest and harnessing of nature. They enabled the richness of Renaissance culture to extend beyond the interior of the house into

the wider landscape and reflected the peace, prosperity and harmony brought by the rule of Elizabeth I. Gardens also became symbols of power and courtly magnificence, as aristocratic interest led to them becoming valued aesthetically as an extended space related to the house, used for display and sensual appreciation as well as for entertainment and leisure. The Renaissance garden became a living art-form, a symbol of man's ability to understand and control the natural world. Above all, Elizabethan gardens were designed to impress: frequently symbolic, they invited the cultured visitor to determine their meaning, using complex imagery to evidence the classical education of the elite.

At the pinnacle of society, England was perceived as Elysium. Thomas Dekker's play *Old Fortunatus*, performed for the Queen in 1600, lists some of the cult names given to her and elevates her to the status of dazzling goddess of her 'happy country', Elysium:

> Are you then travelling to the temple of Eliza?
>
> Even to her temple are my feeble limmes travelling. Some cal her Pandora: some Gloriana, some Cynthia: some Delphoebe, some Astraea: all by severall names to expresse severall loves: Yet all those names make but one celestiall body, as all those loves meete to create but one soule.
>
> I am one of her owne countrie, and we adore her by the name of Eliza.
>
> Blessed name, happie countrie: Your Eliza makes your land Elizium.[3]

Elysium came to mean heaven on earth, a pleasant garden filled with fragrant flowers, as described by John Gerard in *The Herball or Generall Historie of Plantes*, published in 1597:

> Talke of perfect happinesse or pleasure, and what place was so fit for that, as the garden place where *Adam* was set, to be the

Herbarist? Whither did the Poets hunt for their syncere delights, but into the gardens of *Alcinous,* of *Adonis,* and the Orchards of *Hesperides*? Where did they dreame that heaven should be, but in the pleasant garden of *Elysium*? Whither do all men walke for their honest recreation but thither, where the earth hath most beneficially painted hir face with flourishing colours? And what season of the yeere more longed for, than the Spring? whose gentle breth inticeth foorth the kindly sweetes, and makes them yeeld their fragrant smels?[4]

This book is centred on the Queen's own gardens and those of her leading courtiers, many of whom were visited by Elizabeth. The Court lay at the apex of the political, social and religious life of the nation and it dominated the culture of the upper orders of society. At its heart was the Queen herself, while around her were the nobles, the major officers of state, officials of the household and royal favourites. Predominantly masculine under a woman ruler, the Court was highly competitive and courtiers vied with one another to build impressive houses and to create magnificent gardens, displaying their wealth and position. Conspicuous display was an important element of the new relatively peaceful times, and nowhere was this more important than at Court.

The belief during the Elizabethan period in the health-giving benefits of life in the countryside, away from the dirt and disease of cities, led to much time being spent in outdoor activities. The newly built Prodigy houses had vast estates associated with them, and much of the land around the houses was used to create designed landscapes for pleasure and recreation, as well as to display the owner's wealth. One of the grandest of these houses was Holdenby in Northamptonshire where Sir Christopher Hatton, Elizabeth's Lord Chancellor and one of her favourites, built a magnificent mansion in the hope of attracting a

visit from the Queen. A 1587 map of the house shows the extent of the gardens, which included formal knot gardens, orchards, terraces and ponds as well as a less formal grove and a large hunting park (Plate 1).

Yet such Elizabethan gardens were also works of art. They had water gardens, which included exuberant fountains and grottoes, ponds and lakes. Knot gardens were designed with detailed intricate patterns, and mazes were highly fashionable. The sixteenth century saw a dramatic increase in the number of plants available to ambitious gardeners as exotic new species were introduced from overseas by explorers. It was the era of the birth of botanical science and to be a good botanist was considered a suitable aristocratic pastime. Elaborate scented arbours were built of 'carpenter's work', while colourful flowers adorned orchards whose fruit and nuts filled tables in banqueting houses.

Elizabethan gardens should be seen in the context of the Queen herself. When Elizabeth I received the news of the death of her sister Mary and her own accession, just before noon on 17 November 1558, she was 25 years old. According to tradition, she was seated beneath an oak tree in the park at Hatfield Palace. The new young Queen loved the open air and walking in her gardens; she had many fine ones at her own royal palaces, including Hampton Court (Plate 2), Whitehall (Plate 3), Richmond and Greenwich (Figure 1), all on the River Thames (Figure 2).

Amongst the first acts of the new Queen was to appoint the men who would support and assist her in her rule. These included Sir William Cecil, Secretary of State and her chief adviser, Sir Nicholas Bacon, Lord Keeper, and Lord Robert Dudley, her Master of the Horse (Plate 4). These men were all enthusiastic gardeners, who wrote to one another asking for new plants and copied designs and ideas for their gardens, both from others in England and from across Europe. Such courtiers were highly educated and cultured. They were expected to

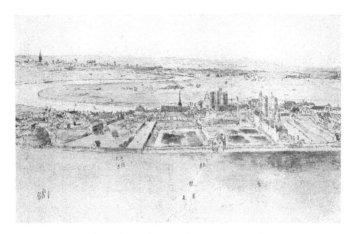

Figure 1 *Greenwich Palace from Observatory Hill, Antonis van den Wyngaerde, c.1558. The palace fronted onto the River Thames, and the drawing shows its gardens at the beginning of the Queen's reign. On the right is the Tiltyard and in the centre is the Great Garden with the Orchard beyond. The Privy Garden is on the left, overlooked by the royal apartments. The Queen later installed elaborate fountains, seats and arbours.*

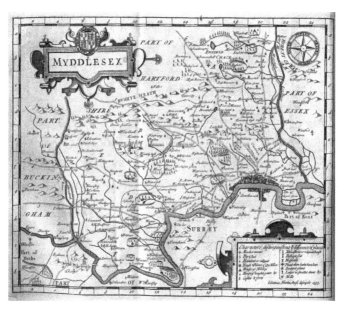

Figure 2 *John Norden's Map of Middlesex, from* Speculum Britanniae, *1593. The map shows the royal palaces of Greenwich, Richmond, Hampton Court, Oatlands and Windsor, all lying alongside the Thames. Hunting parks are marked with circles of pales. The map also marks other important houses including Theobalds in the far north, and Osterley in the west.*

dress in fine clothes, to ride well, to fence, play tennis, swim and leap, to hunt and hawk. Sir Thomas Hoby's translation of Count Baldesar Castiglione's book, *Il Cortegiano* (The Courtier), was published in 1561 and became one of the great books of the Elizabethan age, setting an agenda for the behaviour and attributes of courtiers, and running through four editions.[5] The Queen herself spoke several modern languages, as well as having a good knowledge of Latin and Greek, and she expected her courtiers to do the same. Most would have attended one of the two universities, Oxford or Cambridge, and the Queen set great store by learning.

Elizabeth was also an excellent horsewoman and hunted throughout her life, enjoying both her own hunting parks and those belonging to the many wealthy courtiers she visited across England during the course of her reign. She had her father's enthusiasm for amusement, colour, jewels and pageantry, and her education and upbringing, combined with a fierce intelligence, had left her well prepared for the responsibilities of her new role. The Venetian ambassador described her in 1557:

> She is a young woman, whose mind is considered no less excellent (*bello*) than her person, although her face is comely (*gratiosa*) rather than handsome, but she is tall and well formed, with a good skin, although swarthy (*ancorchè olivastra*); she has fine eyes and above all a beautiful hand of which she makes a display (*della quale ne fa professione*); and her intellect and understanding (*spirito et ingegno*) are wonderful.[6]

Elizabeth's long reign, echoed in the allegorical 'succession' picture (Plate 5), brought prosperity to England; it encouraged wealth and enterprise and rewarded adventure. In the painting, the Queen is glorified as the bringer of peace and plenty, in contrast to her sister Mary and her husband Philip of Spain, who bring only war.

By the end of her 45-year reign, Elizabeth had achieved cult status. She was given symbolic names to epitomize her powers, enhancing her public image. The Queen was often portrayed as Cynthia or Diana, representing the moon and the seas, beauty and chastity, names given to her by Sir Walter Raleigh. She was also frequently represented as Astraea, the Just Virgin of the Golden Age. But perhaps the most famous name given to her was Gloriana, the Fairy Queen, an image initiated by Sir Henry Lee, the Queen's Champion, at Woodstock in 1575. In the portrait painted to celebrate Lee's entertainment of the Queen at Ditchley in Oxfordshire in 1592, Elizabeth's lace wings pay homage to her as Gloriana (Plate 6). Edmund Spenser pursued the tribute in *The Faerie Queene*, published in 1590, continuing to use the image created by Lee. In his letter to his patron, Raleigh, Spenser explained: 'In that Faery Queene I meane glory in my generall intention, but in my particular I conceive the most excellent and glorious person of our soveraine the Queene, and her kingdome in Faery land'.[7] Gloriana is thus explicitly identified with Elizabeth. Designed as a glorification of the Queen and the English nation, in Spenser's poem she is celebrated as 'That greatest *Gloriana* [. . .] That greatest Glorious Queene of *Faerie* lond':[8]

> Sunne of the world, great glory of the sky,
> That all the earth doest lighten with thy rayes,
> Great *Gloriana*, greatest Maiesty.[9]

The leading gardens of Elizabethan England were not, of course, created in isolation, but were influenced by the fashion for ever more complex and ornate gardens, which had spread from Italy across northern Europe during the Renaissance. In 1494, when Charles VIII of France captured the city of Naples, he discovered there the luxurious villas of La Duchesa and Poggio Reale (Figure 3) with their impressive gardens, built shortly before Charles's arrival by Alfonso II, King of

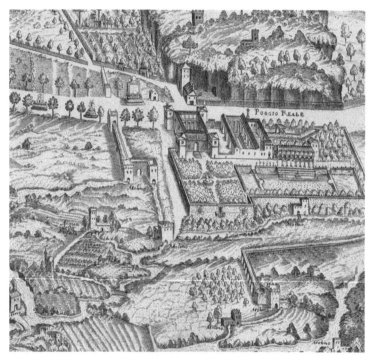

Figure 3 *A detail from Alessandro Baratta's birds' eye view of Naples, 1629, showing Palazzo Poggio Reale. The villa lay just outside the city, surrounded by the formal gardens which had so impressed Charles VIII, with fountains, terraces and a loggia.*

Naples.[10] Charles wrote to his brother-in-law, Pierre de Bourbon, that the gardens of Naples, with their hydraulic systems, fountains, avenues and statues, were 'an earthly paradise':

> You would not believe the beautiful gardens that I had in that town, for, on my faith, it seems that the only thing missing was Adam and Eve to make it an earthly paradise, they were so fine and full of good and unique things, as I hope to tell you when I see you. And moreover, I have found in this country the best artists, and sent you said [artists] to make *planchiers* [beds] as beautiful as possible, and the *planchiers* of Bauxe, Lyon and other places in France are

nothing approaching the beauty and riches of those here. Wherefore I do supply myself and bring them with me to do [work] at Amboise.[11]

These gardens were described in a poem by André de La Vigne, secretary to the Queen of France, Anne of Brittany, entitled *Le Vergier d'honneur*:

Pleasant gardens, filled with delightful flowers,
And beauties in all achieved,
Small meadows, paths and fences,
Banks, fountains and little streams,
To rest in after the fight;
Where there are antique statues of alabaster,
Of white marble and of porphyry too,
Which cannot fail to hasten the heart.[12]

Returning to France in 1495, Charles brought with him twenty-two Italian artists, including Fra Giocondo, the architect of the Palazzo Poggio Reale.[13] He began to lay out the earliest French Renaissance garden, at Amboise, and his lead was followed in France and throughout northern Europe. Knowledge of these Italian and French gardens spread to the courtiers and gentry of Elizabethan England by a variety of means: through travel overseas, by European dignitaries visiting the English court, by the spread of literature, by the employment of garden craftsmen from Europe, as well as through the import of plants and garden ornaments. Elizabethans sought to imitate these impressive Renaissance gardens in their own.

Although the Queen herself never left England, travel overseas was a widespread custom amongst Elizabethan gentlemen, a fashionable means of completing their education by acquiring languages and such physical accomplishments and social graces with which a young man

would win his way at Court. Italy was initially a favoured destination for English travellers and a source of important cultural influences. Throughout the fifteenth century the universities of Italy, pre-eminent for secular studies, had been gaining in reputation and, by the beginning of the sixteenth century, attracted students from many countries, including England.[14] William Camden, in his *Annales*, published in 1625, wrote: 'untill our time many of the most hopefull youths were chosen out of both the Universities, and trayned up in strange Countries, for the better adorning and inabling of their mindes'.[15] The revival of interest in the study of Antiquity in the fifteenth century encouraged northern scholars south to this intellectual hotbed, and the cultural distinction of an Italian degree. A memorial portrait of Sir Henry Unton shows him journeying in northern Italy, where many English men went to complete their education at the great universities of Bologna, Padua and Pisa. Such travellers through Europe brought back with them many new ideas about plants and also direct experience of some of the great European Renaissance gardens, from which they could take ideas for their own. By the Elizabethan period, Italy had many highly complex Renaissance gardens, including those of the Medici in Florence (Plate 7), the Villa Lante at Bagnaia, the Villa Giulia in Rome, the Belvedere at the Vatican (Figure 4), the d'Este gardens at Ferrara and Tivoli (Figure 5), and the Gonzaga Palazzo del Tè in Mantua. English travellers would have had the opportunity to see these at first hand.

France was also a popular destination and, other than in times of war, such as the 1540s, travel to France was extremely popular throughout the first half of the sixteenth century. Indeed, Elizabeth's mother, Anne Boleyn, had been schooled in the Court of France, and her perfect French language, style and dress sense were part of her attraction to Henry VIII.[16] The French Court continued to be seen as highly fashionable, cultured and sophisticated. Young gentlemen

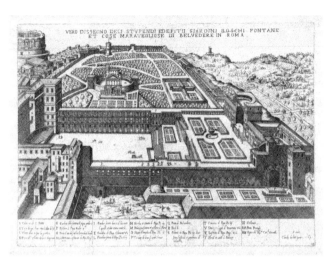

Figure 4 *Part of the Belvedere garden at the Vatican, Ambrogio Brambilla, 1579. The complex gardens were originally laid out by Bramante for Julius II from 1503 and established principles of Renaissance garden design which spread across Europe. On the right, the* Giardino dela fontana *of Julius III has a central fountain and beyond, the* Giardino Secreto *of Paul III has arbours crossing the garden. On the left are the* Palazzina Fontana *and the herb gardens of Pius V.*

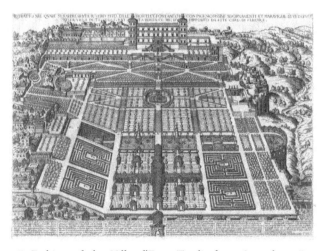

Figure 5 *Etching of the Villa d'Este, Tivoli, from* Speculum Romanae Magnificentiae, *1573. The gardens exhibit the Renaissance principles of order and symmetry. They are laid out with knots, arbours and mazes set on terraced hillsides. The river was diverted to provide a complex system of water jets and pools. Amongst the many fountains are those dedicated to Pomona, Flora, Venus and Neptune, while the Grotto of Diana is on the terrace by the house.*

returned, 'all French, in eating, drinking, and apparell, yea, and in French vices and brags [. . .] so that nothing by them was praised, but if it were after the French turne'.[17] These young courtiers would have been influenced by French cultural and aesthetic ideals, including the gardens of the period – one of the distinguishing elements of life at the French Court. The passionate dedication to gardening of successive French kings and queens, beginning with Charles VIII, resulted in great achievements in garden art during the Renaissance and this was also the culture of the English Court.

Elizabeth's own palaces were also a powerful influence on the gardens of her courtiers. When Henry VIII died in 1547, his energetic building and acquisition of houses had dramatically increased the number he possessed. He owned more than 60 houses, as well as 85 parks and forests.[18] Although this number reduced during the reigns of Edward VI and Mary, Elizabeth inherited more than 40 houses,[19] many of which contained important gardens, created by Henry VII and Henry VIII. The Queen moved regularly between her own houses, taking her Court with her, giving her courtiers direct experience of the royal gardens.

During the winter the Court stayed at one of the royal palaces in or close to London, but after the celebrations of Easter and St George's Day, with the arrival of better weather, the Queen would make short trips to her hunting lodges and the houses of her courtiers nearby. In addition to these short visits, throughout her reign Elizabeth made a practice of leaving London to travel with the Court on a series of longer royal progresses. These always took place during the summer when travel was easier, and when many of the activities and entertainments could take place in the open air. On these progresses, which could last from May until October, as well as visiting her own palaces, the Queen stayed in the houses of courtiers, aristocracy and gentry (Figure 6). The progresses therefore provided an opportunity

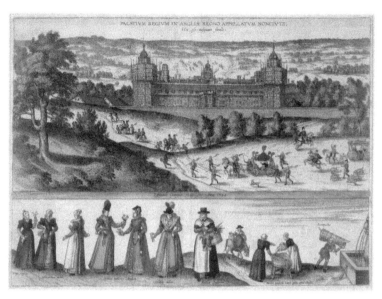

Figure 6 *A detail from an engraving by Georg Braun and Franz Hogenburg, 1582, showing the Queen arriving at Nonsuch Palace. This illustrates how the Queen travelled on Progress, usually in a carriage, accompanied by a large entourage, which must have been an impressive sight. The Latin inscription reads: 'The Royal Palace in the Kingdom of England, called Nonsuch. Nowhere is there anything the like'..*

for the travelling courtiers to see one another's gardens, and for spreading fashions and ideas.

For Elizabeth, the summer progresses allowed her to enhance her image and popularity, to strengthen royal authority and to maintain her social ties. She loved to be entertained in magnificent houses and gardens and would often stay in each place for several days. The Court travelled with her and the organization of provision for the hundreds of people, carriages, carts and horses on progress was considerable (Plate 8). Church bells were rung to announce her arrival in each town and village, and her hosts would provide entertainments, hunting and banquets in their houses, gardens and parks.

The Court accompanied the Queen wherever she went. From the very beginning of her reign, Elizabeth established a set daily routine with which her courtiers would have been familiar. She rose early and, in all but the worst weather, walked in the garden after the work of the morning was done. That the Queen loved gardens and flowers was well known, and her gardens were important to her not only for their green shady walks but, above all, for the fragrance of sweetly scented herbs and flowers (Plate 9). Spenser's poem, *The Shepheardes Calender*, published in 1579, describes her outside, sitting on the grass, wearing a coronet of roses and daffodils:

> See, where she sits upon the grassie greene,
> (O seemely sight)
> Yclad in Scarlot like a mayden Queene,
> And Ermines white.
> Upon her head a Cremosin coronet,
> With Damaske roses and Daffadillies set:
> Bayleaves betweene,
> And Primroses greene
> Embellish the sweete Violet.[20]

From the earliest years of her reign, Elizabeth chose to entertain in the open air on frequent occasions and would have expected to be similarly entertained by her courtiers when she visited their houses. Their gardens were dedicated not only to personal pleasure but also to display and courtly magnificence, especially when visited by the Queen, and her courtiers provided her with lavish hospitality. Such royal amusement would have involved her hosts in enormous expense, but nonetheless she was, for most, a welcome and esteemed guest. In Sir Philip Sidney's *Arcadia*, written for his sister the Countess of Pembroke at Wilton, Arcadia is a land of peace and 'good husbandrie', peopled with princes, shepherds and nymphs. Sidney wrote of Elizabeth:

The world the garden is, she is the flower
That sweetens all the place; she is the guest
Of rarest price, both heav'n and earth her bower.[21]

Symbolically, England was Arcadia, and Elizabeth, its Queen, the 'guest of rarest price' to her hosts.

Gardens were therefore an integral part of the rich European Renaissance culture that extended through all forms of art in Elizabethan England. The desire for riches was great, but men made money in order to enjoy it, and one of the best ways to enjoy it was to lay it out in land. No leading courtier would be without his great house, and no great house was complete without its garden. But gardens change constantly in a cycle of growth that defies the ability of their creators to maintain them in their original form. Their inclination is naturally to grow beyond the limits of the frames and walls that were built to contain and define them, and there are no surviving complete gardens of the period, although some of the more durable elements such as banqueting houses, hunting lodges and fountains survive. This book tells the story of some of these magnificent gardens and through them it re-discovers the opulent world of the elite of Elizabethan England.

2

Knot gardens, mazes and arbours

Where when I come to walke be soundry mazes
With bewties skilfull finger lyned out,
And knottes whose borders set with double dazes,
Doubles my dazed muse with endlesse doubt.
BARNABE BARNES, *Parthenophil and Parthenophe Sonnettes,* 1593.[1]

Elizabethan gardens were created to delight all the senses, and one of the greatest pleasures of a garden was the enjoyment and appreciation of its fragrance. Aromatic plants were used in many different ways by the Elizabethans, but especially in knot gardens and mazes. These ornate creations satisfied the Renaissance fashion for symmetry and decoration, as well as the love of a delightful scent. Patterns formed in squares and circles introduced order to the outside space and represented man's ability to control nature. Knot gardens and mazes are probably the best-known gardens of the period and are widely re-created today by modern gardeners. Knots were such an important element of Tudor formal gardens that most gardening books of the sixteenth and seventeenth centuries contain designs and advice on how to lay them out, as well as suitable plants to use. The variety of

knot patterns can be seen in a contemporary map of All Souls College, Oxford (Plate 10).

Knot gardens were intended to be decorative, but they were also planted for their fragrance. Elizabethans believed in the healthiness of fresh air, and when the casements were opened, the perfume of the herbs in the knots would fill the house. Sweet-scented plants such as pinks and stocks would also have been used, to introduce aromatic scents through the windows. Of pinks or 'Wilde Gillofloures', John Gerard wrote that they were 'not used in Physicke, but esteemed for their use in Garlands and Nosegaies'.[2] Sweet Johns and sweet Williams were also planted for their scent and were 'esteemed for their beauty to decke up gardens, the bosomes of the beautiful, garlands and crownes for pleasure'.[3]

Knot gardens were designed to be walked through, so that the visitor could enjoy the patterns and the sweet aroma. As Hill describes in *The Gardeners Labyrinth*, published in 1577 and dedicated to William Cecil:

> The commodities of these Alleis and walkes, serve to good purposes, the one is, that the owner may diligently view the prosperitie of his herbes and flowers, the other for the delight and comfort of his wearied mind, which he may by himselfe, or fellowship of his friendes conceyve, in the delectable sightes, and fragrant smelles of the flowers, by walking up and downe, and about the Garden in them.[4]

The layout of the garden

The garden is best to be square, encompassed on all the four sides with a stately arched hedge.

FRANCIS BACON, 'Of Gardens', 1625.[5]

The principal formal garden of the Tudor period was generally known as the Great Garden. It was a large square, next to the house and

usually aligned with it, so that its pattern and planting could be seen and admired from the windows of the most important rooms above. There are surviving examples of the site and layout of a Great Garden at Montacute House in Somerset and Hardwick Hall, Derbyshire. In both cases the garden is divided into quarters by paths, with more paths around the outside, and they may have had a fountain at the centre. Quarters were a traditional arrangement for a formal garden, inherited from the mediaeval monastic cloister. Each quarter would be divided again into smaller squares, which would be decorated with knots and other planted patterns such as coats of arms.

Enclosed mediaeval cloister gardens were relatively small, and overlooked by the inward-looking cloister. In the Elizabethan period, however, houses were built to be outward-looking, with windows facing both internally and externally. Gardens were then laid out around the outside of the house, where they could be far larger than a cloister garden, whilst retaining the traditional quartered design, as can be seen on many maps and plans of the period. These formal gardens adjacent to the house were generally divided into four squares with bordering paths and frequently fruit trees or arbours around the perimeter. An illustration of the four quarters squared out from the anonymous *A short instruction very profitable and necessary, for al those that delight in gardening* published in 1592, shows this plan (Figure 7). Such a plan can also be seen in the background of the painting of Sir Thomas More, his household and descendants (Figure 8).

An early example can be seen at Bisham Abbey, where the Great Garden is shown on Elias Allen's 1609 map as a square, enclosed by a wall and divided into quarters by paths. It extends from the house to the moat on the north side and almost to the River Thames on the west, and was about 100 metres square – approximately 2 acres in area. The garden walls define the relationship with the house, with which the garden is aligned. They divide it from the river and

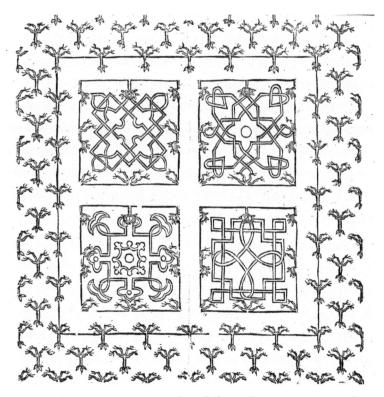

Figure 7 *'Four quarters squared out' from the anonymous* A short instruction very profitable and necessary, for al those that delight in gardening, *1592. It shows how different designs were used in each of the quarters and in this illustration the garden is surrounded by fruit trees. There are paths crossing between the quarters as well as around the perimeter.*

surrounding fields, and from the orchard to the east, providing a contrast with the landscape beyond and emphasizing the formality of the enclosure.

The building of the new Renaissance house at Bisham was begun by Sir Philip Hoby, who was a diplomat during the reigns of Henry VIII and Edward VI. In 1554 Philip was in Padua with his half-brother, Thomas, and they visited Mantua, then Caldiero and Venice in 1555. He then returned via Frankfurt and Brussels, and was back in England by

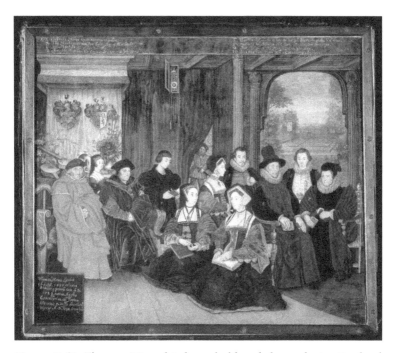

Figure 8 Sir Thomas More, his household and descendants, *Rowland Lockey, 1593–4. More's garden at Chelsea appears in the background, divided into square compartments with hedges and bordering paths. There is a gallery along the left-hand side and the small building in the corner, which has windows overlooking the garden, may be a banqueting house.*

1556.[6] It seems likely that his experiences during these overseas tours influenced the design and building of his new house and gardens. When Philip died on 29 May 1558 at the age of 53, he left Bisham to Thomas.[7]

Thomas continued the work begun by Philip, and he, too, was in some measure influenced by the buildings that he had seen in Italy and described in his journal. After his marriage to Elizabeth Cooke on 27 June 1558, he recorded that: 'The rest of this sommer my wief and I passed at Burleighe, in Northamptonshire.'[8] At the time of the Hobys' visit, Burghley was William Cecil's principal country house and he was still in the process of building it.[9]

Hoby's new wife was one of the five Cooke sisters, educated at home in Gidea Hall, Essex, by their father, Sir Anthony Cooke, tutor to Edward VI. The sisters were among the most highly educated women in England, fluent in Latin, Greek, French and Italian, and they moved in a circle of international reformists through the 1550s and 1560s.[10] Elizabeth was the fourth daughter, and two of her sisters married leading Privy Councillors: Mildred, the eldest, married William Cecil in 1545, while Anne, the second sister, married Sir Nicholas Bacon in 1553.[11] Both men were deeply interested in architecture and gardens, and the sisters lived in houses with some of the most highly developed Renaissance gardens in England. Though a lesser figure at Court than his brothers-in-law, Thomas Hoby had more direct experience of European style and fashion and brought back with him on his return to England an enthusiasm for the Renaissance culture that he had seen at first hand.

Thomas Hoby recorded in 1562: 'This yere were the garden and orchard planted at Bisham, and the gallery made with noble men's armes, etc',[12] implying that the Great Garden was laid out just before that at Cecil House. Hoby's diary also states that the fountain was placed in the garden at Bisham in 1563, probably at the centre of the Great Garden, which was designed to impress.[13] It was overlooked by the new large windows of the principal rooms, which opened the gardens to views from the house. Since Cecil took a close interest in the building works at Bisham, and visited, it is quite possible that the garden at Cecil House was influenced by, and similar to, that at Bisham.

As the gardens of courtiers grew larger, four compartments were no longer sufficient to fill the space, so while the gardens remained generally square, the number of compartments was increased. At the manor of Theobalds, near Cheshunt in Hertfordshire, Cecil worked to convert a simple moated manor house he acquired in 1564 into a grand house of axial design.[14] Re-building commenced in 1571 and by 1582 it was one of the finest houses in England. Theobalds was visited by Elizabeth at

least twelve times between 1564 and 1597,[15] and it was constantly being developed to accommodate her frequent visits.[16] It had two inner courtyards, the second with state apartments rivalling Whitehall and Hampton Court.[17] The Great Garden, next to the house, was twice the size of that at Hampton Court. Because it was still square, it was divided into nine compartments, rather than four. A similar garden with multiple compartments and a central fountain is represented in the Palissy-style dish with Pomona (Plate 11). The Theobalds garden was described in the Parliamentary Survey of 1650 as being encompassed with a good brick wall, and containing an area of more than 7 acres:

> Memorand in the sd garden there are nine large complete squares or knotts lying upon a levell in ye middle of ye sd garden [. . .] all the affforesd knotts are compassed about with a Quicksett hedge of white thorne, and privett cut into a handsome fashion, and at everie angle or corner stands a faire cherrie tree of a great growth, with a Ciprus in the middle of most of the knotts [. . .] In the middlemost knott [. . .] standeth a large and handsome fountain of white marble.[18]

In *The English Husbandman,* published in 1613, Gervase Markham explains how a knot garden is made in four quarters, representing the four corners of the earth, the traditional pattern. He is clear that the best time of year to make a knot garden is the beginning of February:

> After you have chosen out and fenced your garden-plot, according as is before sayd, you shall then beginne to fashion and proportion out the same, sith in the convayance remaineth a great part of the gardiners art. And herein you shall understand that there be two formes of proportions belonging to the garden, the first, onely beautifull, as the plaine, and single square, contayning onely foure quarters, with his large Alleyes every way [. . .] of equall breadth and proportion; placing in the center of every square, that is to say, where the foure corners of the foure Quarters doe as it were

neighbour and méete one another, either a Conduit of antique fashion, a Standard of some unusuall devise, or else some Dyall, or other Piramed, that may grace and beautifie the garden.[19]

Sundials were popular garden ornaments and Thomas Fale's *Horologiographia: The Art of Dialling*, published in 1593, describes how to make a dial using a seasoned hardwood such as pear, walnut or box.[20] As Markham suggests, there was frequently a fountain or other decorative object in the formal garden, placed at the centre of crossing paths, as can be seen in the designs of Hans Vredeman de Vries (Figure 9). Each quarter was enclosed by fencing or hedging (Figure 10), and visitors walking within the gardens could appreciate more closely the different designs and plants. That illustrated in Thomas Hill's *The*

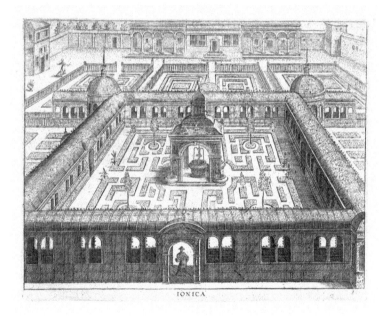

Figure 9 Ionica, *from Hans Vredeman de Vries,* Hortorum Viridariorumque, *1583. This design shows a quartered knot garden surrounded by arbours with an ornate covered fountain at the centre of the crossing paths. It is enclosed on all sides by a vine-covered arbour.*

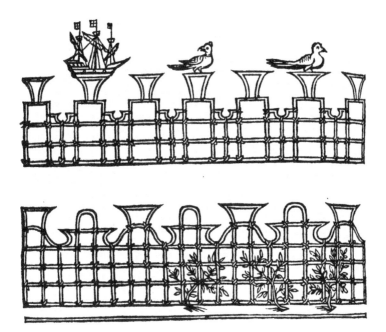

Figure 10 *This illustration of a lattice-work fence is from Gervase Markham's 1616 edition of Charles Estienne's* Maison Rustique. *Such fencing, according to Markham, 'circumferenced' the inward quarters and could be made 'in sundrie forms, according to invention', in the shapes of 'Beasts, Birds, Creeping things, Shippes, Trees and such like'.*

Gardener's Labyrinth is surrounded by a fence and shows how the gardens could be watered (Figure 11). Hill recommended that the alleys between the beds should be 3 or 4 feet wide, although in large important houses with very large gardens, they were as much as 8 feet wide. The alleys were levelled and covered with sifted sand to prevent mud sticking to the feet. In *The Gardener's Labyrinth*, Hill writes of walks and alleys in a garden:

> Alleis even troden out, and leavelled by a line, as eyther three or foure foote broade, may cleanly be sifted over with ryver or sea sande, to the ende that showers of raine falling, may not offend the walkers (at that instant) in them, by the earth cleaving or clagging to their feet.[21]

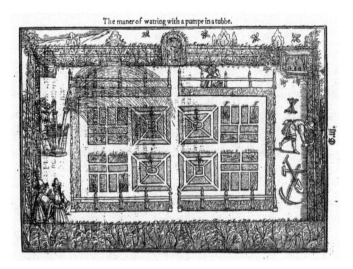

Figure 11 *'The maner of watring with a pumpe in a tubbe', from Thomas Hill's* The Gardeners Labyrinth, *1577. The small fenced garden has paths around it and between the knots. There are beehives in the corner, to provide pollination as well as honey and wax. Two couples are enjoying the garden while the gardeners are at work watering and hedge trimming.*

It was usual for the four quarters to be different, as this provided variety and interest, and enabled each quarter to convey a different meaning. The differences lay in both the patterns used and the planting scheme. In *The English Husbandman*, Markham explains how such conceits would delight visitors:

> And herein I would have you understand that I would not have you to cast every square into one forme or fashion of Quarters or Alleyes, for that would shew little varytie or invention in Art, but rather to cast one in plaine Squares, another in Tryangulars, another in roundalls, & so a fourth according to the worthinesse of conceite, as in some sort you may behould by these figures, which questionlesse when they are adorned with their ornaments, will breed infinite delight to the beholders.[22]

At Kenilworth Castle, the Earl of Leicester's garden was described enthusiastically by Robert Laneham in his letter to his friend Master Humfrey Martin, known as *Robert Laneham's Letter*, recounting the entertainments for the Queen in 1575. Laneham described how the garden plot below the terrace had 'fayr alleyz', some of grass and some of sand, 'smooth and fyrme, pleasaunt too walk on az a sea shore'.[23] This garden was 'much gracified by du proporcion of four eeven quarterz' and in the middle of each quarter was 'a square pilaster rizing pyramidally, of a fyfteen foote hy'.[24] The quarters were planted with 'redolent plants and fragrant earbs and floourz, in form, cooller [colour] and quantitee, so deliciously variant'.[25] Although Laneham does not give details of which flowers and herbs were used, this was clearly a knot garden. English Heritage has now re-created the knots using four different geometric designs and a wide variety of aromatic plants that were grown in the sixteenth century.

Designs for knots

Certayne proper knots devised for Gardeyns, to be placed
at the owners discretion.

> THOMAS HILL, *The Gardeners Labyrinth*, 1577.[26]

The design of the knot, used in a wide variety of artistic contexts, was a familiar part of culture, capable of transfer between media. The knot garden was based on traditional designs that had been used in tapestries, carpets and illuminated manuscripts throughout the mediaeval period. Knots were used by the Romans in mosaic patterns, in Italian and French church architecture, in many Celtic decorations of jewellery and crosses, and in book bindings.

There were many adventurous designs for knots in the sixteenth century, and Elizabethans had a desire to create an ever-greater assortment of patterns. Markham explains in *The English Husbandman*:

The adornment and beautifying of gardens is not onely divers but almost infinite the industry of mens braines hourely begetting and bringing forth such new garments and imbroadery for the earth.[27]

The one thing that knots had in common was that they were always square, adopting the Renaissance principle of symmetry. By the beginning of the Elizabethan period, knots had been used in European Renaissance gardens for decoration and symbolic meaning for almost a hundred years, and they continued to be a fashionable and popular garden treatment throughout the century. The application of the knot to garden design was heralded by Leon Battista Alberti in *De Re Aedificatoria,* completed in 1452 and published in 1485. Alberti's insistence on symmetry and a geometrical design in the laying out of gardens, planned in relation to the house, suited the application of traditional knot designs.

Knot gardens of fifteenth-century Italy appear in Francesco Colonna's *Hypnerotomachia Poliphili: The Strife of Love in a Dream.* Colonna was a Dominican priest in Italy, and although the book, written in 1462, was first published there in Latin in 1499, it enjoyed continuing popularity in the Elizabethan period. The story, which describes Poliphilo's sleep and erotic dream in pursuit of his love Polia, was published in French in 1546 and was partly translated into English and published in London in 1592. In his dream Poliphilo imagines fantastical gardens and the book includes designs for knots (Figure 12) and describes, between bordering paths, 'little square gardens of marvellous work, showing arrangements of various edible plants'.[28]

The fashion for creating intricate knots and mazes in Renaissance gardens spread from Italy through France to England, where they were first used by Henry VII in his gardens at Richmond Palace.[29] The vogue continued in the early sixteenth century and Sebastiano Serlio's recommendations in his *Architettura,* Book IV (first published in

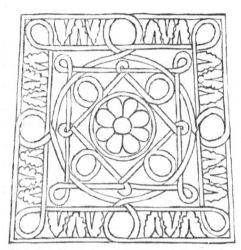

Figure 12 *This knot design from Francesco Colonna's* Hypnerotomachia Poliphili, *1499, demonstrates how the symmetry of the patterns could be used in creating square knot gardens with edible and medicinal plants. These included marjoram, ground pine, mountain thyme, germander and violets.*

Venice in 1537) include designs for garden knots and mazes. The spread of these designs through illustrations in books ensured that gardeners could create intricate knots to adorn the gardens of great houses.

Many knot designs came to England from Italy by way of France. Some can be seen in the drawings of Jacques Androuet du Cerceau, published in 1576 and 1579. His illustration of the château of Blois (Figure 13) shows knot designs similar to those of Serlio. François I expanded the parterre gardens at Blois and created very large new gardens at Fontainebleau. In England – where Henry VIII was always eager to outdo François I – this large pattern was initially used in royal gardens such as Hampton Court and Richmond.

The first English gardening book to include designs for knots was Thomas Hill's *A Most Briefe and Pleasaunte Treatise*, published about

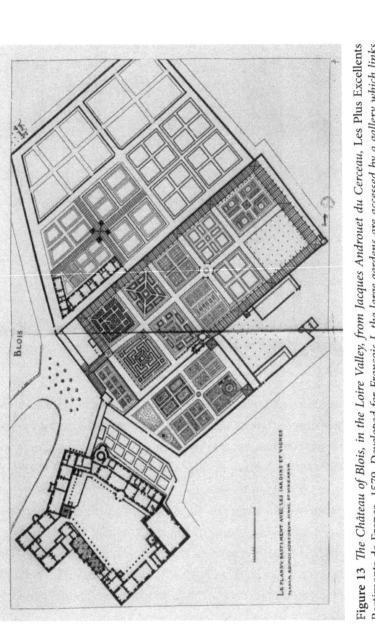

BLOIS

LE PLAN DV BASTIMENT AVEC LES IARDINS ET VIGNES
PLAN A AEDIFICII HORTORVM SIMVL ET VINEARVM

Figure 13 *The Château of Blois, in the Loire Valley, from Jacques Androuet du Cerceau,* Les Plus Excellents Bastiments de France, *1579. Developed for François I, the large gardens are accessed by a gallery which links … The whole plan is divided into ten square compartments, each of a …*

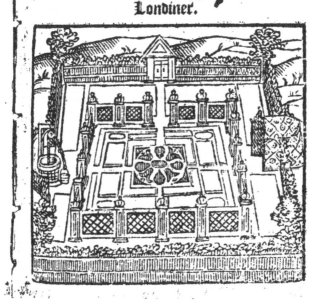

'A MOST BRIEFE
and pleaſaunte treatiſe, tea-
chyng how to dꝛeſſe, ſowe, and ſet a gar-
den: and what remedies alſo may be had
and vſed agaynſt ſuche beaſtes, woꝛmes,
flies, and ſuche like, that noye Gardens,
gathered oute of the pꝛincipalleſt Auc-
thoꝛs which haue wꝛitté of gardening, as
Palladius, Columella, Varro, Ruellius, Dyopha
nes, learned *Cato*, and others manye
moe. And nowe engliſhed by
Thomas Hyll
Londiner.

Figure 14 *The title page from Thomas Hill's* A Most Briefe and Pleasaunte Treatise, *1558. It illustrates a small garden, enclosed by fencing and hedging, with a flower-covered arbour on one side. Within the garden, the knot is surrounded by a lattice fence. The outer part is an open knot with paths between the beds, whilst in the centre is a closed knot in the shape of a flower.*

1558 (Figure 14) and re-published in 1568 with a new title, *The Proffitable Arte of Gardening*. It contained the first design for a 'Proper Knot' published in England and popularized the fashion for knot gardens, despite the clear difficulty of creating a pattern quite this complex with plants.

Garden knots could be of two types: open or closed. Open knots have the patterns set out in aromatic herbs, such as hyssop or thyme, and the spaces between are filled with different coloured earths or gravel. The lines of hedging do not intersect, and it is possible to walk through the knot on paths made of grass or sand. In a closed knot, the lines are interwoven and the spaces between them filled with flowers, such as primroses and violets.

In *Hypnerotomachia Poliphili*, Colonna recounts how the bands of the knots formed loops and 'wove alternately above and below [. . .] interlacing as they turned over and under each other' (Figure 12).[30] Knot designs for gardens were also included in the woodcuts, and the first knot illustrated was planted with marjoram, oregano, ground-pine, mountain thyme, germander, and coriander, while the central rosette was planted with violets. The knot patterns were infilled with cyclamen, rue and primulas. The centres of the loops in the outer band were filled with balls of hyssop, while standard mallows were planted in the inner loops. At the centre of the knot stood a Classical stone 'altar', topped with a cypress-shaped savin, surrounded by chervil.[31] Colonna's second knot is an intersecting design of nine squares and octagons, again with interwoven bands of 'attractive and elegant knot-work' and a 'picturesque distribution of plants'.[32] This time the knot pattern was made with bands of white marble, the spaces infilled with 'simples', or herbs, which included myrtle enclosing cyclamens, mountain hulwort and wild thyme, tarragon, achillea, groundsel and hazelwort. As Poliphilo comments: 'By Jupiter, it was a wonderful exhibition, giving great delight to the senses!'[33]

Patterns for formal gardens could also involve more elaborate designs. One was the use of heraldic emblems, which emphasized the status of their owner. The third and fourth knots in Colonna's dream garden were both decorated with heraldic images. The former had the bands and loops of the knot planted with rue, while in its centre was an eagle with wings spread in wild thyme. The spaces were filled with mountain hulwort, while around the outside was a Latin motto in capital letters of marjoram outlined with ajuga, and in the corners the background was myrtle. The last of these extraordinary knots was a design of an eagle and pheasant, standing on a vase and facing beak to beak, and again there is a motto in the border. The eagle was of groundsel, while the outer bands were periwinkle and aquilegia, the vase was myrtle and the letters wild thyme. In the loops were balls of savin and juniper. Colonna describes it as a 'wondrous work of accuracy, amenity and delight'.[34]

Knots could also be in the form of an *impresa*, or emblem. A desirable *impresa* was described by William Camden as 'a devise in Picture with his Motte, or Word, borne by Noble and Learned Personages, to notifie some particular conceit of their owne'.[35] The combination of picture and text is intended to convey meaning, neither too obscure nor too transparent, and such emblems could be adopted as personal devices. In Italy, Girolamo Ruscelli taught the 'Gentle Art' of attaching illustrations to verses, and making an emblem complete by motto, device or stanza.

Gervase Markham describes such armorial designs:

Now there is another beautifying or adorning of Gardens, and it is most generally to be séene in the gardens of Noblemen and Gentlemen, which may beare coate-armor, and that is, instead of the knots and mazes formerly spoken of, to draw upon the faces of your quarters such Armes, or Ensines, as you may either beare your selfe, or will preserve for the memory of any friend.[36]

Markham suggests that the armour is coloured with various forms of dust: white with chalk, black with coal dust, yellow with sand and red with brick dust. Green, if required, would be camomile plants, all combined with the result that 'the luster will be most beautifull'.[37] The designs for the quarters could include a mixture of knots and emblems for variety and interest.

Plants for knots and mazes

For as in garden knottes diversitie of odours make a more sweet
savor, or as in musicke divers strings cause a more delicate consent.
 JOHN LYLY, *Campaspe*, 1584.[38]

The plants used to create knot patterns in England were more limited than those in Colonna's dream garden, although gardeners became more adventurous in their planting towards the close of the sixteenth century. By the end of the Elizabethan period, Gervase Markham was recommending a wide variety of herbs to be used in knots, although the requirement for hardiness of the plants, and the need to keep them trimmed to shape, remained considerations. In *The English Husbandman*, Markham writes, with practical advice:

> Now, as soone as you have drawne forth and figured your knot upon the face of your quarter, you shall then set it either with Germander, Issoppe, Time, or Pinke-gilly-flowers, but of all hearbes Germander is the most principall best for this purpose: divers doe use in knots to set Thrift, and in time of néed it may serve, but it is not so good as any of the other, because it is much subiect to be slaine with frost, and will also spread upon the earth in such sort that, without very painefull cutting, it will put your knot out of fashion.[39]

Gilly-flowers were so called because they flowered in July, and the name covered a range of plants, including pinks and wallflowers. Markham suggests filling between the lines of the knot with different colours of gilly-flowers, hyacinths, tulips, or 'many other Italian and french flowers' so that when standing back to admire the knot 'you shall sée it appeare like a knot made of divers coloured ribans, most pleasing and most rare'.[40] Other herbs used included cotton lavender (*Santolina*), marjoram, savory, lavender and pennyroyal.

Nicholas Breton's poem, 'A Strange Description of a Rare Garden Plot', published in 1593 in *The Phoenix Nest,* gives a description of a formal garden, with four different quarters, planted in different designs and with different plants. The knots were clearly intended to be walked through, contemplated, and their meaning understood:

Foure quarters squared out, I finde in sundrie sort;
Whereof according to their kindes, I meane to make report:
The first, the knot of love, drawne even by true desier,
Like as it were two harts in one, and yet both would be nier.

The herbe is calde Isop, the iuice of such a taste,
As with the sowre, make sweete conceits to flie away too fast:
The borders round about, are set with privie sweete,
Where never bird but nightingale, presumde to set hir feete.

From this I stept aside, unto the knot of care,
Which was so crost wit[h] strange conceits, as tong cannot declare:
The herbe was called Time, which set out all that knot:
And like a maze Me thought it was, when in the crookes I got.

The borders round about, are Saverie unsweete:
An herbe not much in my conceit, for such a knot unmeete:
From this to friendships knot, I stept and tooke the view,
How it was drawne, and then againe, in order how it grew.[41]

All of these herbs had the additional benefit of medicinal uses, as well as being decorative and aromatic. Germander was soaked in water and used to treat coughs, while thyme, in addition to its culinary use as a seasoning, was mixed with honey to cure shortness of breath, or mixed with wine to treat sciatica. Hyssop was mixed with figs, water, honey and rue, and drunk to assist with lung infections, while a broth mixed with vinegar was used to treat toothache. The leaves of thrift were combined with barley meal and rose oil, and poured on the head to cure a headache. The roots of gillyflowers were held to be good against the plague, and conserves were made from their flowers for the same reason. Pennyroyal was considered useful for cramp and gout, and drunk with wine for insect bites, while dried marjoram leaves were mixed with honey to treat bruises.

Although much used in modern re-creations, box was not used for knots during the Elizabethan period, only for low hedging or topiary. The designs in the beds were never created out of clipped box, which was described by Gerard in his *Herball* as 'of an evill and lothsome smell' and it was never recommended for making knots before 1600.[42] Nor was it used in medicine, and Henry Lyte's translation of Rembert Dodoens *A Niewe Herbal,* published in 1578, explains: 'For Boxe [...] is very hurtfull for the brayne when it is but smelled to.'[43]

Mazes and labyrinths

Thou may'st not wander in that labyrinth;
There Minotaurs and ugly treasons lurk.
WILLIAM SHAKESPEARE, *King Henry VI Part I,* 5. 3.

One of the pleasures of childhood for many people is the challenge of entering a maze, and seeking the goal at its centre. Although the

names maze and labyrinth are often used interchangeably, they are in fact different. A labyrinth has a single winding path that leads to the centre and out again, and has been used as a ritual path for many different cultures representing journeys of conquest, pilgrimages, protection against evil spirits, death and rebirth, or courtship and fertility. Mazes are puzzles, with many alternative paths with junctions and choices to be made, designed to pose difficulty in finding the way in and out. Mazes are only about four hundred years old, but the history of the labyrinth is far older, and the earliest rock carvings of Classical labyrinths may be four thousand years old.

The Greek legend of Theseus and the Minotaur has kept alive the idea of the labyrinth. In the myth, Theseus, son of the King of Athens, is given a ball of golden thread by Ariadne, daughter of King Minos of Crete. Theseus enters the labyrinth of King Minos, kills the Minotaur – half man, half bull – and escapes by following the thread. The Romans took the Classical labyrinth, with its seven rings of paths, and used it in their mosaic patterns to decorate pavements. Several Roman labyrinth mosaics have been found in England as well as at many other sites in the Roman Empire.

Labyrinths were used as floor designs for churches and cathedrals in Italy from the twelfth century, and in France many cathedrals used the design. The great labyrinth in Chartres cathedral, which occupies the centre of the nave, dates to the early thirteenth century and adopts a mediaeval eleven-ring pattern. It reflected journeys by crusaders to the Holy Land: reaching the centre symbolized reaching Jerusalem and salvation. On Easter Sunday the clergy would gather there and perform a ritual ring dance. Floor labyrinths were not built in English churches, but the design is similar to that of many British turf mazes, which have a close association with the rites of Spring, celebrating renewed fertility. More than 200 turf maze locations have been identified in Britain, although only 8 survive.

In the sixteenth century, the historic idea of a labyrinth or maze was translated into a fashionable garden feature. Mazes were a variant on knots and were also square, although the design was often a circle within a square. They were planted within the formal garden, and also created with fragrant herbs, though sometimes could be made of wooden fencing (Figure 15). The earliest designs for a maze were published by Thomas Hill in *A Most Briefe and Pleasaunte Treatise*, which includes two designs, one square and one circular (Figures 16, 17), which he recommends 'mai be set ether with Isope and time, or winter Savory and time, for these will indure grene all the yeare thorow', the same planting as he recommended for knots.[44]

For the more adventurous gardener, Hill notes that 'there be some which set their Mazes with Lavender Cotten, Spike, Maierome and

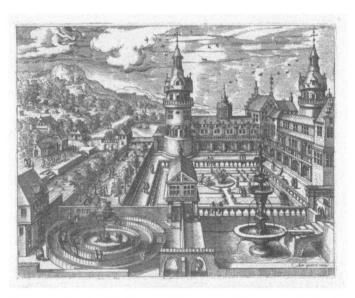

Figure 15 Castle with Maze and Fountain, *Hieronymus Cock after Hans Vredeman de Vries, 1570–80. This shows many of the fashionable elements of a sixteenth-century Renaissance garden, with a knot, fountain and maze and a banqueting house overlooking all three. Couples walk in the maze, which has a tree at its centre.*

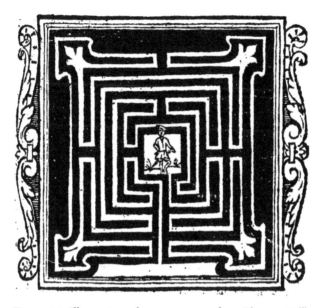

Figure 16 *Illustration of a square maze from Thomas Hill's* A Most Briefe and Pleasaunte Treatise, *1558. There is a single path which winds through the whole maze from the outside to the centre, with no dead ends. Hill described his mazes as 'proper adournements upon pleasure to a garden'.*

such lyke'.[45] The use of these scented herbs to create the pattern of the maze meant that walking within it would release a pleasing aroma, enhancing the walker's pleasure. Hill suggests planting fruit trees in the corners of the maze and 'in the mydle of it a proper herber [arbour] decked with Roses or else some tree of Rosemarie'.[46] These mazes were laid out using low-growing plants only, and the intention was to create an impression on the viewer rather than to conceal or mislead as with later, high-hedged mazes.

Garden labyrinths or mazes extend the theme of the knot into entanglement, and the labyrinth becomes a living dance. The Greek legend of Theseus slaying the Minotaur has long been commemorated in traditional folk dances, and there is a close connection between

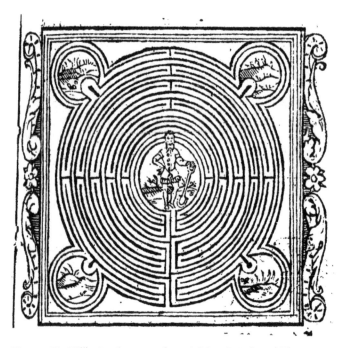

Figure 17 *Hill's circular maze from* A Most Briefe and Pleasaunte Treatise, *1558. The circle is within a square and would have been planted with low-growing aromatic herbs, in a similar manner to a knot garden. There are fruit trees planted at the corners, and in the centre the gardener holds a spade. Like the square maze, there are no dead ends.*

knots and mazes, both in the garden and the masque. A dance in Ben Jonson's masque of 1618, *Pleasure Reconciled to Virtue*, illustrates the connection:

> Come on, come on! And where you go,
> So interweave the curious knot,
> As even the observer scarce may know
> Which lines are Pleasure's, and which not.
>
> First figure out the doubtful way,
> At which awhile all youth should stay,

Where she and Virtue did contend,
Which should have *Hercules* to friend.

Then as all actions of mankinde,
Are but a labyrinth or maze:
So let your dances be entwined,
Yet not perplex men unto gaze.

But measured, and so numerous too,
As men may read each act you do;
And when they see the graces meet,
Admire the Wisdom of your feet.[47]

Hill makes the connection clear as he explains that *The Gardeners Labyrinth* sets forth 'divers Herbers, Knottes and Mazes, cunningly handled for the beautifying of Gardens'.[48] Such garden mazes were conceits, to be solved by walking the path to arrive at the centre and gain possession of knowledge.

Labyrinth patterns were used at the Villa d'Este in Italy (Figure 5), where the gardens were designed by Pirro Ligorio for Cardinal d'Este between 1550 and 1560. In France, too, mazes were common in formal Renaissance gardens, such as at Gaillon in Normandy, created for Cardinal Georges d'Amboise between 1498 and 1510. Published sources such as Hill and Serlio illustrated maze patterns, increasing their popularity. French literature included published architectural drawings by Jacques Androuet du Cerceau. His *Livre d'Architecture* (1559) and the two volumes of *Plus excellents bâtiments de France* (1576 and 1579) contain detailed architectural engravings of many of the French châteaux, from the less well known to the most famous. The engravings also illustrate the gardens and garden buildings of many of these châteaux. This publication, which was dedicated to Catherine de' Medici, was highly influential over a long period.[49]

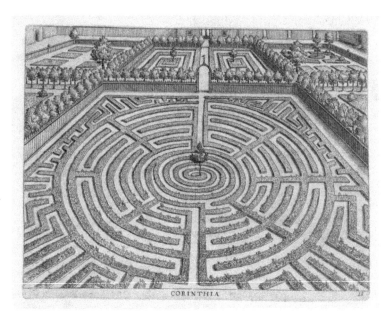

Figure 18 Corinthia, *from Hans Vredeman de Vries,* Hortorum Viridariorumque, *1583. The illustration shows a circular maze within a square enclosure, planted with low growing herbs. There is only one route from the outside to the tree at the centre.*

Also influential were twenty garden engravings by the painter and architect Hans Vredeman de Vries, which were published in Antwerp in 1583 under the title *Hortorum Viridariorumque elegantes et multiplices formae, ad architectonicae artis normam affabre delineatae* (Figures 18, 19). These are divided into Dorica, Ionica and Corinthia, showing that de Vries was highly influenced by the Classical orders.[50]

Descriptions of labyrinths in Elizabethan gardens include Anthony Watson's portrayal of the magnificent gardens at Nonsuch in Surrey. Of the labyrinth there he wrote:

> If you veer to the right, you will enter upon a tortuous path and fall into the hazardous wiles of the labyrinth, whence even with the aid of Theseus' thread you will scarce be able to extricate yourself.[51]

Figure 19 *Palace Courtyard with a Maze, from Vredeman de Vries,* Hortorum Viridariorumque, *1583. This design for a square maze enclosed within a fenced garden is planted with low growing herbs and flowers. The people illustrated in the picture give an idea of the scale of such a maze, which was designed to be walked around.*

In the later Elizabethan period, the amusement of becoming lost in a maze became a pastime for visitors to such impressive gardens. In the labyrinth at Nonsuch the hedges were so high that, by 1599, Thomas Platter wrote that it was impossible to see through them, whereas most had low hedges, as for example that shown in the painting *Pleasure Garden with a Maze* (Plate 12).[52] William Lawson's *A New Orchard and Garden,* published in 1618, envisages a maze of trained fruit trees and describes how 'Mazes well framed a mans height, may perhaps make your friend wander in gathering of berries, till he can not recover himselfe without your helpe.'[53]

Such a maze was created at Wilton in Wiltshire, where Adrian Gilbert, gardener to Mary Sidney, Countess of Pembroke, laid out

elaborate new gardens for her. Gilbert was one of the creators of great gardens in the late Elizabethan period. He was the half-brother of Sir Walter Raleigh and brother of the explorer Sir Humphrey Gilbert. For him, gardening was not simply the creation of a pastoral retreat but, rather, a challenge of science and religion, combining gardening with mathematics and chemistry.[54] Overseas exploration, in which he was involved, was also an important factor in the introduction of new exotic plants to English gardens. By 1593 Gilbert was working for Raleigh at Sherborne, acting as overseer for the estate, where he built a new lodge and elaborate gardens.[55] It was following his work at Sherborne that Gilbert became a major contributor to the development of the late Elizabethan gardens at Wilton for Mary Sidney in the 1590s. John Taylor, the 'Water Poet', visiting Wilton in 1623, described these gardens created by 'the paines and industrie of an ancient Gentleman Mr. *Adrian Gilbert* [. . .] so industrious and ingenious a Gentleman', who at the time of Taylor's visit would have been eighty-two. The Wilton Garden of Divine and Moral Remembrances used complex geometrical designs with fruit trees:

for there hath he (much to my Lords cost and his owne paines) used such a deale of intricate Setting, Grafting, Planting, inocculating, Rayling, hedging, plashing, turning, winding, and returning circular, Trianguler, Quadranguler, Orbiculer, Ovall, and every way curiously and chargeably conceited: There hath he made Walkes, hedges, and Arbours, of all manner of most delicate fruit Trees, planting and placing them in such admirable Artlike fashions, resembling both divine and morrall remembrances, as three Arbours standing in a Triangle, having each a recourse to a greater Arbour in the midst, resembleth three in one, and one in three: and he hath there planted certaine Walkes and

Arbours all with [...] Fruit trees, so pleasing and ravishing to the sense, that he calls it *Paradise*, in which he plaies the part of a true *Adamist*, continually toyling and tilling. Moreover, he hath made his Walkes most rarely round and spacious, one Walke without another [...] and withall, the hedges betwixt each Walke are so thickly set, that one cannot see thorow from the one walke, who walkes in the other: that in conclusion, the worke seemes endlesse.[56]

Lyveden, near Oundle in Northamptonshire, is one of the most important Elizabethan gardens in England. In the late sixteenth century, the estate belonged to Sir Thomas Tresham, who used his garden buildings to show off his Catholic faith in a Protestant England. The site of his lost Tudor maze was revealed by a wartime German spy photograph, and has now been awarded Grade I status by Historic England, ranking it among the most important gardens in Europe. Its layout has been restored by the National Trust (Plate 13). The garden's grass rings are approximately 140 metres across, surrounded on all sides by a square moat, and mark the maze tracing in symbolic form the religious faith of its creator. Tresham was imprisoned from 1596 until 1600, and correspondence between himself and his keeper, John Slynn, in 1597 describes the work then begun: 'If my moated orchard could in any part be prepared for receiving of some cherry trees and plum trees, I should like well thereof.'[57] The remaining circles were planted with standard roses, 6 feet apart, interspersed with 400 raspberries, planted at 5 per yard.[58] The 'moated orchard' was described by Robert Cecil as 'one of the finest orchards in England'. Cecil had sent his gardener, Mountain Jennings, to view the orchard at Lyveden before laying out his own at Hatfield.[59]

Willows were planted around the moat canals at Lyveden: the willow was also specifically associated with the Passion of Christ;

Palm Sunday being known as Willow Sunday. The raspberries also symbolized the Passion, and the white roses the Blessed Virgin Mary, while the labyrinth itself represented a spiritual journey on the one true path. There is only one way through the circles on the ground to reach the centre of the maze. This garden was therefore symbolic of Christ's Passion, as well as a celebration of Tresham's own devotion. At the corners of this square maze were circular mounts, planted with elm, sycamore and laurel, and ascended by a spiral path. Climbing one of these mounts would offer views of the moat and maze.

Another labyrinth was created at Theobalds, for Lord Burghley, where the gardens were under the care of John Gerard, whose famous *Herball* was dedicated to his master in 1597. When the Queen visited Burghley at Theobalds in 1591, she was entertained by speeches, designed to promote Robert Cecil, Burghley's younger son, as his political heir. In the speeches is a description by the 'Gardener' of how he created such a formal, quartered garden, to the design of Robert Cecil, who lived at Pymms, near to Theobalds:

At Pymms, some four miles hence, the youngest son of this honourable old man [...] devised a plot for a garden [...] The moles destroyed and the plot levelled, I cast it into four quarters. In the first I framed a maze, not of hyssop and thyme, but that which maketh time itself wither with wondering; all the Virtues, all the Graces, all the Muses winding and wreathing about your majesty, each contending to be chief, all contented to be cherished: all this not of potherbs, but flowers, and of flowers fairest and sweetest; for in so heavenly a maze, which astonished all earthly thought's promise, the Virtues were done in roses, flowers fit for the twelve Virtues, who have in themselves, as we gardeners have observed, above an hundred; the Grace[s] of pansies partly-coloured, but in one stalk, never asunder yet diversely beautified;

the Muses of nine several flowers, being of sundry natures, yet all sweet, all sovereign.[60]

This floral maze suggests that the planting became more adventurous in the late-Elizabethan period. Flowers were introduced into the patterns to create more colourful displays than the earlier herbal knots and mazes. The conceits of patterns representing the Virtues, Graces and Muses, to demonstrate Classical knowledge and to please the Queen, took the meaning of such gardens to a new level.

A modern Elizabethan-style maze at Hatfield House in Hertfordshire forms one of the quarters of the gardens beside the Old Palace (Plate 14). This is the delightful place where Queen Elizabeth I was staying when she learned of her accession to the throne in 1558. The estate was exchanged for Theobalds by King James I and has been in the Cecil family for more than 400 years. The late Dowager Marchioness of Salisbury, who died in 2016, used sixteenth- and early-seventeenth-century designs as the basis for re-creating the gardens. This restoration and revival of a formal Elizabethan garden is an inspiration, bringing together historical gardens and contemporary design. The symmetry and balance of the patterns please the eye and capture the spirit of the Elizabethan era.

Arbours

Away before me to sweet beds of flowers:
Love-thoughts lie rich when canopied with bowers.
WILLIAM SHAKESPEARE, *Twelfth Night*, 1. 1.

The principal formal gardens of this period would have had arbours covering the walks to provide shade from the sun, creating a floral, scented path for pleasure. In *The Gardener's Labyrinth*

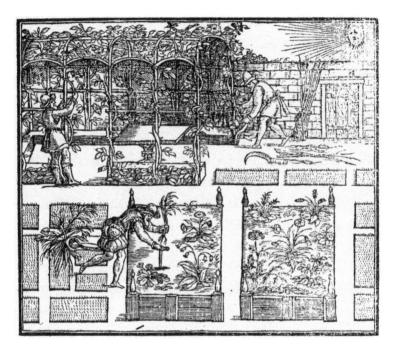

Figure 20 *Illustration from Thomas Hill,* The Gardeners Labyrinth, *1577. This shows two gardeners training plants up an arched arbour. In the background is a bundle of poles which Hill recommends should be ash for durability. Beneath the arbour are benches and a table, where diners can sit in the shade and appreciate the fragrance.*

Hill describes how such arbours were constructed and planted (Figure 20):

> The herbar in the garden may be framed with Ashen poles, or the Willow, either to stretch, or to be bound together with Oziers, or wyers, after a square form, or in an arch manner winded, that the branches of the Vine, Mellon or Cucumber, running and spreading all over, might so shadow and keep both the heat and Sun from the walkers and sitters thereunder. The herbs erected and framed in most Gardens, are to their much refreshing comfort and delight.[61]

Ash frames were recommended as more durable than willow poles, needing repair every ten years, while willow lasted only three. For his arbours, Hill recommended plants that 'ought to be those of a fragrant savour, and that grow or shoot up high', including rosemary, jasmine and red roses.[62] The lower-growing rosemary allowed 'owners friends sitting in the same, may the freelier see and behold the beauty of the Garden, to their great delight'.[63] Hill wrote: 'I have also known Bowers and Arbours made all of Rosemary, which was wondrous sweet and pleasant'.[64] Also, many arbours were planted with vines, and Hill further observed: 'the straight walks, the wealthy make like Galleries, being all open towards the Garden, and covered with the vine spreading all over, or some other trees which more pleased them'.[65] Hardwood frames could be carved with decoration, often in the form of Herms or Caryatids (Figure 21).

Arbours were covered with a wide variety of climbing plants, many of which were annual, and therefore would need to be re-planted each year (Plate 15). A popular plant for this purpose was 'Smilax hortensis' (French Bean), of which the botanist, William Turner, wrote in *The Names of Herbes*: 'It may be called in English Kydney beane, because the seede is lyke a Kydney, or arber beans, because they serve to cover an arber for the tyme of Summer'.[66] Hedge bindweed was called 'Arbor winde' by Turner, and he describes in *A New Herball* how 'It hath above manye whyte floures, and rounde thorowe oute all the braunches; and thereof are made arbores or summer-houses. But in Autumne the leaves fall of'.[67] Other quick-growing arbour climbers included briony and gourd, as well as cucumbers.

Walks crossing the garden were covered with a 'winding or arch herbar' and Hill advised that 'this Arck-herbar for any kind of Roses, may not be built much above a mans height for the short growth of

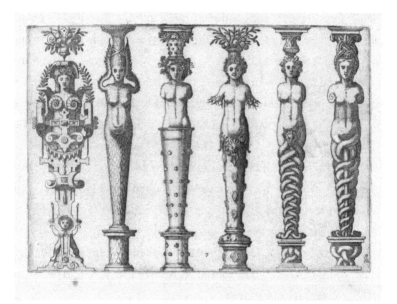

Figure 21 Caryatidum, *Hans Vredeman de Vries, 1560–70. This engraving shows caryatids, which were a column topped by a female figure, used as an architectural support. They were popular in the later sixteenth century and designs for them were distributed as ornamental prints such as this one. It comes from a set aimed at stonecutters, cabinet-makers, glass painters and other craftsmen, and could be used as a design for carving decorative arbours.*

them'.[68] But for royal or 'prince-like' gardens, such as gardens of leading courtiers, the description of taller arbours by Francis Bacon is likely to be more appropriate:

> It will give you a fair alley in the midst by which you may go in front [. . .] but because the alley will be long, and, in great heat of the year or day, you ought not to buy the shade in the garden by going in the sun thorough the green, therefore you are, of either side the green, to plant a covert alley upon carpenter's work, about twelve foot in height, by which you may go in shade into the garden.[69]

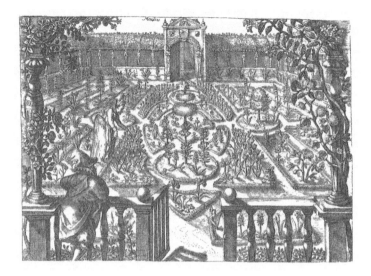

Figure 22 *Engraving of a Summer Garden from* Hortus Floridus, *Crispin de Passe the Younger, 1614. Roses, honeysuckle and jasmine climb the carved pillars of the arbour, providing a fragrant perfume, while the planting includes tulips, hyacinths and in pride of place a Crown Imperial, all recently introduced from overseas.*

Such a grand arbour can be seen in Isaac Oliver's painting, *A Young Man Seated Under a Tree* (Plate 16) and in the engraving of a summer garden from *Hortus Floridus* (Figure ??)

A pleasant scent was also an important feature, and Hill describes such arched arbours as being covered with:

the Jasmine tree, bearing a fragrant flower, the musk Rose, damask Rose, and Privet tree, in beds of drie earth, to shoot up and spread over this herbar, which in time growing, not only defendeth the heat of the Sun, but yieldeth a delectable smel, much refreshing the sitters under it.[70]

Elizabethans also appreciated delicate sounds of music and birdsong, and fine decorative elements. Bacon recommended that within the arbour there be placed

over every arch, a little turret, with a belly, enough to receive a cage of birds; and over every space between the arches some other little figure, with broad plates of round coloured glass, gilt, for the sun to play upon.[71]

3

Fountains and water gardens

And in the midst of all, a fountaine stood,
Of richest substaunce, that on earth might bee,
So pure and shiny, that the silver flood
Through every channel running one might see.

EDMUND SPENSER, *The Faerie Queene*, 1590.[1]

Water, the fundamental ingredient of life on Earth, has always been a quintessential element of gardens. Gently flowing in a river or stream, water fills the air with sound. Its ripples and waves, spreading across a still pond, swell and fade, lapping and murmuring at the bank. Thrown into the air by a fountain, water sparkles in the sun.

In the Elizabethan period, the fashion for large and ornate water gardens and fountains, as part of a desirable setting for an important house, became one of the hallmarks of a wealthy and ambitious courtier. Gardens were works of art, and water – glittering and crystal clear – was used to ornament their beauty and heighten their enchantment.

Fountains

For fountains, they are a great beauty and refreshment
FRANCIS BACON, 'Of Gardens', 1625.[2]

Fountains capture the imagination. Their jets of crystalline liquid, cool and alluring, catch and hold the attention, and offer a natural music of raindrops, creating luminous rainbows against a blue sky. Elizabethans, appreciating their beauty, seized the opportunity of enhancing their gardens with spectacular displays of spraying water. The sensual pleasure of water, rising and falling, sprinkling or splashing into pools, is one of life's delights. In the Renaissance, fountains set the mood and pleased the senses. They drew on the subject matter and imagery created in the works of Classical writers such as Ovid, transforming the tales of mythological poetry, with its erotic themes of gods and mortals, into exquisitely executed garden art. Made of expensive materials such as marble and bronze, Renaissance fountains displayed the wealth and culture of their owners. They were often placed in courtyards, providing a foretaste of what lay within.

The elegant Elizabethan fountain at Wilton (Figure 23) is a rare surviving example of a Renaissance fountain of Italianate design. Today it stands, appropriately, in the Italian Garden to the west of Wilton House, topped with a bronze statue of a voluptuous Venus wringing out her hair, from which water falls into the marble basins below. Venus, the Roman goddess of love, symbolized beauty and fertility, representing the productive power of nature, and the statue, in Classical style, shows her emerging from the waves as she did in mythology at her birth. The lower basin is carved with the Sidney porcupine as well as the Herbert wyvern, and the use of these crests means that the fountain probably commemorates the marriage of Henry Herbert, Second Earl of Pembroke, to the 15-year-old Mary Sidney in 1577.

Figure 23 *The Renaissance fountain at Wilton House is topped with a bronze statue of Venus wringing out her hair as she rises from the sea. It is a rare survival of an Elizabethan Italianate fountain and can be dated by crests on the lower basin to 1577.*

Mary's older brother, Sir Philip Sidney, wrote his pastoral *Arcadia* for her when he was staying with her at Wilton, soon after her marriage. In it he describes a fountain:

> A naked *Venus* of white marble, wherein the graver had used such cunning, that the naturall blew veines of the marble were framed in fitte places, to set foorth the beautifull veines of her bodie,[3]

repeating the sensuous theme of Venus on the Wilton fountain. Another Arcadian delight described by Sidney is a rainbow fountain, ornamented with mechanical birds singing:

> The table was set neere to an excellent water-worke; for by the casting of the water in most cunning maner, it makes (with the shining of the Sunne upon it) a perfect rainbow, not more pleasant

to the eye then to the mind, so sensibly to see the proof of the
heavenly *Iris*. There were birds also made so finely, that they did not
onely deceive the sight with their figure, but the hearing with their
songs; which the watrie instruments did make their gorge deliver.[4]

Sidney described this garden as 'a place not fairer in naturall ornaments,
then artificiall inventions'.[5] Elizabethans were attracted by the ability to
embellish nature with artifice and to demonstrate their scientific
knowledge with amusing displays, such as using running water to make
birds sing. The Huguenot engineer, Salomon de Caus, illustrates a
hydraulic machine to deliver water through a bird's beak in *Les Raisons
des forces mouvantes*, published in 1615 (Figure 24). To create a rainbow
in a fountain was to capture a magnificent natural sight and display

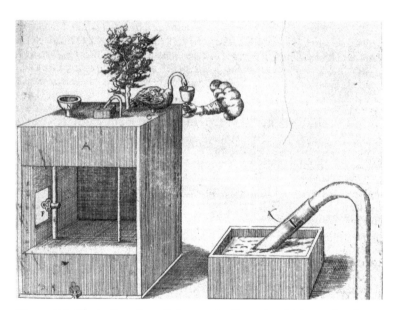

Figure 24 *Illustration from Salomon de Caus,* Les Raisons des forces
mouvantes, *1615. It shows a machine, such as described by Philip Sidney,
which uses running water to make the birds sing. It also supplies water
through a swan's beak. De Caus designed gardens in both Germany and
England, using features such as the singing birds shown here.*

it as a delightful garden conceit, adding to the colourful pleasure and show of the garden. In Greek mythology, Iris is the personification of the rainbow and messenger of the gods. In the *Rainbow Portrait* of Elizabeth (Plate 17) the Queen herself is holding a rainbow, the 'heavenly Iris', demonstrating her power to tame nature and capture its beauty.

At Bisham, Thomas Hoby recorded in his diary that in 1563 water was brought in lead pipes to the house, and a fountain placed in the garden.[6] This fountain no longer exists but was possibly influenced by Giovanni Angelo Montorsoli's incomplete (1547–53) fountain of Orion at Messina,[7] the legendary founder of the city.[8] Hoby described a fountain he saw in Messina in 1550 as:

> of verie white marble graven with the storie of Acteon and such other, by on Giovan Angelo, a florentine, which to my eyes is on of the fairest peece of worke that ever I sawe.[9]

Another impressive Tudor fountain was originally installed in the central courtyard at Cowdray in West Sussex around 1536. The house burned down in 1793 and is now a ruin, and the fountain is in the Victoria and Albert Museum (Figure 25). The Queen visited Lord Montague at Cowdray on her progress in August 1591 and, when she arrived, she would have encountered the imposing fountain, more than 3 metres in height. It is attributed to the Florentine sculptor Benedetto da Rovezzano, who worked in England from 1524 until 1543. On the top is a bronze statue of a young man, now holding a trident, possibly meant to represent Neptune. Water flowed from the mouth of the statue and from pipes among the dolphins at his feet. Around the edge of the upper bronze bowl are four Medusa head-masks through which water ran down into the octagonal marble basin below. Water also issued from four bronze dragons, which faced inwards around the edge of the basin, more like taps rather than the powerful fountain jets above.

Figure 25 *Photograph of the Cowdray fountain, c.1536, now in the Victoria and Albert Museum. On top of the fountain is a bronze statue of Neptune holding a trident in one hand, and in the other the tail of one of the dolphins which play at his feet.*

Fountains were one way in which a courtier could display his wealth and prestige, as well as his culture. The magnificent Tudor palace of Nonsuch in Surrey (Figure 26) was built by Henry VIII and sold by the Crown to the Earl of Arundel in 1556. John, First Baron Lumley, inherited it in 1580 and he created one of the most celebrated Elizabethan gardens there, decorated with many ornate fountains. When Baron Waldstein, a Bohemian traveller, visited Nonsuch in

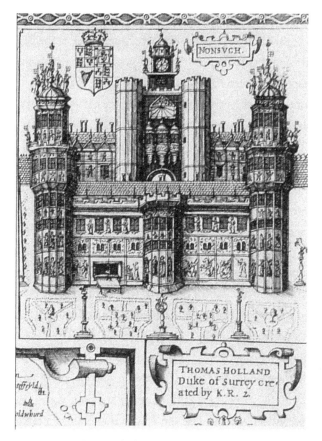

Figure 26 *The south front of Nonsuch Palace, Joducus Hondius, detail of Map of Surrey, 1610, from John Speed's* Theatre of the Empire of Great Britaine, *1611. Nonsuch was built by Henry VIII, and the famous gardens were created by John, First Baron Lumley, whose popinjay heraldic emblems are on top of the columns. A table fountain is shown standing in front of the palace.*

1600 he wrote: 'we went down into the garden which is the finest in the whole of England, and exceeding delightful it is'.[10] Amongst the many fountains was the Fountain of Diana, made between 1580 and 1582 and raised on a mound in the centre of the garden. It was described by Anthony Watson, Rector of Cheam as follows:

In the biggest open part of the grounds three equidistant mounds stand out, in the centre of which everyone admires the beauty of a striking fountain. That addition of beauty (for which the heroic Lumley is responsible) is set inside two circles of grass, of which the one is reached from the other by means of three steps, and similarly the whole plot itself from the lower part. On the top of this tiny mound is set a shining column which carries a high-standing statue of a snow-white nymph, perhaps Venus, from whose tender breasts flow jets of water into the ivory-coloured marble, and from there the water falls down through narrow pipes into marble basins.[11]

In fact, the crescent moon in her hair shows that she is not Venus but Diana, the virgin goddess of the hunt, who symbolized virtue.

There were other elaborate Italianate fountains at Nonsuch, which are illustrated in the Lumley Inventory, known as the Red Velvet Book. In the inner courtyard was a marble fountain, described by Thomas Platter, visiting in 1599 as 'a very handsome and elaborate snow-white stone fountain, showing a griffin angrily spewing water with great violence'.[12] Another typical design was in the form of a table, with a large, flat water basin supported on four marble columns. At Nonsuch there were two table fountains, decorated with Lumley popinjays.

A table fountain also stood at Kelston in Somerset (Figure 27), erected by John Harington, whose wife Etheldreda was Henry VIII's illegitimate daughter, celebrating his links with the Tudor monarchy. Harington's son, Sir John Harington, was the Queen's irrepressible godson, to whom she wrote as 'Boye Jacke'. He in turn wrote to her poetry 'From Your Highnesse Saucy Godson'. The Queen is reputed to have visited the younger Harington at Kelston, and 'dined right royally under the fountain which played in the court', sitting in the cool shade beneath flowing water.[13] Harington was the inventor of the flushing

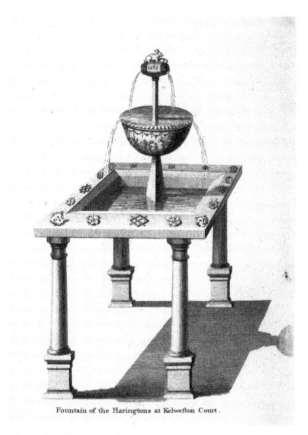

Fountain of the Haringtons at Kelwefton Court.

Figure 27 *Drawing of the table fountain at Kelston Hall, from John Collinson,* The History and Antiquities of the County of Somerset, *1791. On the table was a basin raised on an obelisk. On top of this was a hare holding a ring in its mouth, sitting on a barrel, or tun, a rebus for Harington's name. The table was decorated with symbols of Tudor monarchs: roses and portcullises.*

water closet, where 'unsaverie places may be made sweet',[14] and he presented one for the Queen at Richmond Palace. In 1588 he was banished from Court by Elizabeth for translating some bawdy passages from Ludovico Ariosto's *Orlando Furioso*. As a punishment, she ordered him to return to the country and not come back to Court until he had

completed the translation into English verse. It was the longest narrative poem undertaken by an Elizabethan courtier and, published in 1591, became an immediate success at Court. The translation, in 'English heroical verse by Sr Iohn Harington of Bathe Knight' includes a description of a fountain similar to the one at Kelston:

> But nothing did so much the fight enrich,
> As did the plenteous fountaine, that did stand
> Iust placed in the middle, vnder which
> The Pages spred a table out of hand,
> And brought forth napry rich, and plate more rich,
> And meates the choisest of the sea or land:
> For though the house had stately roomes full many,
> Yet in the summer, this was best of any.[15]

At Kenilworth Castle (Figure 28) the Earl of Leicester installed a finely carved marble fountain in his garden, and Robert Laneham described it in his account of the festivities held when the Queen visited in 1575. Topped by Leicester's heraldic symbol of the ragged staff, it had an octagonal basin decorated with provocative scenes from Ovid's *Metamorphoses*:

> In the center (az it wear) of this goodly Gardein, was theer placed a very fair Foountain, cast intoo an eight square: [...] in the toppe, the ragged staffe, which, with the boll, the pillar, and eyght sides beneath, wear all heawen oout of rich & hard white Marbl [...] Heer wear thinges, ye see, moought enflame ony mynde too long after looking: but whoo so was found so hot in desire, with the wreast of a Cok was sure of a coolar: water spurting upward with such vehemency, az they should by & by be moystned from top too to: The hees to sum laughing, but the shees to more sport.[16]

Figure 28 *At Kenilworth in Warwickshire the formal garden, now re-created by English Heritage, was within the outer walls of the castle, and the central fountain is shown in this engraving of 1620. A large lake surrounded the castle on three sides, which was used for several of the Queen's entertainments in 1575.*

Stylized and ornate fountains can also be seen in the tapestries commissioned for the Earl of Leicester (Plate 18), which may be based on those in his own gardens.

Elizabethan fountains were functional, but they were also fun, providing amusement and games (Figure 29). Such water jokes were frequently used as a part of the entertainment to spray unsuspecting visitors. Paul Hentzner visited Whitehall Palace in 1598 and described his experience:

> In a garden joining to this palace there is a JET D'EAU, with a sundial, which while strangers are looking at, a quantity of water, forced by a wheel which the gardener turns at a distance, through a number of little pipes, plentifully sprinkles those that are standing around.[17]

Figure 29 Games Round the Fountain, *Pieter van der Borcht I, 1545–
1608. The illustration shows a group of people spraying one another with
water from a fountain, while onlookers enjoy the amusement. Jets of water
cascade from the breasts of the statue and from lion masks into the basin
beneath. In the background couples walk in the formal gardens decorated
with knots and arbours.*

Waldstein noted the same water joke when visiting Theobalds in July
1600: 'There is a fountain in the centre of the garden: the water spouts
out from a number of concealed pipes and sprays unwary passers-by.'[18]
This was far from the only water-feature, and Theobalds was well
known for its use of water and fountains. Inside the gatehouse was a
container constructed to look like a bunch of grapes, and Waldstein
commented: 'It has been made with such ingenuity that when the
Queen is present they draw white wine from one part of it and red
wine from another.'[19] Further up, he described how: 'On the way up to
the house there is a fountain: a little ship of the type they use in the
Netherlands is floating on the water, complete with cannons, flags and

sails.'[20] In the central courtyard, the Fountain Court, was a table fountain supported by four pillars of black marble, on which was a group of Venus and Cupid in white marble. This fountain could be seen from the road when the gates were open.

In 1584, the Queen commissioned a new fountain at Hampton Court, to replace an earlier one built by Henry VIII. It was not completed until 1591, and cost more than £700, probably nearer £1,000. The painting and gilding alone cost £123 6s. 8d.[21] Waldstein described the courtyard where it stood as a

> quadrangle paved with squared stone and in the centre there is a fountain with a golden crown around the top of it: above this stands a gilt figure of Justice. This fountain spurts its water out of marble columns.[22]

This was the fountain that Jacob Rathgeb described in the Duke of Württemberg's Diary:

> In the middle of the first and principal court stands a splendid high and massy fountain with an ingenious water work by which you can, if you like, make the water play upon the ladies and others who are standing by, and give them a thorough wetting.[23]

There was another very large and elaborate fountain installed in 1567–70 for the Queen's pleasure palace at Greenwich. It was on a hexagonal base 54 feet around and 4 feet high, topped with 24 pilasters, 9 feet tall. Above, there were many carvings, including of six 'boyes'. The structure terminated with a timber roof topped with a carved and gilded lion holding a vane with the Queen's arms and a crown. The fountain was decorated 'with fine gold jasper & bisse & sondrie fyne collors, with sondrie of Hir Mat[es] beastes and badges.'[24]

Water gardens

Thou shall see the red gild fishes leape,
White Swannes, and many lovely water fowles.
 CHRISTOPHER MARLOWE, *Dido Queen of Carthage*, 1594.[25]

Also highly fashionable were water gardens, and most important houses would have had large artificial freshwater ponds designed as an aesthetic garden feature as well as for practical use. Water gardens reflected the desire of their owners to impress. Ponds were for pleasure, ornamental as well as practical, providing a place for sports such as fishing, duck hunting, and boating. They were also used for grand entertainments, as a setting for masques, pageants and firework displays.

The fashion was set by Henry VIII's gardens at Hampton Court, which included a large ornamental Pond Garden set between the palace and the River Thames, fed with fresh flowing water from the palace conduit, and filled with fish for the table. Here there were three large rectangular ponds, set in low walls, adorned with forty stone pillars supporting heraldic beasts holding shields. The walks around the ponds were planted with quicksets, roses, woodbine, privet and hops, a place of pleasure, built on an unprecedented scale.

Following the royal lead, an impressive Elizabethan water garden was created at Chatsworth in Derbyshire, set above a broad sweep of the River Derwent. A map of 1617 shows the extensive water gardens. There were many large ponds with orchards planted amongst them, and the pleasure of walking between the ponds was clearly one of the purposes of this design. The map shows that they were laid out below the house, extending for a considerable distance along the banks of the river. A bridge crossed the first pond immediately in front of the

entrance to the house, and a visitor standing on it would have been able to look across and admire the water gardens, which covered an area of 20 acres.

Penshurst in Kent, home of the Sidney family and birthplace of the model courtier and talented poet Sir Philip Sidney, stands on the River Medway. Penshurst was built in the fourteenth century and became a royal palace under Henry VIII, but was granted to Sir William Sidney, Edward VI's tutor and steward, in 1552. Sir William's son, Henry, enlarged the house and laid out extensive new gardens, and much of the structure of the remaining gardens at Penshurst today was created in the Tudor period (Plate 19). Despite the river, which would have also provided a source of fresh fish, ponds were made nearby, and carp ponds still survive. Ben Jonson's country house poem, 'To Penshurst', was written to celebrate the estate and it praises the fish ponds:

> And if the high swolne *Medway* faile thy dish,
> Thou hast thy ponds, that pay thee tribute fish,
> Fat, aged carps, that runne into thy net.
> And pikes, now weary their owne kinde to eat,
> As loth, the second draught, or cast to stay,
> Officiously, at first, themselves betray.
> Bright eeles, that emulate them, and leape on land,
> Before the fisher, or into his hand.[26]

Unlike most other elements of Elizabethan gardens many ponds have survived – as at Osterley in West London, built by Sir Thomas Gresham (Plate 20). He enclosed around 600 acres in Osterley Park in 1565, and his impressive new house was completed in 1576. Gresham made a long line of five ponds, which ran from the house down to the River Brent, a distance of more than half a mile. John Norden wrote that Osterley was 'garnished with manie faire ponds, which affoorded not

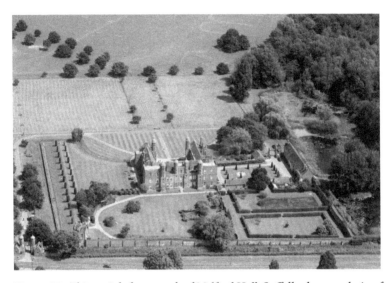

Figure 30 *This aerial photograph of Melford Hall, Suffolk, shows a chain of large ponds, demonstrating the scale of Elizabethan pond gardens, which were designed to be decorative as well as useful. The Banqueting House can be seen in the lower left corner of the garden.*

onely fish, and fowle, as swans, and other water fowle; but also great use for milles' for paper, oil and corn, and there was also 'a verie faire Heronrie'.[27] The Queen was clearly fond of Osterley, because she is recorded as visiting eleven times between 1564 and 1594, continuing to visit Lady Anne Gresham there after the death of her husband.

The ponds at Melford Hall in Suffolk also survive, and demonstrate the scale of Elizabethan pond gardens (Figure 30). They appear on the earliest map, dated 1580, and may have been inherited from the monastic site. Melford Hall was built about 1559 by Sir William Cordell, Master of the Rolls and later Speaker of the House of Commons, on the site of a hall belonging to the abbots of the Benedictine Abbey of Bury St Edmunds.[28] It was granted to Cordell in 1547, following the Dissolution.[29] He entertained the Queen there in August 1578.

At Wilton, there was a water garden, made in 1565, with five large ponds covering an area of 4 acres. The ponds were lined with walks planted with fruit trees, and were described in a survey carried out for the First Earl of Pembroke in 1566 as being 'replete with fishes called carps and tenches'.[30] In *Arcadia*, Sir Philip Sidney describes ponds, lined with fruit trees as at Wilton, as worthy of aesthetic appreciation, in providing still water for reflection:

> They came into a place cunninglie set with trees of the moste tast-pleasing fruites: but scarcelie they had taken that into their consideration, but that they were suddainely stept into a delicate greene, of each side of the greene a thicket bend, behinde the thickets againe newe beddes of flowers, which being under the trees, the trees were to them a Pavilion, and they to the trees a mosaical floore [. . .] In the middest of all the place, was a faire ponde, whose shaking christall was a perfect mirrour to all the other beauties, so that it bare shewe of two gardens; one in deede, the other in shaddowes.[31]

The Wilton garden's walks and fruit trees surrounding the ponds suggest that this was a true garden for pleasure, as in *Arcadia*.

At Gorhambury in Hertfordshire, Sir Francis Bacon inherited his father's house in 1601 and continued the trend for creating water gardens. In a memorandum written in July 1608 he gave directions 'of a plott to be made to turn ye pond yard into a place of pleasure'.[32] His description of the proposed pond garden is very detailed:

> In ye Middle of the laque where the howse now stands to make an Iland of 100 broad; An in the Middle thereof to build a howse for freshnes with an upper gallery open upon the water, a tarace above that, and a supping roome open under that; a dynyng roome, a

bedd chamber, a Cabanett, and a Roome for Musike, a garden; In
this Grownde to make one waulk between trees; the galeries to cost
Northwards; Nothing to be planted hear but of choyse.

To sett in fitt places Ilands more.
An Iland where the fayre hornbeam standes with a stand in it and
 seats under Neath.
An Iland with a Rock.
An Iland with a Grott.
An Iland Mounted wth flowres in ascents.
An Iland paved and with picture.
Every of the Ilands to have a fayre Image to keepe it, Tryten or
 Nymph etc.
An Iland wth an arbor of Musk roses sett all wth double violetts
 for sent in Autumn, some gilovers wch likewise dispers sent.
A fayre bridg to ye Middle great Iland onely, ye rest by bote.[33]

The pond garden created by Bacon was linked to Gorhambury
House by a long tree-lined avenue. About a mile from Gorhambury
Bacon built Verulam House as a summerhouse. The roof of the
house was leaded and 'from the leads was a lovely prospect to the
ponds'.[34]

Three years later Bacon's cousin and political rival, Robert Cecil,
who had acquired the old royal palace at Hatfield in return for
Theobalds, designed a moated water garden known as 'The Dell' with
islands divided by walks, radiating from a banqueting house at its
centre (Figure 31). The idea is similar to that of Bacon but the design
different, with a stream running straight through the centre of the
garden. The drawing shows what may be statues or fountains on either
side of the banqueting house, in the form of mermaids and seahorses.
At the bottom, drawn upside down, is what appears to be a grotto,
with an arched opening in a rugged mount.

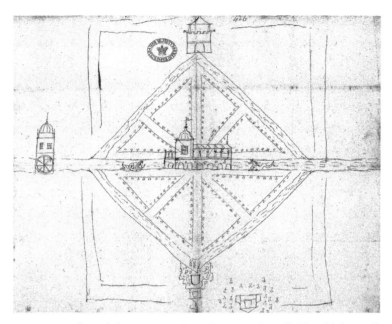

Figure 31 *Plan of the Waterworks to be erected, probably of 'The Dell', Hatfield House, Hertfordshire, 1611. The central stream appears to pass beneath the Banqueting House, which overlooks both the surrounding moat and the walks planted with trees. At the top is a building which has the appearance of a mock fort.*

When Baron Waldstein visited Theobalds he was suitably impressed and described a summer-house containing a pool in the gardens:

An outstanding feature is a delightful and most beautifully made ornamental pool (at present dry, but previously supplied with water from 2 miles away): it is approached by 24 steps leading up to it. The water was brought up to this height by lead pipes and it flowed into the pool through the mouths of two serpents. In two of the corners of this pool you can see two wooden water-mills built on a rock, just as if they were on the shores of a river. The roof itself is painted in tempera with appropriate episodes from history, and is very finely vaulted.[35]

A space beside the pool housed white marble statues of the twelve Roman emperors, arranged in a semicircle. Paul Hentzner, who had visited Theobalds in 1598, described how the upper part of the summerhouse 'is set round with cisterns of lead, into which the water is conveyed through pipes, so that fish may be kept in them, and in summer-time they are very convenient for bathing'.[36]

At Quarrendon in Buckinghamshire, owned by Sir Henry Lee, the earthworks of the mediaeval and sixteenth-century landscapes can only be reached on foot, through fields along the banks of the River Thame. This isolation from the encroachment of modern development has preserved large geometric banks and ditches that testify to the form of ornamental Tudor water gardens created by Sir Henry. The fact that the Quarrendon was virtually abandoned by Lee's heirs, and the house demolished in the early eighteenth century, means that, unlike the majority of Tudor gardens, they have not been overlain by later landscape developments.

Lee was a keen sportsman, and a poem by Joshua Sylvester describes him in his prime, as the Queen's Accession Day Champion:

> hardy Laelius, that great Garter-Knight,
> Tilting in triumph of Eliza's Right
> (Yeerley that Day that her deere Raigne began)
> Most bravely mounted on proud Rabican.[37]

Laelius was the name given to Lee by Sir Philip Sidney in *The New Arcadia*, corresponding to Sidney's own name, Philisides,[38] while Rabican was the literary steed in *Orlando Furioso*. Lee and Sidney tilted against each other on Accession Day in 1581 and 1584, and they also opened the tournament as they do in *The New Arcadia*, in which Philisides enters dressed as a shepherd-knight in his pastoral tale.[39]

Quarrendon was Lee's principal home, and he was buried in a tomb in the church there beside his mistress, Anne Vavasour. A tablet

inscribed with Lee's *Memoriae Sacrum* was mounted on the wall of the chapel, close by his tomb monument. It recorded that

> He gave himself to voyage and travaile into the flourishing States of France, Itally and Germany wher soon putting on all those abilities that became the backe of honour, especially the skill and proof in armes, he lived in grace and gracing the Courtes of the most renowned Princes.[40]

In other words, in common with other elite of the Tudor period, he completed his education by touring the courts of Europe. Such travels would also have given him first-hand knowledge of some of the great European Renaissance gardens.

In common with other Elizabethan courtiers, Lee was expected to use his wealth to build magnificent houses and create suitably impressive gardens to entertain the Queen and her Court. When Elizabeth eventually came to Quarrendon, in 1592, they were both approaching 60 years of age and Lee had already retired from his role as her Champion. But that did not prevent him offering her suitable courtly entertainments on the visit. Lee was no stranger to royal entertainments, and had entertained Elizabeth himself on several previous occasions.[41] The estate at Quarrendon that Lee inherited was a moated manor house with a courtyard and orchards. By 1600 Lee had enlarged the house and developed the gardens to the west into large, complex and highly fashionable pond gardens.

The house was surrounded by a moat with broad outer banks enclosing an area of about 8 acres.[42] This pond garden lay to the south of the church, and was rectangular with raised walkways and islands and a broad canal running diagonally across the complex. The canals would also have acted as a drainage system for the floodplain, and it is likely that they were created after 1570, otherwise the damage of a great flood that year may have been avoided.[43] The main garden occupies a

large rectangular area, defined by water channels and terraced walkways with viewing platforms on which arbours or banqueting houses may have stood. Subdivisions within this would have created small islands, and subsidiary areas enclosed by water channels lie to the north and south of this main area. These Elizabethan garden earthworks are regarded as one of only a few in the country to be so well preserved.

Moats and lakes

But specially this little River with most cleare water, encompassing the Garden, dooth woonderfully set it foorth.

BARNABE GOOGE, *Foure bookes of husbandry, collected by M. Conradus Heresbachius*, 1577.[44]

Moats were common around houses in the Elizabethan period, and came to be incorporated into the design of the gardens. Many of the properties were mediaeval moated manor houses and the moats were inherited, but sometimes new ones were created. Although moats were no longer required for defence, they were popular for recreational purposes. The moat at Bisham Abbey was retained as a part of the pleasure gardens created by Sir Philip Hoby and his brother Thomas after 1552. A 1609 map of Bisham shows the mediaeval moat, which surrounded three sides of the house with the River Thames on the fourth, enclosing an area of 22 acres, more than half of which was an orchard. Thomas Hoby recorded in his diary that in 1562 the garden and orchard were planted.[45] Orchards were frequently associated with water, and the map suggests that a path ran around the perimeter, between the trees and the moat. This would have enabled visitors to enjoy both blossom or fruit and the water. William Lawson, in *A New Orchard and Garden*, describes the pleasures of such a water feature:

I could highly commend your Orchard, if eyther thorow it, or hard by it there should runne a pleasant River with silver streames: you might sit in your Mount, and angle a peckled Trout, or a sleightie Eele, or some other fish. Or Moats, whereon you might row with a Boat, and fish with nets.[46]

Water gardens sometimes also included artificial lakes. These could be used for boating or fishing, as well as duck hunting. They were also used for performances of water festivals, which became popular across Europe. At Raglan Castle, the new Elizabethan gardens created by William Somerset and his son Edward, Third and Fourth Earls of Worcester, included a 'great Poole' – a large lake in the valley below the castle. William added a Long Gallery, which had a large window overlooking the 'great Poole', and there would have been wonderful views across it to the Black Mountains. Thomas Churchyard praises the Raglan water gardens in his poem 'The Worthines of Wales', written in 1587 and dedicated to the Queen:

The curious knots, wrought all with edged toole,
The stately Tower, that lookes ore Pond and Poole:
The fountaine trim, that runs both day and night,
Doth yeeld in showe, a rare and noble sight.[47]

Edward Somerset was responsible for the formal water garden at the head of the 'great Poole'. He also created a moat walk with fifteen brick and shellwork niches, which held statues of Roman emperors. The shellwork was made of cockle shells, forming stars enclosed in a circle, tinged with red and blue. The garden had paths and grass walks, and its remains can be seen on the ground today. A contemporary map shows a small building beside the garden, probably a banqueting house, and a later description mentions an orchard at the head of the pond. Just as at Chatsworth and Wilton, Raglan's pond gardens were associated with fruit trees and banqueting.

Adrian Gilbert, who was responsible for the creation of gardens at Sherborne and Wilton, was a practical man. He was involved in engineering projects as well as the design of gardens, as in Robert Cecil's garden at Theobalds in 1602. Gilbert's letters to Cecil over the course of that summer give an indication of the nature of the work he was carrying out, ploughing new water courses and bringing a new water supply into the park. In September 1602 Gilbert wrote to Cecil, following what had evidently been a dry summer:

> For your hope of more water for me to work on in the pollards or elsewhere, I hope you will have patience and tarry the breaking up of the springs, which this year have been so little in all places as I think this 100 years hath not been the like; for there be many master springs that never have failed before and yet now make no show at all of water [. . .] And for the ponds there in the great island by your lodge will be then best ended, and against her Majesty's coming will look trim.[48]

Clearly, amongst Gilbert's scientific skills was water engineering. The pool shown on the map of 1611 at Theobalds was a straight, regular shape. Gilbert's comment that the ponds 'against her Majesty's coming will look trim', implies that he could have been responsible for this regular shape. The designed water courses were clearly an important feature of the gardens. Paul Hentzner, visiting in 1598, described how 'one goes into the garden, encompassed with a ditch full of water, large enough for one to have the pleasure of going in a boat, and rowing between the shrubs.'[49]

Entertainments on water

The Lady of the Lake [. . .] with too Nymphes waiting upon her, arrayed all in sylks, attending her highness comming: from the midst

of the Pool, whear, upon a moovabl Iland, bright blazing with torches, she, floting to land, met her Maiesty.

<div align="right">

ROBERT LANEHAM'S Letter, 1575.[50]

</div>

Water gardens were also used as locations for grand entertainments, such as masques and pageants. These had their origins in antiquity (Figure 32). At Elvetham in Hampshire, the Earl of Hertford created a large lake especially for the Queen's visit in September 1591. The lake was in the shape of a crescent moon, symbolizing Cynthia, goddess of the moon, and a pageant was held on the water. The Queen was addressed as 'Faire Cynthia the wide Ocean's Empresse'.[51] Here Nereus, Prophet of the Sea, swam ahead of five Tritons 'brest-high in the water [. . .] cheerefully sounding their trumpets', while three Virgins in a pinnace played Scottish gigs on cornets.[52] The account of the events describes the scene:

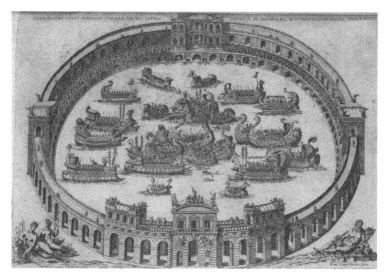

Figure 32 Naumachiae, *Etienne Dupérac from* Speculum Romanae Magnificentiae, *1581–86. This illustration shows the ancient Roman spectacle of a mock naval battle. In the Renaissance, the tradition of* naumachia *was re-invented as a form of water festival for some of the grandest royal entertainments.*

There was also in the saide pinnace an other Nymph of the Sea, named Neaera, the old supposed love of Sylvanus, a God of the Woodes. Neare to her were placed three excellent voices, to sing to one lute, and in two other boats hard by, other lutes and voices, to answer by manner of eccho. After the pinnace, and two other boats which were drawne after it by other Sea-gods, the rest of the traine followed brest-high in the water [. . .] [and] brought the pinnace neare before her Majesty.[53]

The events at Elvetham were recorded in a pamphlet, published the same year. This included a drawing of the lake there (Figure 33), illustrating how a large number of people attended the entertainment, some on foot, some on horseback.

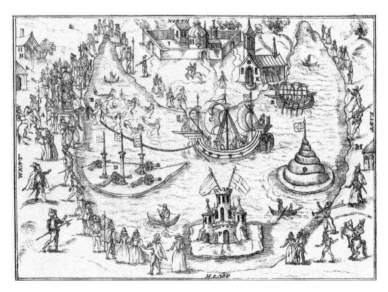

Figure 33 *The Pageant on the lake at Elvetham, Hampshire, in September, 1591 from John Nichols,* The Progresses and Public Processions of Queen Elizabeth, *1823. The Queen is sitting beside the lake on a platform beneath a canopy, surrounded by her courtiers, while she watches the entertainment. In the water is Nereus, Prophet of the Sea and five Tritons sounding trumpets, while in the pinnace, led by sea gods Neptune and Oceanus, are three virgins with cornets playing Scottish gigs.*

The earl had hastily built for the Queen's retinue a group of new buildings on a hillside in the park. The complex included a room of estate for the nobles, with a withdrawing place for the Queen, of which

> the outsides of the walles were all covered with boughs and clusters of ripe hasell nuttes, the insides with arras, the roofe of the place with works of ivy leaves, the floore with sweet herbes and greene rushes.[54]

In the lake, the earl constructed a 'Snayl Mount', a 'Ship Ile' and a 'Fort' for the entertainments. Addressed in a song sung by the Graces at her arrival as 'O beauteous Quene of second Troy',[55] Elizabeth was entertained lavishly for three days and at the end of the third day after supper were 'curious fireworks and a sumptuous banket' held 'in a lowe Gallerie in her Majesties Privie-garden':

> First, there was a peal of a hundred chambers discharged from the Snail mount; in counter whereof, a like peale was discharged from the Ship Ile, and some great ordinance withal. Then was there a castle of fire-works of all sorts, which played in the Fort [. . .] During the time of these fire-workes in the water, there was a banket served, all in glasse and silver, into the lowe Gallerie in the garden, from a hillside foureteene score off, by two hundred of my Lord of Herteforde's gentlemen, everie one carrying so many dishes, that the whole number amounted to a thousand: and there were to light them in their way a hundred torch-bearers.[56]

Another water festival took place when the Queen visited Kenilworth in July 1575 for a three-week visit to the Earl of Leicester – the longest visit of her reign. Kenilworth had been granted to Leicester by Elizabeth in 1563 and he added luxurious new apartments designed to receive her, their windows glittering with expensive glass, offering views across the lake, which encircled the castle on three sides. The Kenilworth festivities

have been interpreted as an extended marriage proposal by her long-time favourite, and they were certainly spectacular. Leicester staged a series of lavish entertainments aimed at impressing and delighting his royal guest, sparing no expense in the pageantry, with speeches, music, fireworks, costumes and extraordinary theatrical props.

Two records survive of the entertainments during her visit. The first, *The Princely Pleasures at the Courte at Kenelwoorth,* was written by the poet George Gascoigne, who not only composed many of the speeches and entertainments but also acted in them. The second account is described in *Robert Laneham's Letter.* As mentioned, a large lake surrounded the castle on three sides (Figure 28) and the water was used during the Queen's sojourn as a back-drop to several of her entertainments. Laneham's letter describes the lake:

> Too avauntage hath it, hard on the West, still nourisht with many lively Springs, a goodly Pool of rare beauty, bredth, length, deapth, and store of all kind of freshwaterfish, delicat, great, and fat, and also wildfooul byside.[57]

When the Queen arrived at the castle on Saturday 9 July, it was eight o'clock in the evening as she was greeted by Hercules, giving up his club and keys, proclaiming the gates open and granting her free passage. Trumpeters dressed in silk, walking on the walls 'had this musik mainteined from them very delectably' while Elizabeth rode through the tiltyard to the inner gate.[58] There, the Lady of the Lake with two nymphs, all dressed in silk, floated from the middle of the pool to land to meet her 'upon a moovabl Iland, bright blazing with torches'.[59]

The following day there was a firework display over the lake late at night, described by Laneham:

> With blaz of burning darts, flying too and fro, leamz [beams] of starz coruscant, streamz and hail of firie sparkes, lightninges of

wildfier a water and lond, flight & shoot of thunderboltz: al with
such continuans, terror and vehemencie, that the heavins thundred,
the waters soourged, the earth shooke [. . .] This a-doo lasted while
[t]he midnight waz past.[60]

At a water pageant later during her stay, as the Queen was crossing the
bridge across the lake, Laneham's letter describes how Leicester had
erected this 'beautifull bracelet of a fayr tymbred bridge',[61] 600 feet
long, stretching from the Chase to the castle, from which the Queen
could view the pleasures. Returning from hunting in the park, she was
met by Triton, on the back of a swimming mermaid, sounding his
trumpet, and Arion on a dolphin, singing a song. This seems to
resemble the water festival at Bayonne organized by Catherine de'

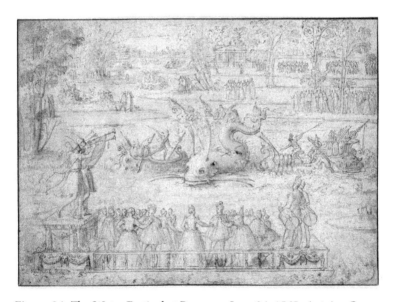

Figure 34 The Water Festival at Bayonne, June 24, 1565, *Antoine Caron,*
1565. This festival was devised by Catherine de'Medici to entertain Charles
IX and his sister Elizabeth. Courtiers watch the spectacle of a sea monster
under attack by men dressed as Romans, armed with spears. In the
background is Neptune in his chariot carrying his trident, pulled by three
seahorses. Tritons blowing cornets are seated on a large turtle.

Medici in 1565 (Figure 34). At Kenilworth, the Queen watched from the bridge, as the Lady of the Lake and her nymphs floated on 'moovable Ilands' with 'Triton on hiz mermaid skimming by' while Arion, riding a dolphin, sang 'a delectabl ditty of a song'.[62]

In *A Midsummer Night's Dream*, Shakespeare recalls the legend of Arion, the musician saved from drowning by a dolphin and a mermaid whose songs could seduce voyagers, while the shooting stars are fireworks. Kenilworth is only fourteen miles from Stratford, and many local people attended the entertainments. Some scholars think Shakespeare may have been there as a young boy, and is writing from experience. Oberon's speech recalls the scene:

> Well, go thy way: thou shalt not from this grove
> Till I torment thee for this injury.
> My gentle Puck, come hither. Thou remember'st
> Since once I sat upon a promontory,
> And heard a mermaid, on a dolphin's back,
> Uttering such dulcet and harmonious breath,
> That the rude sea grew civil at her song,
> And certain stars shot madly from their spheres,
> To hear the sea-maid's music.[63]

Leicester, of course, was unsuccessful in his bid for the royal hand, his midsummer dreams dashed, despite the extravagance of his welcome. In Oberon's words, 'Cupid's fiery shaft/[was] Quenched in the chaste beams of the wat'ry moon', and the 'fair vestal', the Queen, 'passèd on/ In maiden meditation, fancy-free'.[64] Leicester may have been disappointed by the outcome, but the memory of those summer pleasures lives on.

4

Dining Al Fresco *and* *banqueting*

A pleasant smiling cheeke, a speaking eye,
A brow for Love to banquet roiallye.
CHRISTOPHER MARLOWE, *Hero and Leander*, 1598.[1]

Sharing a meal in good company, whether with friends and family or when entertaining guests, has always been one of life's greatest pleasures – an integral part of the bonding of human society. To eat outside, where the fresh air and a gentle breeze can accompany the taste of the food and where birdsong can combine with musicians playing, enhances the experience and delights all the senses. Elizabethans took such pleasures to new levels and whether in intimate banqueting houses or at large tables laid in the garden, food became an art form. Delicate and complex presentation of produce from parks and gardens was used to further demonstrate wealth and ingenuity, and guests were provided with sumptuous feasts for their delectation, served as formally and impressively as they would have been in the house (Figure 35).

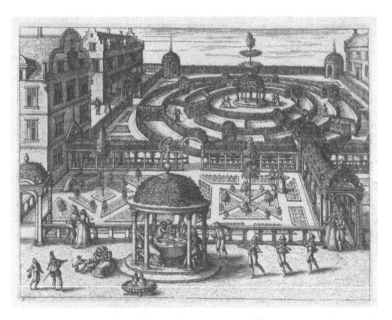

Figure 35 Courtyard garden with a party at a table, *Pieter van der Borcht I, 1545–1608. A group are sitting at a table beneath an arbour attended by liveried servants. The table is dressed with a cloth and fine plate, whilst there is an ornate wine cooler in the foreground, illustrating how dining outdoors could be just as formal as inside. In the background are gardens with knots, arbours and a large maze.*

Dining *Al Fresco*

On Thursday she dined in the privie walkes in the garden, and the Lordes and Ladies at a table of xlviii. [forty-eight] yardes long.

> *The speeches and honorable entertainment given to the Queenes Maiestie in progresse, at Cowdrey in Sussex, by the right honorable the Lord Montacute. 1591.*[2]

The pleasure of dining *al fresco* was an important aspect of Elizabethan hospitality, and in the summer months, when the weather was fine, a feast could be held outside in the garden rather than indoors. This

gave the host an opportunity to arrange the seating to display to best advantage his elaborately designed gardens and to impress his guests with his fragrant summer flowers. The formal dining tables would be dressed with crisp white linen cloths and laid with the best tableware, prepared for the service of fine food (Plate 21). Tables in the garden could be longer and accommodate more people than would be possible indoors, and guests could enjoy the added pleasure of a garden setting for the feast. It was also preferable for hosts to entertain the Queen and her large Court in the gardens, where there was more space for so many people.

These royal occasions, held outside in the summer, sometimes in the evenings illuminated by candlelight and torchlight and glittering with silver and gold, must have offered an unrivalled combination of luxury, ceremony, opulence and show. The association of banqueting, wine and love, this time the drink being nectar –the drink of the Gods – is elegantly made in Ben Jonson's *Song to Celia* (1616), which begins:

> Drink to me only with thine eyes,
> And I will pledge with mine;
> Or leave a kiss but in the cup,
> And I'll not look for wine.
> The thirst, that from the soul doth rise,
> Doth ask a drink divine:
> But might I of Jove's nectar sup,
> I would not change for thine.[3]

A record of two such ceremonial occasions exists in the account of the Queen's visit to Cowdray for six days in August 1591, when her host was the elderly Lord Montague. The description of the occasion relates that 'On wednesdaie the Lords and Ladies dined in the walkes, feasted most sumptuously at a table foure and twentie yards long'.[4] On the Thursday, the Queen dined 'in the privie walkes in the garden', at a

table 48 yards long.[5] The narrator describes it as 'honourable feasting and abundance of all things that might manifest a liberall and a loyall heart'.[6]

The two dinners at Cowdray were served in the open air. On other occasions, however, even if the weather was fine, a temporary banqueting house might be built in the garden or park for outdoor dining.

In May 1559, the Queen entertained the French ambassadors to a banquet in the garden at Whitehall Palace 'dressed entirely in purple velvet, with so much gold and so many pearls and jewels that it added much to her beauty'.[7] The association of a walk in the orchard, where banqueting fruits are grown, to heighten the appreciation of the banquet, is mentioned in a letter written by Il Schifanoya to the Castellan of Mantua, describing how the party banqueted:

> in the garden [. . .] under the long and wide gallery on the ground floor, which was all hung with gold and silver brocade, and divided into three apartments, in the centre of which was the table prepared for her Majesty, and at a short distance from it another for the Ambassadors. There was also a table 54 paces in length for the other lords, gentlemen, and ladies. The whole gallery was closed in with wreaths of flowers and leaves of most beautiful designs, which gave a very sweet odour and were marvellous to behold, having been prepared in less than two evenings so as to keep them fresh.[8]

Banqueting houses were also built in parks as well as in formal gardens. A banquet was held in Greenwich Park on 10 July 1559:

> therefore was set up [. . .] a goodly banqueting-house for her grace, made with fir-poles, and decked with birch-branches, and all manner of flowers both of the field and garden, as roses, July-flowers, lavender, marigolds, and all manner of strewing herbs and rushes [. . .] About five in the afternoon came the Queen, with the ambassadors, and divers lords and ladies, and stood over the park

gate to see the exercise [. . .] After this the queen came down into
the park and took her horse, and rode up to the banqueting-house,
and the three ambassadors; and so to supper.[9]

In June 1572, when the Duc de Montmorency and the French
ambassadors were again entertained by the Queen at Whitehall,

the rest of that daie, with great part of the night following, was
spent in great triumph, with sumptuous bankets [. . .] the Queenes
Majestie havinge provided a place all breaded and deckt with
flowers on the forrests, and also covered with canvas on the head.[10]

This banqueting house had required 116 workmen to decorate it, at a
cost of £224 including:

the decking therof with birche & ivie: and the ffretting and garnishing
thereof, with fflowers and compartementes, with pendentes & armes
paynted and gilded for the purpose. The ffloore therof being all
strewed with rose leaves pickt & sweetned with sweete waters &c.[11]

William Hunnis, who was keeper of the gardens at Greenwich, provided
79 bushels of roses, with pinks, honeysuckles, and privet flowers.

In 1581 a new and very large banqueting house was built in the
gardens of Whitehall for a visit by the Duke of Alençon, for 'the
Intertaymt of mounsere by Queen Elyzabethe'.[12] Von Wedel, who saw
the house in 1584, was told that birds sang in the bushes overhead
while the entertainment was in progress. Made in the 'forme of a long
square, three hundred thirtie and two foot in measure about', it took
24 days to construct, at a cost of £1,744 19s., by 375 workmen.[13] Its
construction was of 'thirtie great masts, being fortie foot in length a
peece' standing upright, 10 feet apart. The walls were canvas and
painted outside 'most artificiallie with a work called rustike, much like
to stone' and there were 292 'lights of glasse'.[14] Inside were ten tiers of
stands for spectators. The resulting banqueting house survived until

1606, and must have seemed extraordinary, decorated with golden flowers, fruit and vegetables in the sky:

> and in the top of this howse was wrought most cuninglie upon canvas works of Ivie & holy, wth pendants made of wicker rods, & garnished wth baies, Rue & all manner of strang flowers, and garnished wth spangs of gould, as also garnished wth hanging Toseans made of holly & Ivie, wth all manner of strang fruits, as pomegarnetts, orrengs, pompions, Cowcombers, grapes, carretts, Peaes wth such other like, spanged wth gould & most ritchlie hanged. Betwene thes works of baies & Ivie were great spaces of Canvas, wch was most cuninglie painted, the cloudes wth the starrs, the sunne and sunne beames, wt diverse other coats of sundry sorts belonging to Qs matie, most ritchlie garnished wth gould.[15]

The English weather, of course, was not always conducive to a pleasant outdoor banquet. In September 1574, when the Queen was visiting the Earl of Pembroke at Wilton, she chose to hunt

> in Claryngdon Parke where the said [Earl] had prepared a very faire and pleasant banquett [-house decorated with] leaves for her to dyne in; but that day happened soe great raine, that although it was fenced with arras, yet it could not defend the wett, by meanes whereof the Queen dyned within the Lodge and the Lords dyned in the Banquett-house,[16]

the men caring less about the rain.

All of these banqueting houses, some very large, were temporary structures, built in a garden or park setting and much use was made of flowers and plants in their decoration. The close personal association with gardens and flowers was to last for the entire duration of Elizabeth's reign, and would have been a point of note for the many hosts whom she visited, as was her evident enjoyment of banqueting.

As her reign progressed and she was entertained at ever more houses, her hosts made efforts to provide a suitable banqueting house and appropriate garden setting.

Thus, in 1575, the competition between her courtiers to entertain the Queen moved to a new level. Leicester, expecting her at Kenilworth in July 1575, wrote to Lord Burleigh: 'I have to thank your L. also very hartely [. . .] that I may have some stone toward the making a lytle banquett-house in my garden.'[17] There had in fact been a wooden banqueting house built in the park at Kenilworth for Henry V about 1414, but a new, more permanent stone building was required by Leicester for Elizabeth. Robert Laneham's account relates how: 'After the play oout of hand, folloed a most delicioouz and (if I may so terme it) an Ambrosiall Banket [. . .] & number of the disshez (that wear a three hundred).'[18]

This was clearly a large banquet in the sense of a full meal for many guests, as it may have been when, on her first summer progress, Lord Cobham entertained the Queen at Cobham Hall on 17 July 1559 in

> a banqueting house made for her Majesty in Cobham Park, with a goodly gallery thereto composed all of green with several devices of knotted flowers, supported on each side with a fair row of hawthorn trees, which nature seemed to have planted of purpose in summer to welcome her Majesty.[19]

From 29 August until 5 October 1575, the Queen stayed with Sir Henry Lee at the royal manor of Woodstock in Oxfordshire. There was an elaborate but temporary banqueting house built around the trunk of a great oak, which may have been similar to those shown in Nicolaes de Bruyn's engraving (Figure 36) and Dieter van der Heyden's engraving (Figure 37). The centrepiece of the entertainment was the dramatized presentation of the *Tale of Hemetes the Hermyte* and its sequel. At the climax of the narrative, Hemetes leads the Queen to his

Figure 36 Spring, *Nicolaes de Bruyn after Maerten de Vos, 1581–99. A large banqueting house decorated with caryatid columns is built on stilts around a tree. Inside a group is dining, while musicians play and people dance beneath. In the foreground gardeners are preparing and planting the beds.*

Figure 37 Spring, *Dieter van der Heyden after Pieter Breughel the Elder, 1570. Here there is a double-tiered banqueting house built around a tree overlooking the river, with diners above and below. As at Woodstock, the tree is trained to create a roof. On the river a couple are boating whilst other couples lie on the grass and musicians play.*

'simple hermitage', which is in fact the elaborate banqueting house on a mount, constructed around the oak. The hermitage, also referenced to Jupiter, was described as:

> A place by art so reared from the ground [. . .] incompassed the number of 200 paces round with lattise, the place of the princes entrance bedect with Ivy and spanges of gold plate [. . .] The ground from thence reared litle and litle to the altitude of forty foot or more, the path in mounting covered with fresh turves [. . .] The way was railed with lattice, beset with sweet flowres & Ivy [. . .] above in the house was a Table made in order of a halfe moon or more, covered with green turves (& so replenished with sorts of dainty, & those divers dishes belonging to banquet, that the beholders might wel have though[t] *Iupit.* had hoped the comming, & trusted the pleasing by banquet of his faire *Europa.*) [. . .] this mount made [. . .] aboute an Oake, the toppe whereof was inforced by strength too bende downe her branches to cover the house [. . .] A number of fine Pictures with posies of the Noble or men of great credite, was in like sort hanging there.[20]

In other words, the branches of the oak were bent to form an arbour, and on them were suspended pictures with allegorical 'posies' that served as emblems.

Other oak trees were used for the Queen's entertainment during her summer progresses, making a symbolic association between the longevity and strength of the tree and that of the loyalty of her nobility. The opportunity to use the tree for symbolic purposes, as well as for the pleasure of banqueting, compares with Spenser's description of the Bower of Bliss in *The Faerie Queene*:

> With bowess and braunches, which did broad dilate
> Their clasping armes in wanton wreathings intricate:

So fashioned a Porch with rare device,
Archt over head with an embracing vine,
Whose bounches hanging downe, seemed to entice
All passers by, to taste their lushious wine [. . .]
And them amongst, some were of burnisht gold,
So made by art, to beautify the rest,
Which did themselves emongst the leaves enfold,
As lurking from the vew of covetous guest.[21]

On the two occasions when the Queen was served an *al fresco* feast at Cowdray, both were at dinner, which was generally served at eleven o'clock for the gentry and midday for farmers and merchants. For everybody it was the main meal of the day, and could last for two or three hours. For a feast, however, the number of dishes was many more than for a normal dinner. Feasts made use of the produce of the gardens and estate in a wide array of complicated and inventive ways. The host had an opportunity to impress the Queen with the delicate presentation of his herbs and flowers – which she may have admired growing in the gardens and walks – carefully prepared and arranged in dainty dishes and decorations for the table. Gervase Markham described in *The English huswife* how, when preparing a royal feast, 'she shall first marshall her sallets, delivering the grand Sallet first, which is ever more compound'.[22] He lists a wide array of garden flowers, herbs and vegetables. Some were designed to be eaten, others only to 'furnish out the table', while others were for both 'use and adornation'.[23]

'Compound Sallets' could involve the combination of fresh flowers, such as violets and marigolds, with young buds of sage, mint, lettuce and spinach, served with an oil, vinegar and sugar dressing, allowing a host the opportunity to showcase garden produce at the table. Markham provided a recipe suitable for a royal feast, which combined garden produce such as 'Red-sage, Mints, Lettice, Violets, Marigolds,

Spinage' with imported luxuries including raisins, figs, almonds, capers, olives, oranges and lemons.[24] He described how flowers picked from the gardens could be used in 'Sallats' for their colour and to dress the table. Flowers could be preserved in sugar and vinegar, and were 'both good and daintie'. Markham described preserving gilliflowers, primroses, cowslips, violets and bugloss flowers this way, which were laid in the shape of the flower in a fruit dish 'for better curiositie and the finer adorning of the table'.[25] He explained that 'these Sallats are for both shew and use; for they are more excellent for taste then to looke on'.[26]

Although for the winter months flowers were preserved, in the summer they would have been freshly picked, though preserved flowers could still be used for decoration. The style of the garden was extended to the table for adornment and admiration at a feast. The heraldry on display in the gardens, according to Markham, could also feature in the dressing of the table:

> Now for Sallats for shew onely [. . .] they be those which are made of Carret rootes of sundrie colours well boiled, and cut out into many shapes and proportions, as some into knots, some in the manner of Scutchions and Armes, some like Birds, and some like wild Beasts, according to the Art and cunning of the Workman.[27]

Given the hunting that took place during the Queen's visits, it was also usual that venison was included. As Gascoigne commented: 'The Venson not forgot, most meete for Princes dyshe'.[28] Markham suggested that fallow deer might be included with the first course and served as a hot dish in a pasty, or red deer served as a cold baked meat with the second course. Cooks made great efforts to create pies and pasties, which were both visually exciting and full of flavour, spiced and fruited. The crusts could be made into the shape of animals or heraldic devices, or decorated with leaves or flowers.

The second course of the feast, according to Markham, probably would have included:

> The lesser wild-fowle, as Mallard, Tayle, Snipe, Plover, Wood-cock, and such like: then the lesser land-fowle; as Chicken, Pigeons, Partridge, Raile, Turkie, Chickens, young Pea-hens, and such like. Then the greater wild-fowle; as Bitter, Hearne, Shoveler, Crane, Bustard, and such like. Then the greater land-fowles; as Peacocks, Pheasant, Puets, Gulles, and such like.[29]

Ponds would have attracted wildfowl such as mallard, snipe, plover, bittern, heron, and crane, while the swans, which were also eaten, would have been on the pond or river. The turkeys and chickens would have been kept in cages or pens, while partridge and pheasant would have been bred on the estate. To the extent that birds for the table were caged, rather than wild, they would have provided an element of interest in the gardens and walks. For example, in 1542 and in 1543 payments were made for carpenters' work in the King's House in Southwark, for the making of birdcages there.[30]

A grand outdoor banquet was held in Hyde Park – then a deer park – in July 1551 at which the food was cooked outside. A letter from Sir Thomas Caverden describes the banquet, for the visit of Marshal St André:

> Encloses, The charges and proportions of the banqueting house newly erected in Hyde Park, and divers standings in the same Park, and also in Marybone Park, 6–28 July, 5 Edw. VI.:—
>
> Hyde Park.—The banqueting house 62 ft. long and 21 ft. wide, the stairs containing one way 60 ft. and the other way 30 ft., with a great turret over the 'halpase.'
>
> Item. Three ranges of brick for roasting, and furnaces for boiling.
>
> Item. All kinds of tables, forms, trestells, dressers, rushes, &c., for furnishing the house and banquet.[31]

Banqueting

I myght more muze at the deintynesse, shapez and the cost: or els at
the variete & number of the disshez.

ROBERT LANEHAM'S Letter, 1575.[32]

One of the other great pleasures of entertainment in Elizabethan
gardens was also known as a banquet but it had a different meaning.
This was the serving, after a meal, of sweet wine and delicacies
intended to delight, amuse and impress the guests. After dinner or
supper, they moved away from the main dining tables to eat apart,
giving an opportunity for intimate conversation and entertainments,
away from public view. Such banquets were served in banqueting
houses, which arose as conceited little rooms and took on a wide
variety of sizes, shapes and forms. Some were within the house, in
towers or on the roof, while others were separate buildings in the
garden. Some were very small, with room for just a few people, others
were larger and would accommodate more guests. Many banqueting
houses were permanent buildings of brick or stone, but some were
temporary constructions of wood, canvas or arras, or were arbours
woven with twigs, canes and vines, to meet a short term requirement
to entertain. But whether temporary or permanent, all these
banqueting houses shared a common relationship with the garden,
either being located within it, or overlooking it, as in the painting by
Lucas van Valckenborch (Plate 22) in which a formal garden is shown
in the background and the tablecloth is strewn with flowers. The
banqueting house was designed to impress, and a host's garden was an
essential element in creating that impression.

An intimate banquet, served after a meal, normally comprised a
range of fruits, pastries, sweetmeats and sweet, spiced wines such as
hippocras, almost all luxury foodstuffs. Much use was made of sugar

– at that time an expensive import –in pastries, sweets, marmalades and preserved fruits. Sugar was also used to make the centrepiece of the banquet: march-pane or marzipan (Plate 23, bottom left). Gervase Markham, in *The English huswife,* required the use of costly ingredients such as almonds from Jordan and rosewater from Damascus, as well as sugar, to make march-pane. In November 1559, Robert Dudley entertained the Queen at Eltham Palace in Kent for a few days, and his accounts include a brick of marmalade, a 'marchepayne', a 'boxe of collingale', quinces and 'dyvers other kinds of banqueting stuff'.[33] Although fruits such as apples and pears were served both fresh or preserved, rarer fruits such as oranges, lemons and apricots were preferred. Preserved fruit might be a 'wet sucket' if it was in syrup or a 'dry sucket' if candied. The anonymous writer of *A Closet for Ladies and Gentlewomen* provided advice on 'how to make divers kinds of Syrups: and all kinds of banqueting stuffes' ranging from preserved apples to preserved 'Apricockes' and 'Pomcitrons'.[34]

Many books of recipes and advice on 'banqueting stuffes' were published. These aimed not just at women, such as Hugh Plat's *Delightes for Ladies,* published *c.*1600, but also at men, such as Thomas Dekker's *The Batchelars Banquet,* published in 1603, in which 'is prepared sundry daintie dishes to furnish their Table'.[35] *Delightes for Ladies* describes 'How to preserve whole Roses, Gilleflowers, Marigolds, etc'.[36] The expense and exoticism of sugar and spices led to them being locked away in cabinets, as if they were jewels. But they were also viewed as medicines that would refresh or comfort the spirits, credited with great powers of restoration. The Wild Rose, or 'Sweet Brier', was grown in Elizabethan gardens for its attractive flowers and fruit. John Gerard wrote that the hips, when ripe, 'maketh most pleasant meates and banketting dishes, as Tartes, and such like'.[37]

As important as the actual food served at banquets was the presentation and variety offered, since the intention was to impress as

well as entertain. The Dudley Box, damascened with gold and silver, was clearly designed for this purpose, as well as to hold sweetmeats (Plate 24). Gervase Markham advised that the banquet might comprise:

> March-panes [. . .] your preserved fruites shall be disht up first, your Pastes next, your wet Suckets after them, then your dried Suckets, then your Marmelades, and Goodiniakes, then your Cumfets of all kindes; next your Peares, Apples, Wardens bak't, rawe or roasted, and your Orenges and Lemmons sliced; and lastly your Wafer cakes [. . .] no two dishes of one kinde going or standing together, and this will not only appeare delicate to the eye, but invite the appetite with the much varietie thereof.[38]

Banqueters not only ate and drank – they also talked, played games, sang and listened to music. Books such as Anthony Munday's *Banquet of Daintie Conceits,* published in 1588, which provided lyrics and music for 'sweete ditties', suggest the form of some of these amusements.[39] The author of *A Closet* also indicates that small amusements would have been presented along with the food, providing recipes such as 'To make a Walnut, that when you crack it, you shall find Biskets and Carrawayes in it, or a pretty Posey written'.[40] Even the thin wooden trenchers off which banqueters ate were designed to amuse, being elaborately decorated and often incorporating a short verse to recite or sing. George Puttenham, in *The Arte of English Poesie,* published in 1589 and dedicated to the Queen, described how such epigrams were 'Printed or put upon their banketting dishes of suger plate, or of march-paines' and 'we call them Posies, and do paint them now a dayes upon the backe sides of our fruite trenchers of wood'.[41]

 With this need for hosts to entertain and impress their guests, all late sixteenth-century houses of any consequence had a banqueting house, permanent or temporary. An example is shown in the portrait of Sir

Henry Unton at his house at Wadley near Faringdon in Oxfordshire (Plate 25). These were constructed to provide a view – usually of the gardens – and were therefore often high up, either in a rooftop tower, on a mound or hill in the garden or park, or simply a small tower in the garden. There was a feast for the eye, both in the banquet and in the landscape. Elizabeth spent almost a week staying with Sir Henry Sharington at Lacock, Wiltshire, in late August 1574. His cousin, William Sharington, had acquired the old monastic buildings in 1540, and converted them into a new house with an octagonal tower at one corner (Figure 38). Inside the tower are two small banqueting houses, one above the other, with windows that offer views across the gardens. Sometimes banqueting houses were within the building, as the lower tower room, and could be reached from within the house. Sometimes, they were high up on the roof, and could only be reached from the leads, as the upper tower room. Both rooms had ornate octagonal banqueting tables designed to fit the room (Figure 39).

Rooftop banqueting houses were built at Chatsworth in the 1570s, while at Hardwick, built in the 1590s, there were six turrets, of which one served as a banqueting room. At Burghley House in Lincolnshire, re-modelled between 1573 and 1588, the roof was covered with turrets. Elizabeth stayed at Longleat with Sir John Thynne on 2 September 1574, where the roof was covered with banqueting houses, built by Robert Smythson in the 1560s (Figure 40). At least four of them had 'lytle stares won fro the roofe so as they may serve as banketting houses'.[42] Multiple banqueting houses such as at Longleat, probably reflected a large group of guests breaking into smaller groups, either each with a private banqueting house, or moving from house to house with different delicacies served in each. The privacy of these little alcoves would have offered the opportunity for personal conversations or lovers' trysts. For the Queen's visit, Thynne employed a cook 'qualified both in skill and good behaviour', and presented her with a gift of a Phoenix jewel set

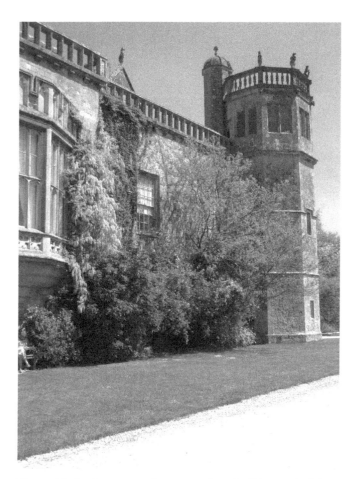

Figure 38 *In the octagonal tower at Lacock Abbey in Wiltshire there are two small banqueting houses, one above the other. The lower room is accessed from inside the house but the top room can only be reached from the leads. Both rooms offer views across the gardens, an important element of the pleasure of banqueting.*

with a large emerald, fifty diamonds and rubies and a pendant pearl which cost him £160.[43] A month later Thynne received news that 'Thanks be to God, her Majesty is well returned with good health and great liking of her entertainment in the western parts, and especially at your house, which twice since she hath greatly commended.'[44]

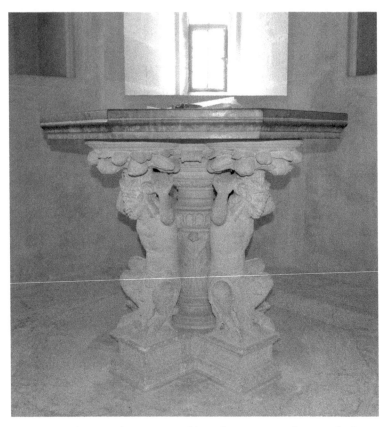

Figure 39 *The stone banqueting table with an octagonal top in the lower tower room at Lacock matches the shape of the room and still stands in the position for which it was originally made. Carved with pagan satyrs, it is attributed to the mason John Chapman.*

Instead of being built into the house, banqueting houses might be separated. The twin pavilions at Montacute (*c.*1598) at the corners of the forecourt (Plate 26), or the Queen's octagonal banqueting house at Windsor, built on the terrace overlooking the gardens in the 1570s, are examples. In addition to its rooftop banqueting turret, Hardwick Hall also had two banqueting houses in the corners of the forecourt, built in 1596. Banqueting houses could also be associated with water features in the garden: around 1570, Richard Carew planned, but

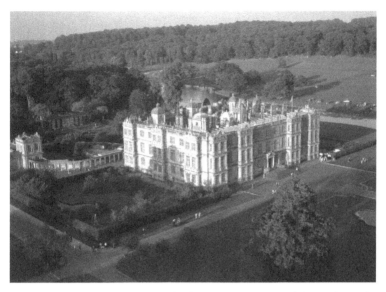

Figure 40 *This aerial photograph of Longleat House, Wiltshire, shows the many small banqueting houses on the roof, built in the 1560s. Large groups of guests could break into smaller, more intimate groups for the banquet, with excellent views of the gardens from the top of the house.*

never built, a banqueting house on an island in the saltwater pond below Antony, his house in Cornwall.[45]

At Melford Hall in Suffolk there is an octagonal banqueting house (Figure 41), which was probably built in the 1570s. Inside was a marble table, described in an inventory of 1635, which is now lost.[46] An estate map shows the banqueting house in a far corner of the walled garden. It is set in an elevated position, and the windows would have offered views both across the formal garden and over the wall to the landscape beyond. The Queen visited Melford Hall in August 1578 and was probably entertained in the new banqueting house.

Banqueting houses took on whimsical shapes. There were fanciful structures at Hampton Court, some rectangular, some circular or polygonal (Figure 42). The tower at Lacock was octagonal, whilst the aforementioned Carew's plan of 1570 was a complex of squares and

Figure 41 *This ornate octagonal banqueting house at Melford Hall, Suffolk was built in the 1570s. It is set in a raised position, offering views both across the formal garden and over the wall to the landscape beyond.*

circles, and Thomas Tresham's of 1593 at Rushton, Northamptonshire, was triangular (Plate 27). The association of Christian symbolism with banqueting houses can be seen at Lyveden New Bield in Northamptonshire, built by Tresham in 1596. The banqueting house, built at the centre of the elaborate water garden, was rich in symbolism

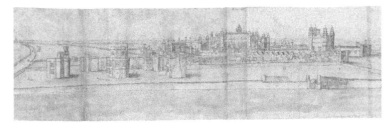

Figure 42 *A detail from* Hampton Court Palace from the North, *Antonis Van der Wyngaerde, c.1558. The drawing shows some of the ornate banqueting houses at the beginning of Elizabeth's reign. Built in 1537, they were fanciful buildings of varied design. These little towers, built on the side of the Tiltyard, had flat crenellated roofs which could be used as viewing platforms for watching the tilt.*

of the Trinity and Passion. Amesbury Abbey in Wiltshire boasts two pleasure houses built for Catherine, wife of the Earl of Hertford. One is known as Kent House, and the other inscribed over the door 'Diana Her Hous 1600', which has ogee turrets and octagonal and triangular ground plans (Figure 43).

Figure 43 *This little lodge at Amesbury Abbey is inscribed 'Diana Her Hous 1600' above the door. One of two pleasure houses built for the Countess of Hertford, it overlooks the gardens and park in one direction, and the River Avon in the other.*

At Nonsuch, Surrey, a separate banqueting house was constructed
in 1538–46, situated on a mound within Nonsuch Little Park. It was
demolished in 1667 but excavations in 1930 and 1959–60 show that it
resembled a Tudor artillery fort, built on a raised platform and
enclosed by a wall. It was a timber-framed two-storey building
surmounted by a lantern, and staircases ascended the platform on
every side except the southwest.[47] The banqueting house was described
in an account of 1582 by Anthony Watson as having 'the most peaceful
views, the most agreeable lights, the spaciousness of the rooms and
hall [. . .] worthy of King Henry – of Diana herself'.[48] The Earl of
Arundel entertained Elizabeth there in August 1559:

> There the Queen had great entertainment with banquets, especially
> on Sunday night, made by the said earl; together with a mask; and
> the warlike sounds of drums and flutes and all kinds of music, till
> midnight. On Monday was a great supper made for her [. . .] After
> that, a costly banquet accompanied with drums and flutes. The
> dishes were extraordinary rich, gilt. This entertainment lasted till
> three in the morning.[49]

Later that month, Elizabeth visited Lord Clinton at West Horsley in
Surrey:

> The said Lord built a goodly banqueting-house for her Grace; it
> was richly gilded and painted; that lord having for that end kept a
> great many Painters for a good while there in the country.[50]

In May 1577 Elizabeth visited Sir Nicholas Bacon at Gorhambury,
Hertfordshire, her fourth visit in six years. On this occasion she stayed
for five days, during which he entertained her sumptuously at an
expense of nearly £600. Built during the 1560s, Gorhambury was
famous for its fine gardens, where the walls of the Italianate piazzas
were frescoed with the adventures of Ulysses by Van Koepen. The

banqueting house, which stood in the orchard, was a temple to the Liberal Arts, decorated with verses in Latin and pictures of the learned men who had excelled in each:

GRAMMAR.
O'er speech I rule, all tongues my laws restrain,
Who knows not me seeks other arts in vain.
ARITHMETIC.
The wit to sharpen, I my secrets hide,
These once explor'd, you'll soon know all beside.
LOGIC.
I sep'rate things perplex'd, all clouds remove,
Truth I search out, shew error, all things prove.
MUSIC.
Sorrow I sooth, relieve the troubled mind,
And by sweet sounds exhilarate mankind.[51]

Rhetoric, Geometry and Astrology were similarly commended, all accompanied by pictures of their famous proponents including Euclid, Copernicus, Cicero and Aristotle. As Pennant wrote, 'this room seemed to have answered to the Diacta, or favourite summer room of the younger Pliny at his beloved Laurentinum, built for the enjoyment of an elegant privacy apart from the noise of his house'.[52]

Elizabeth visited Sir Thomas Kytson at Hengrave Hall, Norfolk, where she stayed for three nights in August 1578. The team moving ahead of her spent two days setting up a temporary banqueting house in readiness for some special entertainment. Thomas Churchyard, who was there, judged 'the fare and banquets' as far exceeding those at a number of other places. A show was put on featuring fairies, which he considered 'as well as might be'.[53] A similar temporary banqueting house was built for the Queen's visit to Lord North at Kirtling Tower, Cambridgeshire, the following month, who was 'no whit behind any of the best' for his

hospitality and entertainment.[54] He calculated that the Queen's visit had cost him £762, including jewellery worth £120.[55]

Red Lodge in Bristol (Figure 44) was built in the 1580s for Sir John Young as a banqueting house in the gardens of his now demolished

Figure 44 *Red Lodge, Bristol, was built in the 1580s as a banqueting house for Sir John Young, in the garden of his Great House. The rooms were large and the windows commanded views across the garden down towards the River Avon.*

Great House, which stood below on the quay. These formal gardens were laid out on the hillside beyond the house on land that Young bought during the period 1575–81.[56] One of a pair of banqueting houses, its sister White Lodge now gone, it provides an example of how large and spacious banqueting houses could be. The Queen had visited Young in Bristol in August 1574, when she was entertained to a mock battle and fireworks on the water, which she watched from a 'skafold [. . .] set up full over against the Fort'.[57] Red Lodge was built after this visit, but Sir John would no doubt have liked to entertain her there.

5

Groves, wildernesses, mounts and grottoes

No garden yet was ever half so sweet
As where Apollo and the Muses meet.

A.B. 'Of this Garden of the Muses', 1600.[1]

Gardens of the Renaissance were places not only for the display of plants but also for the communication of ideas. The re-flourishing of Classical culture could be expressed in these green sacred spaces, where beauty lay not only in the gardener's skill but also in the power by which the gardens themselves spoke of Renaissance knowledge. Leading courtiers were well versed in the classics, as was the Queen herself, and during the Elizabethan period increasing numbers of translations of Classical texts were published. In 1565, Arthur Golding translated Ovid's *Metamorphoses* (written from about the first century AD), dedicating the volume containing the first four books to the Earl of Leicester.[2] This was followed by the translation of all fifteen books two years later. This popular work was reprinted in several editions throughout Elizabeth's reign. In Ovid's description of the mythical Golden Age – an age of perfection to which men aspired to return – spring lasted all year round. In the myth, it was not until the

later Silver Age that the four seasons occurred, with their less desirable heat and cold. Ovid describes a time when a mild spring climate allowed nature to provide food throughout the year:

> The fertile Earth as yet was free, untoucht of spade or ploughe,
> And yet it yéelded of it selfe of every thinge ynough.
> And men them selves contented well with plaine and symple
> foode,
> That on the earth of natures gyft without their travell stoode,
> Did live by Raspis, heppes & hawes, by cornelles, plummes and
> cherries,
> By sloes and apples, nuttes and peares, and lothsome bramble
> berries,
> And by the acornes dropt on grounde, from *Ioues* brode trée in
> fielde.
> The Springtime lasted all the yeare, and *Zephyr* with his mylde
> And gentle blast did cherryshe thinges that grewe of owne
> accorde,
> The ground untylde, all kinde of fruits did plenteously avorde.[3]

Many of the tales from *Metamorphoses* feature in different forms in Renaissance culture. Diana and Actaeon appear in the gardens at Nonsuch; Venus and Adonis appear in Shakespeare's poem of the same name and in the description of the Garden of Adonis in Spenser's *Faerie Queene*. The tale of *Apollo and Daphne* was performed during the entertainment of the Queen at Sudeley Castle in 1592, while Hercules was present on many occasions, bearing his club, to welcome her. Robert Laneham's description of the fountain at Kenilworth suggests that its octagonal base was carved with scenes from Ovid, while the tale of *Pyramus and Thisbe* is told in Shakespeare's *A Midsummer Night's Dream*. References to these ancient gods can be found repeatedly in the masques presented to Elizabeth on her

progresses, and familiarity with the work of the ancient poets, especially Ovid, is a central theme of the Renaissance and expected of the cultural elite.

The Queen and Court referred to Classical authors to display their knowledge and culture, and gardens were often associated with earthly paradises of Classical mythology. Many of the entertainments presented to the Queen did not romanticize the landscape but, instead, mythologized it. The role of the Queen was to be a goddess herself, to be worshipped by the mythological deities who appeared in the gardens and parks she visited, paying her homage.[4] The allegorical picture of *Elizabeth and the Three Goddesses*, presumed to be painted for the Queen, re-tells the beauty contest 'The Judgement of Paris' (Plate 28). In the painting, Elizabeth is portrayed in the company of other Classical gods and goddesses: Juno, Pallas and Venus. Playing the part of Paris, she keeps the prize, an orb instead of an apple, for herself.[5]

So Elizabeth herself was incorporated into these Classical themes as a goddess. In Michael Drayton's *Shepheards Garland*, published in 1593, she is portrayed in 'Rowland's Song' as Queen of the Muses, bedecked with flowers:

> O see what troups of Nimphs been sporting on the strands,
> And they been blessed Nimphs of peace, with Olives in their hands.
> How meryly the Muses sing,
> That all the flowrie Medowes ring.
> And *Beta* sits upon the banck, in purple and in pall,
> And she the Queene of Muses is, and weares the Corinall.[6]

Eglantine was taken by Elizabeth as her personal emblem, and it was used beside her image on silver coins. This small five-petalled flower, painted pure white with some artistic licence, was used repeatedly in

portraiture and poetry associated with Elizabeth throughout the rest of her reign. Nicholas Hilliard's miniature, *Young Man Among Roses* (Plate 29), probably of her favourite, the young Earl of Essex, illustrates him wearing the Queen's colours of black and white, hand on heart to show his passion, entwined with eglantine.[7] It was a flower to be appreciated; as Shakespeare expressed it in *A Midsummer Night's Dream*:

> I know a bank where the wild thyme blows,
> Where oxlips and the nodding violet grows;
> Quite over-canopied with luscious woodbine,
> With sweet musk-roses and with eglantine.[8]

Sir Arthur Gorges, one of Elizabeth's Gentlemen Pensioners, wrote *A Pastorall unfynyshed*, otherwise known as 'Eglantyne of Meriflur', probably before 1584, adding later lines to the still incomplete poem as a tribute to the Queen, named 'thys brave Eglantyne'.[9] The eglantine is 'enspyred with heavenly power', representing the royal power of the Queen, ordained by God. In the Classical scene with the goddess Diana, a 'Jollye swayne', his hair garlanded with red and white roses and eglantine, plays a harp and sings:

> But when of Eglantyne he spake
> his strynges mellodiously he strake
> The Albion flowre so fayer so pure
> whose Excellen[c] doothe well declare
> whatt worthy braunch thys blossom bare
> Shee woonnes in plesaunte Meryfleur
>
> Greate flora Sommers soveraygn queene
> to make hyr glory to us seene
> from Paradys dyd fetch this flower
> It first was planted in that place

and after grafte in humane race
Butt styll enspyred with heavenly power.[10]

Meryfleur is named after the Queen's Hunting Tower, called Mirefleur, at Greenwich Palace. The tower was named after the castle described in *Amadis de Gaul*, a popular chivalric romance. It was available in French translation throughout the Elizabethan period, and the first two books were translated into English in the 1590s. The story narrates the love of Amadis for his childhood sweetheart, Oriana, heiress to the throne of England. Oriana, a role Elizabeth enjoyed playing, liked to retire to her castle of Mirefleur:

> Now you must understand, that this place of Mirefleur, was a little castle most pleasantly seated two leagues from London, built upon the side of a hill, and compassed upon the one side with the forrest, and upon the other with many orchardes full of all sorts of trees and pleasant flowers: moreover it was environed with many great fountaines, which watered it on all partes.[11]

This place of retirement and pleasure, away from the palace, gave the opportunity of a setting for chivalric role play while watching the hunt.

Groves

Actaeon, The day's hunt finished, idly wandering through unknown clearings of the forest, found the sacred grove.
> OVID, *Diana and Actaeon*.[12]

One of the ways in which Classical knowledge was translated into an Elizabethan garden setting was in the creation of groves. These were

areas of woodland, wilder than formal gardens, yet still used for
pleasure and inhabited by mythological deities, whom they honoured.
In a grove, trees were arranged in a formal pattern, including one
which appeared to be without order, creating copses and glades with
shaded walks contrived by topiary. Here the landscape abandoned its
symmetry – but not its meaning. Groves were also sacred spaces,
frequently dedicated to deities and ascribed metaphorical significance.
They often included a significant and symbolic tree, usually an ancient
oak, as at Nonsuch, where an important grove attracted large numbers
of visitors. Anthony Watson, visiting there in 1582, described the
Grove of Diana created by Lord Lumley, named 'Diana her woodde',
which combined many of these elements. The Piper probably implies
a statue of Pan:

> In the woodland walk near to the Piper an ancient oak rises up into
> the sky with its propitious branches and shows the way straight
> into the shady Grove of Diana. There throughout almost the whole
> copse and the glade, are places arched over by the skill of topiary,
> walls erected and sandy walks which lend an air of majesty worthy
> of the chaste virgin and most powerful goddess. So that I am not
> surprised that Diana herself, guardian of the groves, lurks in the
> shadows, satisfied with the service of nymphs alone [. . .] she fears
> the ceaseless dins of earthly affairs and stays fast in the leafy
> woods.[13]

The Grove at Nonsuch makes reference to Ovid's story of *Diana and
Actaeon*, in which Actaeon sees the naked goddess Diana bathing in a
spring in her sacred grove, and as a vengeance she turns him into a
stag to be killed by her hounds. Diana was goddess of the hunt and the
moon, and was associated with wild animals and woodland, as well as
being the virgin goddess of childbirth, who swore never to marry. She
preferred to dwell on high mountains and in sacred woods and is

depicted as a beautiful, youthful huntress, carrying bow and arrows; her attribute is a diadem shaped as a crescent moon. The grove in *Diana and Actaeon* is in the mythical Vale of Gargaphy, described by Ovid:

> There was a valley clothed in hanging woods
> Of pine and cypress, named Gargaphie,
> Sacred to chaste Diana, huntress queen.
> Deep in its farthest combe, framed by the woods,
> A cave lay hid, not fashioned by man's art,
> But nature's talent copied artistry,
> For in the living limestone she had carved
> A natural arch; and there a limpid spring
> Flowed lightly babbling into a wide pool,
> Its waters girdled with a grassy sward.
> Here, tired after the hunt, the goddess loved
> Her nymphs to bathe her with the water's balm.[14]

Frequently, a spring or stream would be associated with a grove. The stones of the spring might be carefully arranged, nature transformed by art, to create a feature to inspire the imagination of a visitor. At Nonsuch, Watson described how: 'If the goddess should be faint from the chase, weary of effort, the Vale of Gargaphy will provide her with its icy spring.'[15] Mirroring Ovid's description, a feature of the Vale of Gargaphy at Nonsuch was 'the sacred spring of the Nymphs', named 'The rocke welle', where Diana bathed after she transformed Actaeon into a stag. Watson describes his experience there:

> Now the divine virgin enjoys the pleasures of the rock-well in peace, washes her limbs in the icy liquid [. . .] and listens to the wily hounds pursuing with pleasing barks the new stag through all the wood. Whether the rock is more of an embellishment to the well or

the well to the rock, is a problem full of hazards [. . .] Of no matter what art, nature or divinity it may be, who is there who does not admire in this hardest rock, the skilful arrangement of stones, the plentiful variety of blossoms and fruits, but especially how the rush of spraying water now subsides with gentle murmur, now bubbles up on high in full force?[16]

In the poetic world of Ovid, natural features are prevalent and animals, birds, stones, trees and flowers are all attributed mythical origin. Similarly at Nonsuch, the visitor admired the elements of nature, transformed by art. As Baron Waldstein described, when he visited in 1600, the Nonsuch tableau was designed to depict Ovid's tale:

We entered the famous Grove of Diana, where nature is imitated with so much skill that you would dare to swear that the original Grove of the real Diana herself was hardly more delightful or of greater beauty. This Grove is approached by a gentle slope leading down from the garden by a path half hidden in the shade of trees [. . .] which leads to the Fountain of Diana itself. This spring rises in a secluded glade at the foot of a little cliff. The source was from a number of pipes hidden in the rock, and from them a gentle flow of water bathed Diana and her two nymphs; Actaeon had approached; he was leaning against a nearby tree to hide himself and gazing lecherously at Diana; she, with a slight gesture of her hand towards him, was slowly changing his head to that of a stag; his 3 hounds were in close pursuit.[17]

In the middle of the Vale of Gargaphy at Nonsuch was a bower dedicated to Diana, and Watson's account continues: 'Where the most renowned goddess bathes the snowy parts of her virgin body, the way leads through the middle of the vale to a stately bower – some woodland palace.'[18] This had a winged Eagle on top of its arch, with a

Pelican on one pinnacle and a Phoenix on the other. The Pelican and Phoenix were both symbols used by the Queen, and portraits of her with them were painted in the 1570s by Nicholas Hilliard. The Pelican is a symbol of self-sacrifice and the Phoenix, connected with virginal purity, represents imperial renewal, implying that the Queen will re-create a new Golden Age.

Reference to *Diana and Actaeon* was also made at Whitehall Palace, where Hentzner recorded an inscription at the entrance to the park. By the time Waldstein visited, two years later, it had been moved to Nonsuch, where it was probably more suited to the Grove of Diana.[19] Elizabeth herself was frequently portrayed as the chaste Diana and there is a clear reference to the Queen in the final lines:

> The fisherman who has been wounded, learns, though late, to
> beware;
> But the unfortunate Actaeon always presses on.
> The chaste virgin naturally pitied:
> But the powerful goddess revenged the wrong.
> Let Actaeon fall a prey to his dogs, an example to youth,
> A disgrace to those that belong to him!
> May Diana live in the care of Heaven;
> The delight of mortals;
> The security of those that belong to her![20]

There is a grove illustrated on the map of Holdenby, drawn in 1587 (Plate 1. Top lefthand corner), which was located outside the formal walled gardens, in a wilder part of the estate. Such groves were nevertheless incorporated into the idea of an Elizabethan garden and used as part of the pleasure grounds. At Holdenby the pattern of the trees is illustrated, together with a stream running through, forming a pool, reflecting the descriptions of Classical groves.

There was also a grove at Cowdray, with an ancient oak, which compares directly with the grove at Nonsuch. When the Queen visited in 1591, a masque set in the landscape was presented to her, in which speeches were made by a 'Pilgrime' and a 'Wilde Man' at an oak tree in the park. Her host was Lord Montague, and the account of her visit describes how 'she came to view my Lorde's walkes, where shee was mette by a Pilgrime, clad in a coat of russet velvet fashioned to his calling, his hatte being of the same with scallop-shelles of cloth of silver'.[21] The Pilgrime delivered a speech to the Queen:

> I have travelled manie Countries, and in all countries desire antiquities [...] Harde by, and so neere as your Maiestie shall almost passe by, I saw an Oke, whose statelines nayled mine eies to the branches, and the ornamentes beguiled my thoughts with astonishment.[22]

Standing about a mile to the north east of Cowdray House, in the 'Single Park', is a sessile oak (*Quercus Petraea*) called the Queen Elizabeth Oak (Figure 45). It is reputed to be the tree at which the Pilgrime and Wilde Man addressed Elizabeth in 1591, and the longevity of oaks suggests that this is possible. The Tree Register records its girth as 1,222 cm.[23] It is one of the largest sessile oaks in Britain. Although now hollow, it is still growing, and may be more than 1,000 years old.[24] The political imagery connecting the Queen with oaks already existed, Elizabeth having learned of her accession under an oak tree at Hatfield.[25] The Cowdray oak was used in the masque to represent the Queen herself: the Wilde Man said: 'This Oke, from whose body so many armes do spread: and out of whose armes so many fingers spring: resembles in parte your strength & happinesse.'[26]

The description of the woodland near to the oak suggests that this part of the park was laid out as a formally designed landscape. The fact that the Queen 'came to view my Lordes walkes' implies a pattern

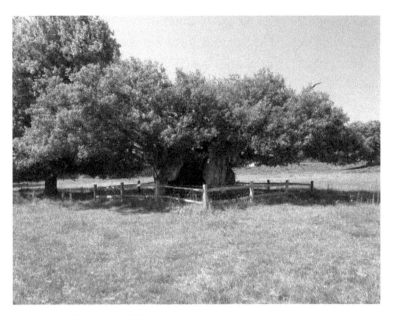

Figure 45 *The Queen Elizabeth Oak at Cowdray is in the park about a mile from the house. It was in a grove in a wilder part of the estate. When the Queen visited in 1591, the lower branches were ornamented with arms for the masque.*

of avenues through the woodland. The Wilde Man comments that 'this passage is kept and this Oke honoured'.[27] The oak tree was ornamented with arms for the masque. The description of the entertainment, records how: 'Then did the Pilgrime conduct her Highnes to an Oke not farre off, wheron her Maiesties armes, and all the armes of the Noblemen, and Gentlemen of that Shire, were hanged in Escutchions most beutifull.'[28]

This 'Tree of Chivalry' was an assertion by Montague on behalf of the Sussex nobility and gentry of their honour and hence their right to bear arms. It symbolized the loyalty of the county to the Queen. The hanging of arms and escutcheons in a tree was symbolism similarly used by Lord Burghley in the portrait of him riding on his grey mule (Plate 30). Here he is portrayed in his garden walks, through which it

would be usual to ride, his coat of arms tied with a bow of ribbon to a tree behind him. At his home at Theobalds one of the rooms in the house displayed coats of arms hung from trees, as Baron Waldstein noted:

> Another room displays the coats-of-arms of the earls and barons of England: all round the walls are trees painted in green, one tree for every county in England, and from their boughs hang the arms of those earls, barons and nobles who live in that particular county.[29]

Standing at the Cowdray oak tree to greet the Queen was 'a wilde man cladde in Ivie' who 'at the sight of her Highnesse spake as followeth':

> Your maiesty theuy account the Oke, the tree of *Iupiter*, whose root is so deeply fastened, that treacherie, though shee undermine to the centre, cannot finde the windings, and whose toppe is so highly reared, that envie, though she shoote on copheigth, cannot reach her, under whose arms they have both shade and shelter [...] Abroad courage hath made you feared, at home honoured clemencie. Clemencie which the owner of this Grove hath tasted.[30]

Montague is referred to as 'the owner of this Grove'. Because groves were associated with wild places or wildernesses, they were a natural home of a 'Wilde Man'. The grove at Cowdray was in the north of the park, a mile from the house, illustrating how far away from the formal gardens such features might be located. The description of the Oak in the Wilde Man's speech as the 'tree of Iupiter' is a reference to the Classical association of an oak with Jupiter's shrine at Dodona. In *Metamorphoses,* Ovid described it: 'It chanced that close at hand there stood an oak, Jove's sacred tree, a special spreading tree, Sprung from Dodona's seed.'[31]

Ancient gods and goddesses made their appearance in entertainments for the Queen presented to her on progresses throughout her reign and a 'Wild Man' was also a repeated figure in these masques. Thus, Diana and her nymphs appeared in the *Princely Pleasures* at Kenilworth in 1575, where there was also 'one clad like a Savage man, all in ivie'.[32] At Elvetham in 1591 the water pageant featured Neptune and Oceanus, while Sylvanus, 'a God of the Woodes', dressed in 'kiddes' and his followers covered with ivy leaves 'comes out from the leafy groaves to honor her whom all the world adores, Faire Cinthia'.[33] The Queen herself was again Cynthia, in other words Diana, associated with groves. At Sudeley in 1592, Apollo and Daphne appear, together with an old Shepherd, while at Bisham in the same year, the Queen encountered Ceres with her nymphs.[34] Ceres, too, has a sacred grove in Ovid's poem *Erysichthon*, in which an oak tree is hung with garlands and votive tablets, just as the oak at Cowdray was hung with escutcheons:

> That gift of changing Erysichthon's daughter
> Also possessed. Her father was a man
> Who spurned the gods and never censed their shrines.
> His axe once violated Ceres' grove,
> His blade profaned her ancient holy trees.
> Among them stood a giant oak, matured
> In centuries of growing strength, itself
> A grove; around it wreaths and garlands hung
> And votive tablets, proofs of prayers fulfilled.[35]

The Roman goddess, Ceres, was the goddess of cultivated land, of fruit and grain. The holy grove dedicated to her, containing a giant oak hung with tablets, would have been a recognizable Ovidian reference. An entertainment that turned literary fictions into literal realities delighted Elizabeth and her courtiers.[36]

Wildernesses

As it fell upon a Day,
In the merrie Month of May,
Sitting in a pleasant shade,
Which a grove of Myrtles made,
Beastes did leape, and Birds did sing,
Trees did grow, and Plants did spring
 WILLIAM SHAKESPEARE, *The Passionate Pilgrime*, 1599.

Counterposing garden and wilderness was a Biblical idea where, in the Judeo-Christian tradition, the Lord transforms the desert into a garden:[37]

> For the LORD shall comfort Zion:
> he will comfort all her waste places;
> And he will make her wilderness like Eden,
> and her desert like the Garden of the LORD.[38]

A similar idea of garden and wilderness can be found in the Classical traditions of Greece and Rome, espoused by the Renaissance culture of the Elizabethan elite. Symbolically, Virgil's poetry adopted the Classical Greek Arcadia and placed it in a Roman context, representing the development of human society 'from a wild, asocial state to a pastoral communality expressive of fruitful physical love'.[39]

In the first *Eclogue,* Virgil creates a world in which rustic shepherds utter learned verses, and display 'sudden and surprising education',[40] a format adopted by Sidney in *Arcadia.* The Virgilian shepherds are banished from their homeland to remote parts of the Roman Empire, 'even to Britain – that place cut off at the very world's end'.[41] The *Georgics* advocate the taming of such wild places, exhorting the rural community to the cultivation of even barren land to create a garden:

I saw an old man, a Corycian, who owned a few poor acres
Of land once derelict, useless for arable,
No good for grazing, unfit for the cultivation of vines.
But he laid out a kitchen garden in rows amid the brushwood,
Bordering it with white lilies, verbena, small-seeded poppy.
He was happy there as a king. He could go indoors at night
To a table heaped with dainties he never had to buy.
His the first rose of spring, the earliest apples in autumn.[42]

The idea of a wilderness or desert was adopted in Elizabethan gardens, in contrast to the formality of knot gardens or the orderly layout of orchards. The Wilderness at Nonsuch was such an attraction that Anthony Watson wrote:

If I were given a free choice [. . .] I should prefer to acquire this wilderness, beloved of the muses and pleasant by day and night, than the strange beauties of any other garden [. . .] The land, which is of its own nature somewhat raised and 'rejoices in sweet moisture', is set out with lofty and magnificent tree-lined walks [. . .] The pathway for the south wind has some trees as turning points at the ends which, though they once spread their branches far and wide, now by wonderful skill are trimmed into a circular shape [. . .] The other walk [. . .] is thought to have been designed for the woodland gods and fauns whom you may chance to see sitting on their flower-decked seats to voice their opinion on the rustic festival of Pan or perhaps about shaggy Pan himself.[43]

This Nonsuch Wilderness was woodland with three paths running through it, two grassy and one of sand. It was planted with a wide mixture of fruit trees including apple, pear, cherry and plum, as well as oak, walnut, ash and elm, hazel, maple, elder and yew, and populated with birds and a wide variety of woodland animals. Below the trees

grew strawberries, brambles, honeysuckle, ferns, vines and roses. In one part was a large plane tree with its lateral branches cut to equal length, resting on green posts, forming a canopy beneath which visitors could sit in the shade. As Watson described:

> There many people sit down and dressed in the gayest of clothes, converse on various topics, listen to the calls of the animals and the songs of the birds, gaze upon the wire-fenced enclosure crowded with pheasants and partridges from across the sea, and unless I am very much mistaken are captivated by the pleasure of this leafy wilderness and the circular plane tree.[44]

The birds that the visitors could watch and listen to included peacocks 'born for ornament' and guinea fowl, which 'give little pleasure with their harsh voice'.[45] More melodious was the song of the blackbird, robin and chaffinch, while

> the chaste turtle-dove pours forth its laments from the lofty elm, and the wood-pigeon utters its mournful cries [. . .] If the thrush fails to delight any man with her bodily appearance, yet he will be soothed by the sweetness of her mouth [. . .] she fills our ears with all the loveliness that nature and practice can give.[46]

Amongst all this appreciation of the songs of wild birds, visitors to the Wilderness were interrupted by the calls of wild animals, which must have been contrived to add to the experience:

> For indeed the wilderness is from time to time shattered by the terrifying roar of lions or now resounds with the savage grunt of the foaming boar. Here a bear falls killed by a shot from a gun; there a deer struck by a forester's spear breaths its last breath. Here the single-horned Indian ass steps assuredly with firm hooves. Here the mute crocodile, armed with sharp claws, pursues those that flee and flees from his pursuers, pours out tears at the sight of

a man, but snaps him up when he comes near [...] on the other hand cunning dogs fill the whole place with baying and are urged on through the whole wilderness in the swift hunt.[47]

How this menagerie was created is not explained – perhaps by actors dressed in costume – but the Elizabethan visitor experience of the Wilderness at Nonsuch must have been unforgettable.

Sir Francis Bacon's essay, 'Of Gardens', describes a garden divided into three parts, with 'a green in the entrance; a heath or desert in the going forth; and the main garden in the midst'.[48] Bacon gives a description of the third part of the plot, which compares in many ways with the description of the Nonsuch Wilderness and throws more light on the wide variety of plants to be found in this part of the garden, contrived to appear wild, and to artificially imitate heathland:

For the heath, which was the third part of our plot, I wish it to be framed, as much as may be, to a natural wildness. Trees I would have none in it, but some thickets, made only of sweet-briar and honeysuckle, and some wild vine amongst; and the ground set with violets, strawberries and primroses. For these are sweet, and prosper in the shade. And these to be in the heath, here and there, not in any order. I also like little heaps, in the nature of mole-hills (such as are in wild heaths), to be set, some with wild thyme; some with pinks; some with germander that gives a good flower to the eye; some with periwinkle; some with violets; some with strawberries; some with cowslips; some with daisies; some with red roses; some with lilium convallium; some with sweet-williams red; some with bear's-foot; and the like low flowers, being withal sweet and sightly. Part of which heaps to be with standards of little bushes pricked upon their top, and part without. The standards to be roses, juniper, holly barberries (but here and there, because of the smell of their blossom), red currants, gooseberries, rosemary, bays, sweet-briar and such like.[49]

An estate map of Gorhambury, made by Benjamin Hare in 1634 (Plate 31), comparably shows a wilderness, referred to as the 'Desert' and separated from the main garden by an oak wood. At the entrance gate there was a statue of Orpheus, the legendary Greek poet and musician whose music could charm all living things, beneath which were verses in Latin that announced the taming of the Desert within:

> Of yore how frightful did this place appear,
> Here howl'd wild beasts, and satyrs frolick'd here,
> When luckily for me this Orpheus came,
> Whose heav'nly art has smooth'd my rugged frame,
> For withered stocks, gave these fair spreading-trees,
> And rais'd a shade that deities might please.
> Labours like his my Orpheus here employ,
> Oh may we both each other long enjoy![50]

This contrast of nature and art, the wild and the tamed, is a recurring theme in Elizabethan gardens.

Mounts

When you behold in diverse corners of your Orchard Mounts of stone or wood, curiously wrought within and without, or of earth covered with fruit trees: Kentish Cherry, damsons plummes &c. with stares of precious workmanship [. . .] How will you be wrapt with Delight?

WILLIAM LAWSON, *A New Orchard and Garden*, 1618.[51]

In many ancient cultures mountains reaching up towards the sky were places where the gods lived. One of the most important of these in Classical culture was Mount Parnassus, which towers above the ancient site of Delphi in central Greece. Parnassus was sacred to Dionysus, god

of the grape harvest, winemaking and fertility, as well as to Apollo, son of Zeus, god of the sun and patron god of music and poetry, who was also associated with medicine and healing (Figure 46). Apollo was leader of the Muses and director of their choir, and his common attribute was the lyre, created for him by Hermes. Mount Parnassus was also

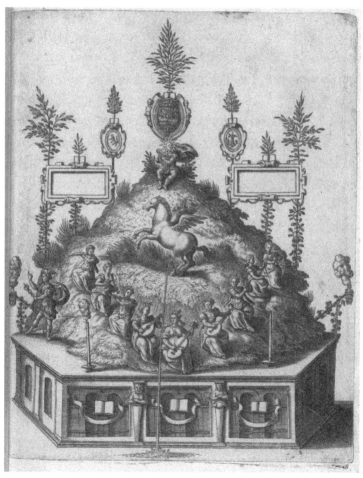

Figure 46 Apollo on Parnassus, *unknown artist, 1594. The illustration shows a stylised mount planted with grass and trees to represent Parnassus on a hexagonal wooden plinth. Apollo sits at the top with his lyre and below are Pegasus and the nine Muses, playing musical instruments.*

home to the Muses, whilst the Corycian Cave – a large stalactite grotto on the slope of Parnassus – was sacred to the Muses and also a place of worship of Pan. The nine Muses, daughters of Zeus, were goddesses of the arts including literature, music, dance, drama and poetry as well as astronomy. Therefore, as home of the Muses, Mount Parnassus became known as the home of poetry, music and learning.

In Renaissance gardens, mounts were created in a variety of shapes and sizes and they frequently represented real or mythological mountains, drawn from Classical literature. Some, as at Hampton Court, were built by raising a mound of bricks, covering it with earth, planting it with trees and shrubs, and topping it with a lantern arbour.[52] Others, like that designed by Salomon de Caus for Richmond Palace in 1610, were rocky with grottoes beneath. The one at Theobalds had a labyrinth around it and was called the Venusberg.[53] Venusberg is the name of a mythical mountain in Germany, celebrated in German poetry, where caverns housed the court of Venus, goddess of love, which was supposed to be hidden from mortal men. Some mounts, such as that created for Anne of Denmark at Somerset House by Isaac de Caus in 1611, represented Mount Parnassus.[54] The scale of mounts can be seen in the design by Salomon de Caus, topped with a mighty statue of Hercules (Figure 47).

In Spenser's *Faerie Queene* there is a mount in the centre of the Garden of Adonis, topped with an arbour, and beneath it a rocky cave is hewn, creating a grotto. It is a place of secret trysts for Venus, where Adonis lives in eternal bliss, joining his goddess:

> Right in the middest of that Paradise,
> There stood a stately Mount on whose round top
> A gloomy grove of myrtle-trees did rise,
> Whose shadie boughs sharpe steele did never lop,
> Nor wicked beasts their tender buds did crop,

Figure 47 *A detail of a design for a mount by Salomon de Caus, from* Les Raisons des forces mouvantes, *1615. A path ascends the rocky rectangular mount, planted with trees. At the top is a square balustraded belvedere with a statue of Hercules.*

But like a girlond compassed the hight,
And from their fruitfull sides sweet gum did drop,
That all the ground with precious deaw bedight,
Threw forth most daintie odours, & most sweet delight.

And, in the thickest covert of that shade,
There was a pleasant Arbour, not by art,
But of the trees owne inclination made,
Which knitting their ranke branches part to part,

With wanton Ivie-twine entrayld athwart,
And Eglantine, and Caprisole emong,
Fashiond above within their inmost part,
That neither *Phoebus* beames could through the throng,
Nor *Aeolus* sharp blast could work them any wrong.

There wont faire *Venus* often to enjoy
Her deare *Adonis* ioyous companie.[55]

A painting by Nicholas Hilliard of Henry Percy, Ninth Earl of Northumberland (Plate 32), shows him lying on a mount. His head rests in his hand in a position associated with melancholy, his gloves are cast aside and a book lies beside him. The mount is rectangular, and a row of four trees is planted along the top. Hanging from a branch is a balance with a globe or ball on one end and a feather on the other. The Latin word 'TANTI' written beside it has a dual possible meaning as 'so much' or 'so little', depending on its context. Normally, melancholic man is portrayed in art as outside the confines of ordered nature, but here Northumberland is within the context of cultivated nature, where the square signifies the firmness and constancy of wisdom.[56] It is the attribute of Hermes, in his aspect Trismegistus, god of reason and truth.[57] George Peele described Northumberland in his poem celebrating his election as Knight of the Garter in 1593, again referencing the Classical Muses:

Renowned lord, Northumberland's fair flower,
The Muses' love, patron, and favourite[. . .]
Familiar with the stars and zodiack,
To whom the heaven lies open as her book.[58]

In common with many such Elizabethan portraits, the underlying meaning is deliberately opaque. It may allude to a mount at Syon House in Middlesex, where Northumberland lived from 1595.[59]

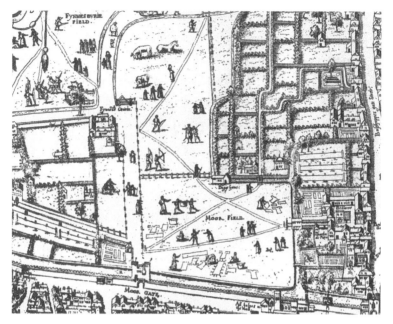

Figure 48 *A detail from the Moorfields plate of the 'Copperplate' map of London, c.1559, showing the garden of a house on Bishopsgate, with a mount in the form of a square stepped pyramid planted with a tree on top. This implies that there were mounts even in the gardens of city houses.*

However, his choosing to be painted there reflects, perhaps, the growing popularity of mounts in the Elizabethan period and their greater allegorical significance.

A map of London drawn in 1559 shows a house in Bishopsgate with a square tiered mount, planted with a tree on top (Figure 48). This appears very similar to the early rectangular mount at Syon, though less heavily planted. A circular mount with trees and an arbour, reached by a winding path, can be seen in the background of Robert Peake's portrait of Elizabeth, daughter of James I (Plate 33). In his essay, 'Of Gardens', Francis Bacon recommended the construction of a large garden mount. He wrote that in the main garden, within a great hedge:

I wish also, in the very middle, a fair mount, with three ascents, and alleys, enough for four to walk abreast; which I would have to be perfect circles, without any bulwarks or embossments; and the whole mount to be thirty foot high [. . .] At the end of both the side grounds, I would have a mount of some pretty height, leaving the wall of the enclosure breast high, to look abroad into the fields.[60]

Mounts are one of the few features of Tudor gardens which, because of their substantial construction, have survived the course of time, such as those in Sir Thomas Tresham's garden at Lyveden New Bield and the well preserved mount at New College, Oxford. The latter, begun in the 1590s and also called 'Parnassus', was three tiers high with hedges (Figure 49). It was topped with a column, and was high enough to be able to see over

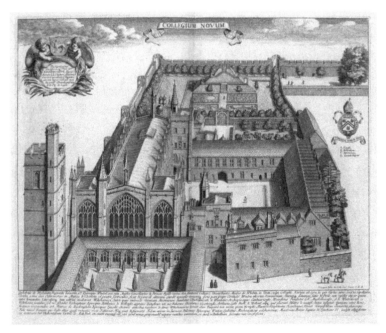

Figure 49 *New College Mount, Oxford, from David Loggan,* Oxonia Illustrata, *1677. The mount, begun in the 1590s, still survives. From the top there were views of both the formal gardens below and over the college walls to the landscape beyond.*

the garden walls to the landscape beyond, as well as providing a view of the elaborate formal gardens below. The mount had appeared by the end of the sixteenth century, although the stone steps were added in the seventeenth century.[61] New College Mount is now covered with large trees, obscuring the view from the top.

At Lyveden there is a viewing mount at each corner of the square, moated orchard (Figure 50). The mounts had spiral paths, like snail shells, planted with sycamore or wych elm, and underplanted with laurel or butcher's broom, to form a dense hedge.[62] The top of the mounts would have provided views across Sir Thomas Tresham's orchard maze. The mounts could also have been used for watching deer hunting in the park, and Tresham's iconic Triangular Lodge would also have been visible from the top.

At Cecil House in the Strand, William Cecil's important London town house, a plan of the house and its gardens, made in the 1560s,

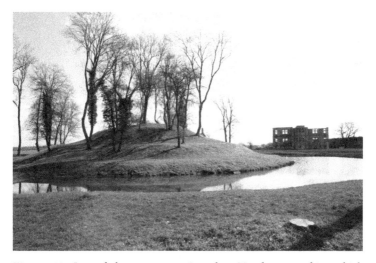

Figure 50 *One of the mounts at Lyveden, Northamptonshire which were raised at each corner of the square moated orchard. The spiral path which led up to the viewing platform is still visible. The mounts were planted with sycamore and wych elm, with an underplanting of laurel. From the top there would have been views across the orchard maze.*

shows a spiral mount in the garden in a walled compartment approximately 20 metres by 16 metres, with a tree at each corner. It appears to have been in a sunken garden, approached by steps in one corner.[63] The mount would have been a dramatic vantage point from which the other formal gardens could be viewed. The ground plan of Lord Bedford's house and garden at Twickenham, drawn by Robert Smythson in 1609, shows a very large garden, 321 feet square (Figure 51). The circular design of birch and lime trees was flanked by a circular mount at each corner. The larger pair of mounts were 40 feet across and in two tiers, with a total ascent of eleven steps.

To have several mounts in a formal garden became fashionable. At Nonsuch, there were three mounts, arranged in a triangle with a fourth mount topped by a fountain at the centre. Sir Christopher

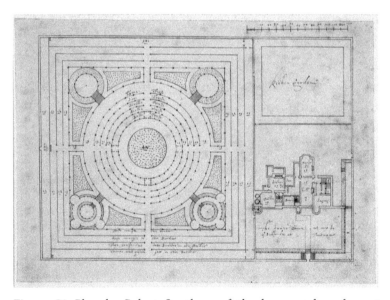

Figure 51 *Plan by Robert Smythson of the house and gardens at Twickenham, c.1609. Four round mounts were raised in each corner of the square garden, while the centre was planted with circles of birch and lime trees. Francis Bacon lived here in the late sixteenth century and Lucy, Countess of Bedford in the early seventeenth century.*

Hatton's gardens at Holdenby had a mount in the corner of the orchard, shown on the 1587 map as a spiral (Plate 1). There was another large mount, traces of which survive, in the lower part of the garden, below the terraces, which Hatton had made into a Pond Garden with at least six formal rectangular pools. This remains over 4 metres high and would have offered views across the gardens to the house, and over the garden wall to the deer park beyond.

At Bindon Abbey in Dorset, water gardens and a mount were created from 1544 in the grounds of the dissolved Cistercian Abbey by Thomas Howard, a cousin of the Queen, who later created him Viscount Bindon. Howard dug two large moated enclosures, one square with a lozenge-shaped island at its centre, and the other with a horse-shoe shaped moat around a mount. This is in two stages with a circular terrace halfway up. The mount (Figure 52) survives, although now covered with trees.[64]

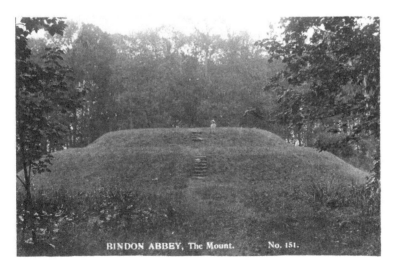

Figure 52 *The Mount at Bindon Abbey in Dorset is in the centre of one of the two water gardens and still survives. This photograph shows it in around 1920, before the trees, which cover it now, grew up. It has two tiers and was partly surrounded by a horse-shoe shaped moat.*

Grottoes

There is a beautiful pleasure house, artificially built with
all kinds of shells.

A gentleman in the train of the Landgrave of Hesse, 1611.[65]

Grottoes were a popular feature of some of the greatest European
gardens in the sixteenth century, but in England they were a rare and
exotic development in style and taste, restricted to just a few of the
grandest gardens. Decorated with shells and shiny minerals, they were
artistic creations evoking the ancient Greek *nymphaeum*, originally a
shrine at a water source dedicated to water nymphs. The Romans
built grottoes around fountains and at the sites of natural springs
and made *nymphaea* in their villas and gardens. Grottoes were one of
the ways in which the garden-makers of the Renaissance chose to
emulate the culture of their ancient predecessors. Similarly, magical
plays with water, combined with mechanical devices and artificial
sounds, were expressions of the Renaissance desire of man to
overcome nature.

The famous Surrey garden of Beddington, created by Sir Francis
Carew, exhibited two of these glittering creations. These fanciful
grottoes were amongst the earliest in England. Beddington was very
popular with the Queen, and she visited Carew there at least fifteen
times over a period of thirty years. His father, Sir Nicholas, had been
Master of the Horse to Henry VIII and Francis was close in age to the
Queen, and, like her, never married, although he lived to the age of 81.
He devoted his long life to his house and gardens, where he used
French gardeners who would have had experience of waterworks and
grottoes. Carew was well travelled, having spent time in France, some
in the company of the young Thomas Cecil, and his passion for
gardens matched that of William Cecil at Theobalds.

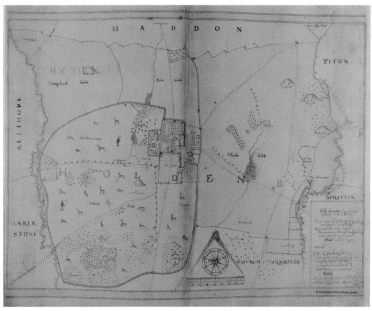

Plate 1 *Detail of Ralph Treswell's map of Holdenby House, Northamptonshire, 1587. The map shows many of the most important elements of Elizabethan gardens, including knots, ponds, an orchard, banqueting house and mounts. There is a Grove outside the formal gardens which is associated with a stream and pool, while deer are illustrated in the Hunting Park.*

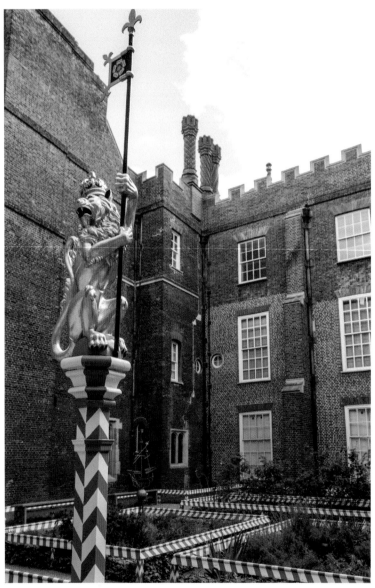

Plate 2 *The re-created Tudor Garden at Hampton Court has authentic green and white striped railings and heraldic beasts on poles. It is planted with flowers and herbs which were available in the sixteenth century.*

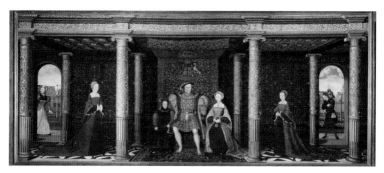

Plate 3 The Family of Henry VIII, *English School, c. 1545, probably painted for the king. The painting shows Henry VIII at Whitehall Palace seated beneath a canopy of estate, with his third queen Jane Seymour and the young Prince Edward, later Edward VI, beside him. The Princesses Mary and Elizabeth stand at either side, while the gardens can be glimpsed through the archways.*

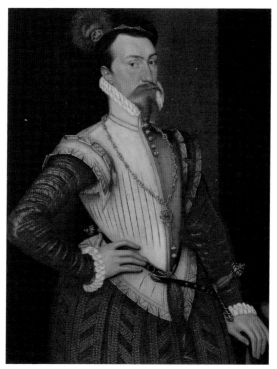

Plate 4 Portrait of Robert Dudley, *unknown artist, c. 1565. Dudley, created Earl of Leicester in 1564, was a royal favourite, Master of the Horse and leading privy councillor.*

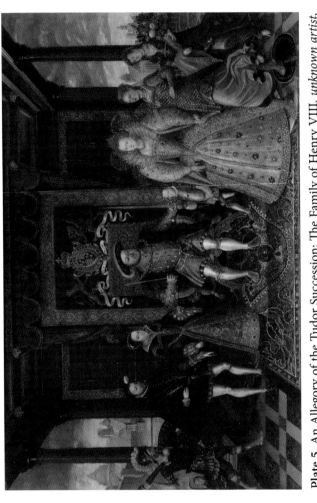

Plate 5 An Allegory of the Tudor Succession: The Family of Henry VIII, *unknown artist, after Lucas de Heere, c. 1572. The young Edward VI kneels beside his father. Entering from the left are Philip and Mary bringing Mars, the God of War. From the right, entering from a formal garden, comes Elizabeth, holding the hand of Peace and followed by Plenty.*

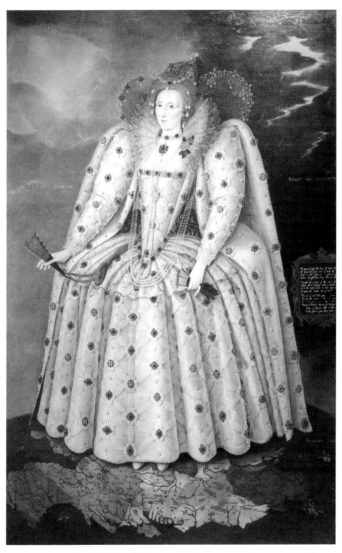

Plate 6 Queen Elizabeth I, 'The Ditchley Portrait', *Marcus Gheeraerts the Younger c. 1592. The Queen is standing on a map of England, with her feet in Oxfordshire. The painting was made for Sir Henry Lee, probably to commemorate her visit to him at Ditchley in 1592, when he organised elaborate entertainments for her. The stormy sky, the clouds parting to reveal sunshine, and the inscriptions on the painting symbolise forgiveness, whilst the lace wings represent her as* Gloriana, *the Fairy Queen.*

Plate 7 Villa Medicea di Castello, *Giusto Utens, 1599, one of a series of lunettes depicting views of the Medici villas, near Florence. Water flows down through the gardens in a series of pools and fountains. There are formal gardens and orchards around the villa. These gardens had a great influence on Renaissance gardens across Europe.*

Plate 8 Queen Elizabeth with Fame, *from* Calligraphical Penmanship, *1570. The picture shows the Queen, attended by Fame, riding in an elaborate chariot, creating a public image of a powerful monarch, watched by her people. Such display was an important element of Elizabeth's court.*

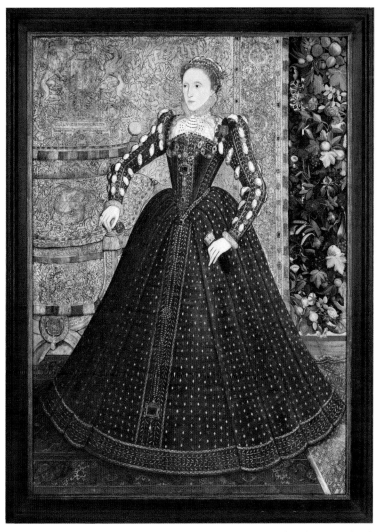

Plate 9 Queen Elizabeth I, 'The Hampden Portrait', *Anglo-Flemish School,* c. 1563. *The Queen holds a red carnation in her right hand, symbolizing love. The background is filled with flowers, fruit and foliage. The entwined honeysuckle flowers suggest a union and the ripe fruit symbolises Elizabeth's fertility.*

Plate 10 *A map of All Souls College, Oxford, c. 1590, commissioned by Warden Robert Hovendon, shows fashionable knots of different patterns. The Warden's garden and the Fellows' garden each have two knots based on those illustrated by Thomas Hill. There is also a small garden in the cloister, planted with trees.*

Plate 11 *Lead glazed earthenware dish with Pomona, in the manner of Bernard Palissy, based on an engraving by Philis Galle after Maerten de Vos, late sixteenth or early seventeenth century. The formal knot garden in the background has a fountain at the centre. In the foreground Pomona sits beside a vase of flowers and various gardening implements of the period, including a watering jar.*

Plate 12 Pleasure Garden with a Maze, *Lodewijk Toeput, c. 1579–84. This illustrates the scale and use of large mazes in gardens of the sixteenth century. Couples walk through the low-hedged maze, while in the centre a group dine. On the right another group are banqueting beneath an arbour. The painting celebrates the pleasures of life: food, music and dancing.*

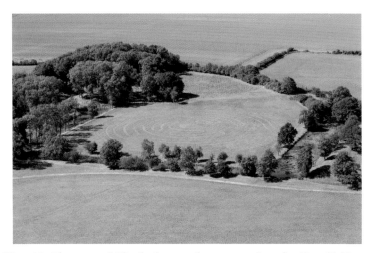

Plate 13 *The restored Elizabethan garden maze at Lyveden New Bield was re-discovered from wartime aerial photographs. It is in a square garden surrounded by a moat, and there is a mount at each corner. This was Sir Thomas Tresham's 'moated orchard'. The outer circles were cherry and plum, whilst the inner circles were planted with rose trees and raspberries.*

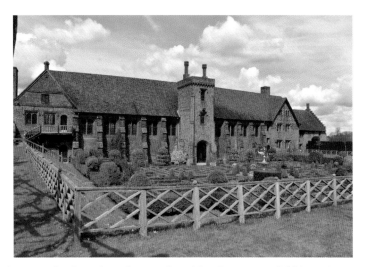

Plate 14 *The formal gardens at the Old Palace at Hatfield have been re-created by the late Dowager Marchioness of Salisbury. There is a maze in one of the four quarters and knots in the other three. The gardens include plants known to have been grown between the fifteenth and seventeenth centuries.*

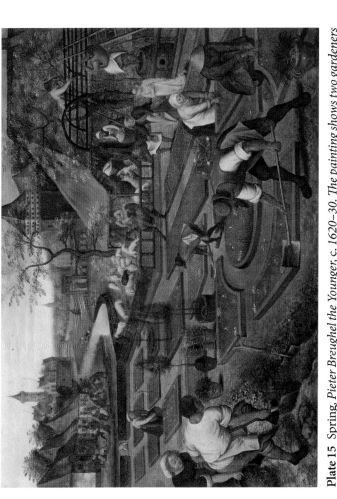

Plate 15 Spring, Pieter Breughel the Younger, c. 1620–30. The painting shows two gardeners winding climbing plants across an arched arbour, made of wood supported by carved caryatids. The arbour is probably around twelve feet high, since they have to use ladders and an upturned barrel to reach the top. Other gardeners are busy preparing the beds for planting.

Plate 16 A Young Man Seated Under a Tree, *Isaac Oliver, c. 1590–5. The background of the picture shows a wealthy couple walking through a garden, with a high arched arbour of carpenter's work covered in green vine leaves running across the garden behind them.*

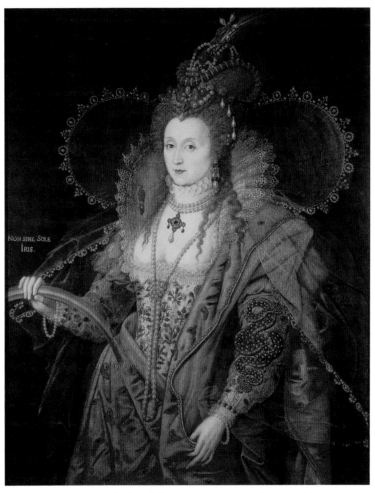

Plate 17 Queen Elizabeth I, 'The Rainbow Portrait', *Isaac Oliver, c.1600.* The Queen's bodice and sleeves are embroidered with fragrant flowers, including honeysuckle, pansies and pinks. In her hand she holds a rainbow, and the inscription 'Non sine Sole Iris' can be translated as 'no rainbow without the sun', reminding viewers that only the Queen's wisdom can ensure peace and prosperity.

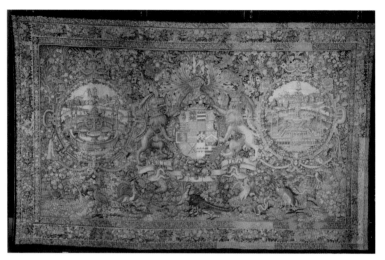

Plate 18 *This tapestry, one of a series commissioned by the Earl of Leicester, was made in around 1585. It displays his arms and depicts two ornate fountains set within fenced enclosures, amid a decoration of birds, fruit and flowers.*

Plate 19 *This aerial photograph of Penshurst in Kent shows the structure of the formal gardens around the house remaining from the Tudor period as well as the proximity of the River Medway.*

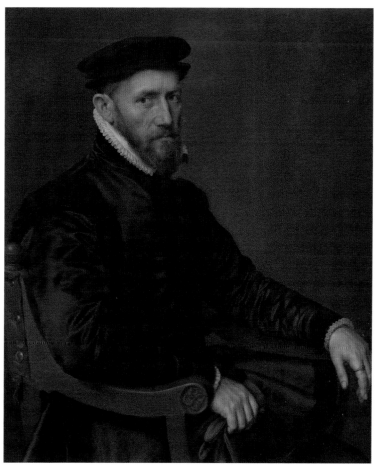

Plate 20 Sir Thomas Gresham, *Anthonis Mor, c.1560–5. Gresham was a merchant and financier who established the Royal Exchange. His new house at Osterley was completed in 1576 and was visited by the Queen on many occasions. Osterley had a long chain of ponds with mills and a heronry.*

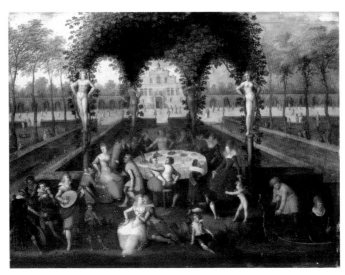

Plate 21 Venus, Bacchus and Ceres with Mortals in a Garden of Love, *Louis de Caullery, 1590–1620. The painting shows a group dining beneath an arbour whilst musicians play. Though allegorical, it depicts the pleasure of al fresco dining in a garden setting, an important aspect of Elizabethan hospitality.*

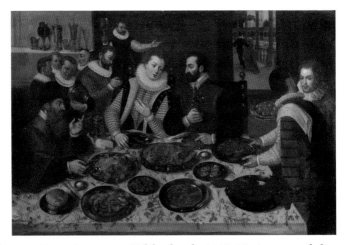

Plate 22 Feast, *Lucas van Valckenborch, 1580–90. A group of elegantly dressed people eat at a table strewn with fresh flowers, the fragrance probably being as important as the appearance. In the background a couple stroll in a formal garden.*

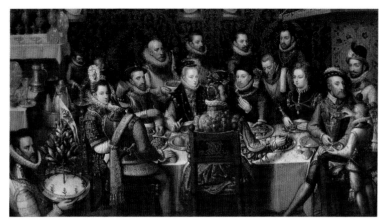

Plate 23 The Royal Feast, *Alonso Sànchez Coello, 1579. The painting depicts King Philip II of Spain banqueting with his family and courtiers. On the left, the centrepiece of the banquet is served: a marchpane decorated with flowers and topped with a tree made of sweetmeats.*

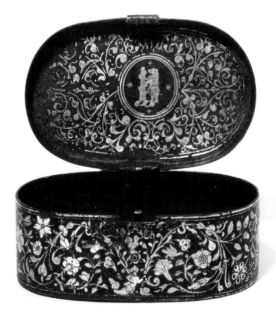

Plate 24 *The Dudley Box, unknown maker, 1579. It is made of iron, damascened with gold and silver floral decoration. The box was intended to impress as well as to contain sweetmeats for a banquet. Inside the lid is the crest of Robert Dudley, Earl of Leicester, and it was probably given to him as a gift.*

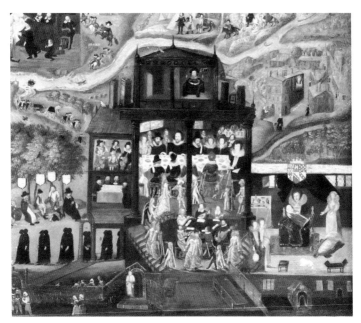

Plate 25 *A detail from the portrait of* Sir Henry Unton, *English School, c.1596. This scene represents Unton's life at Wadley House. He is shown sitting in his study, making music and talking with learned divines. In the centre he is depicted in a banqueting house, presiding over a banquet while a masque of Mercury and Diana is performed, accompanied by musicians.*

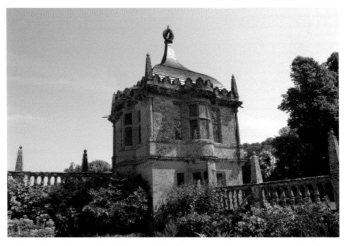

Plate 26 *One of a pair of banqueting houses in the corners of the forecourt at Montacute House, Somerset, built in about 1598 by Sir Edward Phelips. The banqueting houses give views over both the courtyard and the approach to the house.*

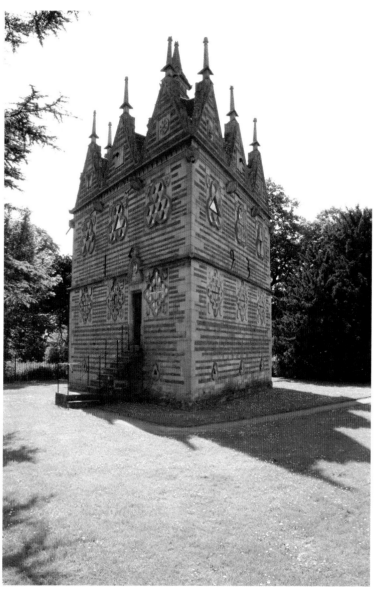

Plate 27 *The Triangular Lodge at Rushton, Northamptonshire, was built by Sir Thomas Tresham in 1593. Tresham was a Catholic recusant and this unique building uses the number three in many ways in its architecture, symbolic of the Holy Trinity.*

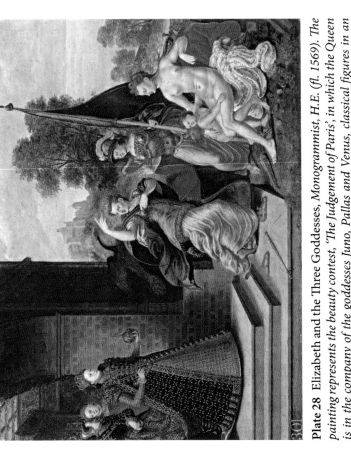

Plate 28 Elizabeth and the Three Goddesses, Monogrammist, H.E. (fl. 1569). The painting represents the beauty contest, 'The Judgement of Paris', in which the Queen is in the company of the goddesses Juno, Pallas and Venus, classical figures in an English landscape. The Queen keeps the prize, an orb instead of an apple, for herself. The building in the background is thought to be the earliest painted representation of Windsor Castle.

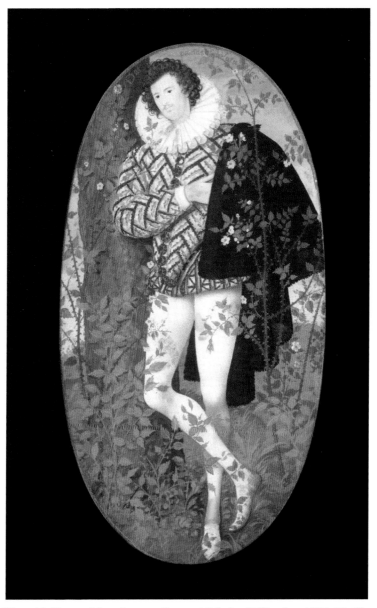

Plate 29 Young Man Among Roses, *Nicholas Hilliard, c.1585–95. The young man is probably Robert Devereux, Second Earl of Essex, one of the Queen's favourites. Leaning against a tree, hand on heart, he wears the Queen's colours of black and white and is entwined with Eglantine, her personal emblem, demonstrating his loyalty.*

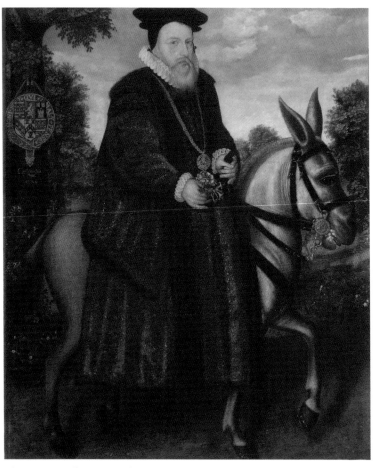

Plate 30 William Cecil, 1st Baron Burghley, *attributed to Marcus Gheeraerts the Younger, c.1570. Cecil is riding his mule through his garden walks, and holds a gillyflower and honeysuckle, both symbolizing love and devotion. His coat of arms is delicately tied to an oak tree behind him, symbolic of strength, while the background is filled with wild flowers.*

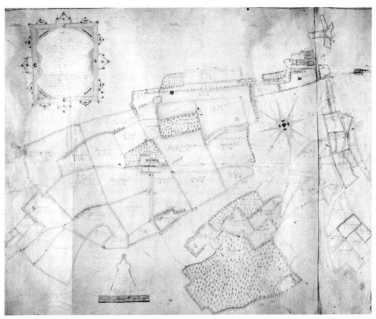

Plate 31 *A detail from the Map of the Manor of Gorhambury, Hertfordshire, Benjamin Hare, 1634. This shows a rectangular enclosure called 'The Dessert', separated from the house by an oak wood. Both form part of the wilder landscape beyond the formal gardens. The Dessert had a small building in one corner, probably a banqueting house.*

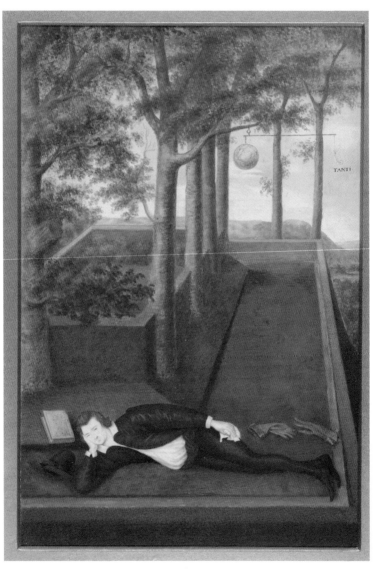

Plate 32 Henry Percy, Ninth Earl of Northumberland, *Nicholas Hilliard,* c.1590–5. *The Earl is lying on top of a rectangular mount planted with trees and enclosed by a clipped hedge, adopting the pose of a melancholic. The book at his side emphasises his devotion to study.*

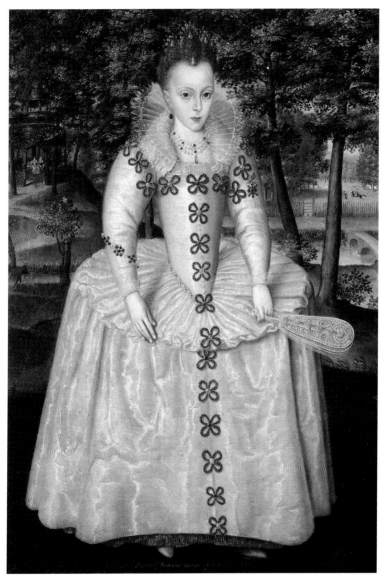

Plate 33 Princess Elizabeth, later Queen of Bohemia, *Robert Peake, 1603.*
In the background on the right is a river and bridge, with a hunting scene
beyond the park pale. On the left a path climbs a mount to an arbour at the
top, formed from pleached trees. The central tree is trained to create a dome,
and a circle of trees is trained to form the walls. Two ladies sit on a turf
bench beneath the arbour.

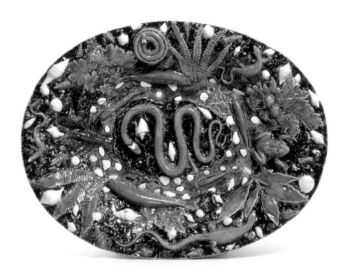

Plate 34 *Earthenware dish by Bernard Palissy, 1565–85, showing the brightly coloured glazes and water creatures of the kind he would have used to decorate his grotto at the Tuileries. This demonstrates how colourful such grottoes could be.*

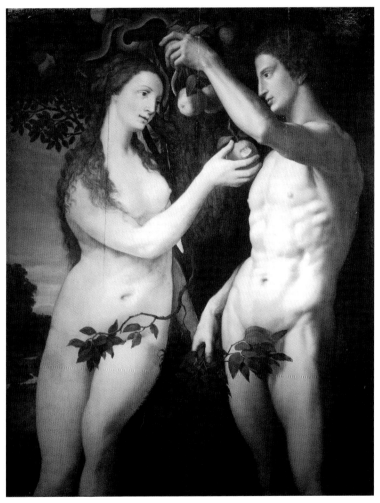

Plate 35 The Fall of Man, *Frans Floris, c.1560. Adam and Eve are shown in the Garden of Eden, before the Fall, living in innocence. In the sixteenth century it was believed that Eden might still exist. The Bible states that it included every plant given by God to Man for food and medicine.*

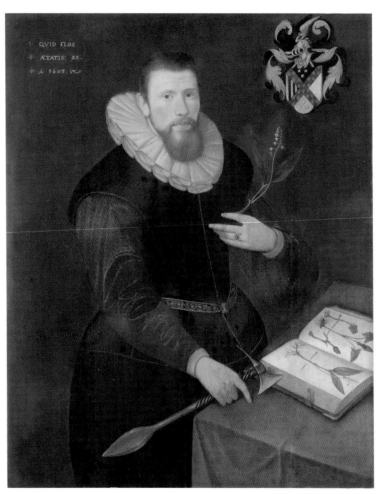

Plate 36 Portrait of a Botanist, *unknown artist, 1603. Renaissance botanists formed a closely-knit scholarly community across Europe. Plants were studied and exchanged, increasing medical knowledge. The young man is holding a Lily of the valley and comparing it with the illustration in a herbal.*

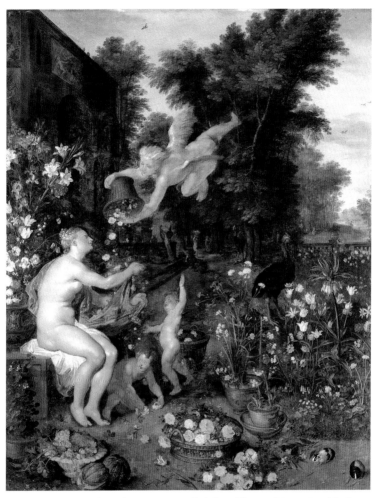

Plate 37 Flora and Zephyr, *Jan Breughel the Elder and Peter Paul Rubens,* *c.1617. In Ovid's myth, Zephyr the west wind abducted the nymph Chloris,* *made his bride the goddess Flora, mistress of the flowering spring. As a* *wedding present, he gave her a garden filled with flowers where it was* *always springtime. The flowers in this painting include tulips and crown* *imperials, both newly introduced in the late sixteenth century.*

Plate 38 Young Daughter of the Picts, *Jacques Le Moyne de Morgues,* *c.1585. The painting shows a young girl, her body decorated with a wide* *range of flowers, including the newly introduced red and yellow tulips on* *her thighs. It served as the model for an engraving for a plate in Theodor de* *Bry's publication of Thomas Harriot's* A Briefe and True Report of the New *Found Land of Virginia.*

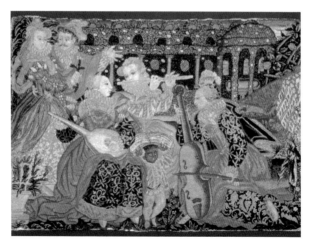

Plate 39 *Detail of a bed valance, maker unknown, 1570–99. The setting is* *an ornamental garden and the figures, wearing rich contemporary court* *fashions, are enjoying a musical entertainment. In the background is an* *arbour covered in roses with a banqueting table beneath.*

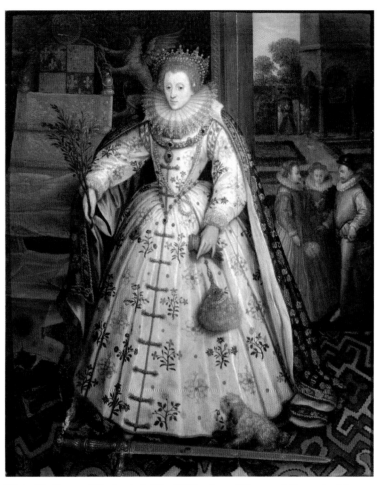

Plate 40 Queen Elizabeth I, The Welbeck or Wanstead Portrait, *Marcus Gheeraerts the Elder c.1580–5. The Queen, wearing a gaily coloured gown and cape embroidered with flowers, holds the olive branch of peace. The painting is said to depict the gardens of Old Wanstead House in the background, which belonged to the Earl of Leicester. It is laid out with squares in a geometric pattern, and there is an arcaded loggia running around the side.*

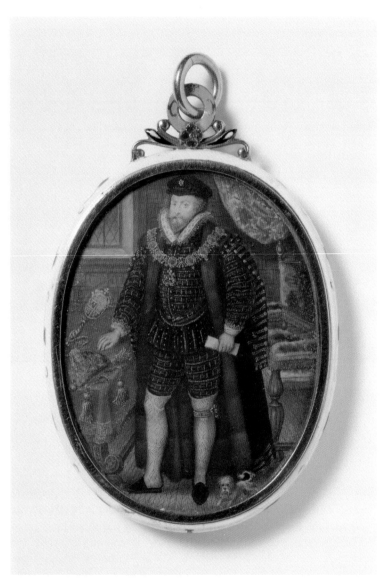

Plate 41 Sir Christopher Hatton, *Nicholas Hilliard, 1588–91. A favourite of the Queen, Hatton was appointed Lord Chancellor in 1587. He built a new house at Holdenby in Northamptonshire and created stylish gardens there in the hope of attracting a visit from the Queen.*

There was a fast-flowing river which ran through Beddington and Carew made good use of it, expending great cost 'upon the said river for the delight of our late Soveraigne Lady the Queenes Majestie'. Waldstein described the grotto:

The garden contains a beautiful square-shaped rock, sheltered on all sides and very cleverly contrived: the stream flows right through it and washes all around. In the stream one can see a number of different representations: the best of these is Polyphome playing on his pipe, surrounded by all kinds of animals. There is also a Hydra out of whose many heads the water gushes.[66]

The rock, 'cleverly contrived' in midstream was described by Thomas Coryat as 'one most excellent rock there framed all by arte, and beautified with many elegant conceits'.[67] In 1611 a gentleman accompanying the Landgrave of Hesse further recounted this scene as a:

stream of water cheerfully running out of a little hill which is handsomely furnished with all sorts of neatly made animals and little men as though they were alive. Further down are two little corn mills, well made, driven by water. There are also small boats and a little naval vessel lying at anchor on the water.[68]

The Duke of Württemberg, visiting Beddington in 1610, wrote: 'There is here one of the most pleasant and ornamental gardens in England, with many beautiful streams.'[69] The following year the gentleman accompanying Hesse described them in more detail: 'In the first garden we saw a very fine fountain with neatly made fishes, frogs etc. swimming in the fountain as if they were alive'.[70] The inspiration for this kind of decorative work was the French ceramicist, Bernard Palissy, who made a grotto for Catherine de' Medici in her new gardens at the Tuileries in Paris containing a basin in which there were models of frogs, tortoises, crayfish, shells and branches of coral (Plate 34).

Similar coloured pottery has been found at Beddington, and the movement of the water with ripples and jets in the fountain would have given the illusion of lifelike movement in the decorative animals. Not far away from these water attractions was

> an exceedingly fine pleasure house built all of mineralibus or various kinds of brass in cheerful fashion, the ceilings made like the sky from which rain pours down [. . .] There is a mirror in the pleasure house which is laid with all sorts of marble.[71]

It is not surprising that the grottoes and miniature water world attracted visitors from afar. A drawing of a grotto with figures and water jets by Salomon de Caus (Figure 53) gives an idea of how such

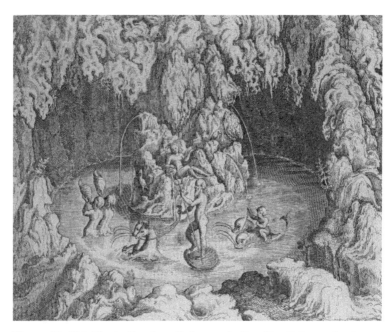

Figure 53 *This illustration from Salomon de Caus' Les Raisons des forces mouvantes, 1615, shows a design for a grotto operated by hydraulics. Two Tritons revolve around a central rock, followed by Neptune and Arion riding dolphins, while jets of water spray.*

a marvel may have appeared. Two surviving grottoes of the early seventeenth century, both attributed to Salomon's kinsman, Isaac de Caus, show how grottoes could be elaborately decorated, creating mythical creatures with shellwork. One is at Woburn Abbey in Bedfordshire, and the other at Skipton Castle in Yorkshire.

The grotto at Woburn is within the building, as was the one built for Lord Burghley at Theobalds, where the Presence Chamber on the first floor was decorated in an extraordinary way. It had a working model of the solar system on the ceiling and the supporting columns were decorated as trees with real bark. Jacob Rathgeb described them in the Duke of Württemberg's Diary:

> On each side of the hall are six trees, having the natural bark so artfully joined, with birds' nests and leaves as well as fruit upon them, all managed in such a manner that you could not distinguish between the natural and these artificial trees.[72]

In this room was a grotto, of which Waldstein wrote:

> In the first room there is an overhanging rock or crag (here they call it a 'grotto') made of different kinds of semi-transparent stone, and roofed over with pieces of coral, crystal, and all kinds of metallic ore. It is thatched with green grass, and inside can be seen a man and a woman dressed like wild men of the woods, and a number of animals creeping through the bushes. A bronze centaur stands at the base of it. A number of columns by the windows support the mighty structure of the room: these columns are covered with the bark of trees, so that they do in fact look exactly like oaks and pines.[73]

The grass thatch would have given the impression of a cave and the bronze centaur completed the mythological scene. The semi-transparent stone decorating the grotto may have been 'Bristol

diamonds', actually quartz crystals, which came from St Vincent's Rock in the Avon Gorge. Burghley wrote to Sir John Young of Bristol asking him to send him some of these stones in 1584.

Wimbledon House in South London was built for Lord Burghley's eldest son, Thomas Cecil, later Earl of Exeter. Begun in 1588, the house

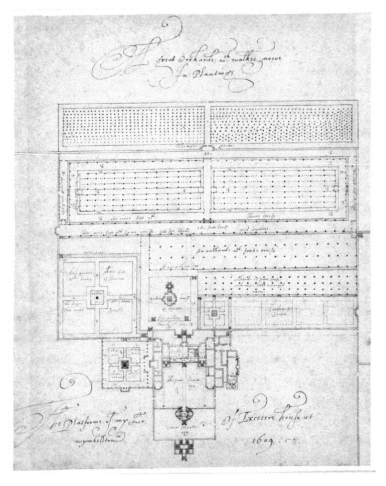

Figure 54 *Plan of Wimbledon House, Robert Smythson, c. 1609, showing in detail the layout of the gardens, with their vines, orchards and flower and herb gardens. The Orange Garden on the lower left is adjacent to the house. It is overlooked by a loggia, beneath which was the grotto.*

was sited on a hill, which was terraced in Italianate style with flights of stairs approaching the entrance courts. Although nothing now remains of the house, it was a large and dramatic building, surrounded by extensive formal gardens, and was sufficiently impressive to be purchased by Charles I for Queen Henrietta Maria in 1639 (Figure 54). There is a grotto described at Wimbledon in the Parliamentary survey of 1649, which was beneath the loggia on the east side of the house, facing onto the Orange Garden. Although this is a later description, it is very likely that this grotto was constructed in the Elizabethan period for Thomas Cecil, as the room is part of the architecture of the house. The survey records:

> One other roome called the stone gallery floored with squared stone one hundred and : 8 : foote long seeled overhead pillored and arched with gray Marble lying on the east end of the said Manor house to and levell with he said Oringe garden [. . .] One other roome placed in the midle of the said stone gallery called the Grottoe having three double-leaved doors opening thereunto floored with very good paynted tyle and wrought in the arch and sides thereof with sundry sorts of shells of greate lustre and ornament formed into the shapes of men Lyons serpents and antick formes and other rare devices the bottomes of the walls are sett round with cement of glass in nature of little rockes in the midle of this roome is one cesterne of lead : 7 : foote square and twentie one inches deepe sided with black and whyte marble having one pipe of lead in the midle therof there is allsoe opposite to the doors of this roome fortie Lights of seeing glass sett together in one frame much adorning and setting forth the splendour of the roome.[74]

The use of glass to allow light into the grotto would show off the white marble and lustrous shell decorations, while the lead pipe in the

central pool suggests that this was a fountain which would have sparkled in the light from the glass when playing.

Thus, Elizabethans demonstrated Classical knowledge in their gardens, both for their own amusement and pleasure, but also to impress equally educated visitors, not least the Queen herself. Allusions to mythological deities, derived from Classical literature, were contrived to delight and fascinate, while mounts provided an opportunity for extended views beyond the formal gardens into the wider landscape. Groves and wildernesses transformed areas of that landscape into elements of Elizabethan gardens, to be explored and appreciated with reference to Classical knowledge.

6

Botany, medicine, and plant introductions

> *In that same Gardin all the goodly flowres,*
> *Wherewith dame Nature doth her beautify,*
> *And decks the girlonds of her Paramoures*
> *Are fetcht: there is the first seminary*
> *Of all things, that are borne to live and dye,*
> *According to their kynds. Long worke it were,*
> *Here to account the endlesse progeny*
> *Of all the weeds, that bud and blossome there;*
> *But so much as doth need, must needs be counted here.*
>
> EDMUND SPENSER, *The Faerie Queene*, 1590.[1]

In 1625, Sir Francis Bacon wrote, in his essay 'Of Gardens':

God Almighty first planted a garden. And indeed it is the purest of human pleasures. It is the greatest refreshment to the spirits of man, without which buildings and palaces are but gross handyworks: and a man shall ever see that when ages grow to civility and elegancy, men come to build stately sooner than to garden finely, as if gardening were the greater perfection.[2]

The garden referred to by Bacon was the Garden of Eden and the Bible gives in *Genesis* an account of God's garden, created by Him as the perfect place in which Adam and Eve lived in peace and innocence before the Fall (Plate 35). It included every plant given by God to Man for food and medicine. A quest in all ages – but particularly the Renaissance – was the location of the Garden of Eden. Indeed, there was in the sixteenth century no credible alternative account of the origin of the world, and the hope continued that Eden had somehow survived the Flood and could be re-discovered.[3]

Thus, when navigators began to explore the world in the fifteenth century, they hoped to find Eden. But the Portuguese failed to locate it in their voyages to the west: in Madeira, reached in 1419, the Azores in 1439, or the Cape Verde Islands in 1456–60. Mediaeval map makers had located Eden in parts of Africa or India, but explorers did not find it to the east when they rounded the Cape in 1488, or when Vasco da Gama reached India ten years later. When Columbus sailed west on his first voyage in 1492 he was convinced that he had arrived back in the country of the Old Testament, whilst on his third voyage in 1498–1500 he felt sure that he had come close. The Portuguese continued to look for Eden in Brazil for another century.[4]

Having thus failed to re-discover Eden, for educated men of the Renaissance it was but a short step to the idea of re-creating it by collecting plants from around the known world and 'bringing the scattered pieces of Creation together'.[5] These plants were then systematically arranged in gardens for the purpose of botanical study and a proper knowledge and understanding of their medicinal use. These early botanic gardens were motivated by the quest for knowledge and understanding of the natural world, a desire to learn and practise better 'Physic', and an aspiration to re-create the Garden of Eden. This in turn led into the early study of botany, which, as the sixteenth century progressed, became an increasingly desirable subject, both for

medical purposes and for the educated elite with large gardens who wished to demonstrate their botanical knowledge and to display exotic new plants.

Luca Ghini

In the knowledge of herbs and the whole materia of simple remedies [Luca Ghini] is second to no one in Italy.

LAURENTIUS GRYLLUS, 1556.[6]

Medical humanism was the other force driving the collection and study of plants. Mediaeval medicine had been based on the ancient Greek medicine of Hippocrates, Aristotle and Galen, but in the late fifteenth and sixteenth centuries medical humanists began translating these texts into Latin.[7] Scholars had coined the term *simple* as meaning a single plant that could produce a single medicinal substance, but university professors spent little or no time examining plants directly when teaching simples. The humanists' enthusiasm for ancient texts led them to Dioscorides' *De Materia Medica*, compiled in AD 50–70, the largest and most important pharmaceutical guide in antiquity.[8] The *Historia Naturalis* of Pliny the Elder (AD 23/4–79), which included seven books dealing with botany, had been corrupted by mediaeval scribal errors, and in the Renaissance, it was newly studied and corrected.[9]

De Materia Medica was a catalogue of more than six hundred plants giving their names, origin, physical characteristics and medicinal uses.[10] Dioscorides advised his readers to learn by examining plants personally. A Latin translation was published in 1478,[11] opening the way for the new discipline of medical botany, with the first lectureship at the University of Rome in 1514.[12] Padua followed, establishing a professorship in 1533. Luca Ghini (1490–1556) was the holder

of the first chair of simple medicines at Bologna University and the originator of the *hortus siccus,* a herbarium, in which plants were pressed and dried and then attached to card, which could be kept or sent to others.[13] Ghini collected plants from around the Mediterranean and compared them with descriptions in Dioscorides and Pliny.[14] He was among the first naturalists to introduce the field trip as a standard feature of student training; by the 1540s professors and students were regularly scouring the countryside for plants.[15] He also took live plants into lectures to show his students.[16]

Botanic gardens

And every sort is in a sondry bed
Sett by it selfe, and ranckt in comely rew.
 SPENSER, 'The Garden of Adonis' in *The Faerie Queene,* 1590.[17]

Since plants had been given by God for the purpose of healing as well as food, a knowledge and understanding of all plants from around the world would be expected to provide treatment for all injuries and diseases, and the earliest university botanic gardens were created for the purpose of medical research. For Renaissance physicians, both knowledge of Physic and the plants themselves from which they prepared medicines were gifts of God. These first botanic gardens emerged as a means of identifying and classifying plants, for the purpose of teaching medical students about the healing properties of plants from living specimens. Italian universities played an important role in the development of medical botany by creating the earliest botanic gardens in the world.[18]

 Cosimo I de' Medici became ruler of Florence in 1537 and, in order to train civil servants and win acclaim as a patron of learning, he restored the University of Pisa, which had been closed since 1526 by plague. Twenty professors were appointed in 1543, and Ghini moved

from Bologna to join them in 1544, as professor of medical botany, remaining until 1555. He established, and was the first Prefect of, the university botanic garden, which opened late in 1544 or in 1545.[19]

In 1543 the professors and students at Padua petitioned the Venetian government to establish a garden of *simples*, which they claimed would enable them to learn more in two years than from studying all the past writers. The campaign was successful and in June 1545 the Venetian Senate authorized construction,[20] though there is some dispute as to whether Pisa or Padua was the earlier. At the Padua botanic garden, the area of planting was about one-and-a-quarter acres. Designed by the architect Giovanni Moroni, the garden was circular, with rows of small beds around the outside.[21] The central area was square and divided into quarters in the traditional way (Figure 55), and the original layout of this garden remains. The *Orti Botanici* of Florence, Ferrara and Sassari followed Padua and Pisa within the next ten years.[22] Also established in the sixteenth century were botanic gardens at Zurich, Paris, Leipzig, Bologna and Heidelberg.[23] Leiden and Montpellier created their gardens later in the sixteenth century. These were followed by the Oxford garden, the first university garden in England, which was founded by the Earl of Danby in 1621, opened in 1632 and completed by 1640. John Gerard had tried to gain the support of Lord Burghley to persuade the University of Cambridge to establish a botanic garden, but Burghley died in 1598 before the plans could be realized.[24]

Mediaeval gardens were traditionally square, and divided into four quarters representing the four corners of the earth in the ancient tradition. The discovery of the New World led to the newly established botanic gardens representing the four continents of Europe, Africa, Asia and America, before the discovery of Australia.[25] Each quarter was divided into many separate beds, which at Padua were set out in geometric designs. At Leiden the beds were set out in long narrow rows and each bed, known as a *pulvillus* (small cushion), was dedicated

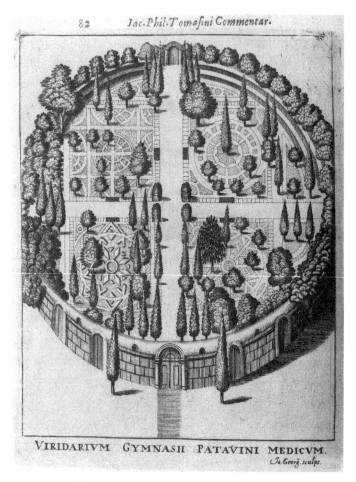

Figure 55 *The Botanic Garden at Padua, from* Gymnasium Patavinum, *Giacomo Filippo Tomasini, 1654. The circular walled garden is divided into four quarters and the separate beds are arranged so that every plant can be accessed individually.*

to a family of plants (Figure 56). The *pulvillus* was subdivided into smaller numbered plots for each member of the family, and there was space to walk between the *pulvilli* so that every plant could be seen, smelled and sketched by students.[26] Each new plant discovered was eagerly awaited, identified and named.

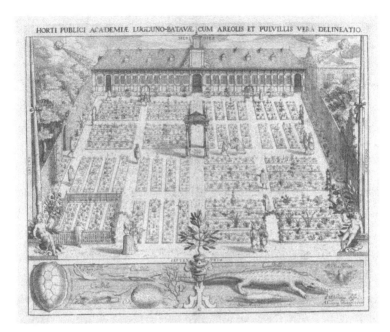

Figure 56 *The Botanic Garden at Leiden, from* Hortus Botanicus van de Universiteit Leiden, *Willem Swanenburg after Jan Cornelis Woudanus, 1610. Established in 1587, the garden was divided into quarters and sub-divided into* pulvilli. *The illustration shows professors and students studying the plants, as well as strolling couples enjoying the garden.*

William Turner

Although (most mighty and Christian Prince) there be many noble and excellent arts and sciences, which no man doubteth, but that almighty God the author of all goodness hath given unto us [. . .] yet is there none among them all which is so openly commended by the verdict of any holy writer in the Bible, as is the knowledge of plants, herbs and trees, and of Physic.

WILLIAM TURNER, *A New Herball*, 1551.[27]

In England, William Turner (*c.*1508–68) was the first scientific student of zoology and botany, 'with whom the great succession of field-naturalists in Britain may properly be said to begin'.[28] He is now generally known as the 'Father of British Botany'.[29] His fame as a botanist rests on his three works on plants, published over a period of thirty years. Turner went up to Pembroke Hall, Cambridge, in 1526 to study 'physic and philosophy' and it was there, in 1538, that he published his first book on herbs: *Libellus de Re Herbaria Novus.*[30] Because Turner held extreme Protestant views, in 1540 he was faced with a stark choice between martyrdom and exile, and he chose exile abroad until 1547. English physicians educated abroad were at that time a small but influential group and Turner was one of only twelve scholars who left Cambridge for a period of Continental medical study during the sixteenth century and returned to complete their qualification.[31] A substantial part of his period of exile was spent in Italy, where he studied briefly at Padua, then at Ferrara and Bologna under Luca Ghini, taking a medical doctorate.[32] He was therefore directly exposed to the latest developments in medical botany. Shortly after the accession of Edward VI, he returned to England to take up the position of physician to Edward Seymour, Lord Protector and First Duke of Somerset at Syon House.[33]

The combination of theology and botany was common across Europe, and many Early Modern botanists, including Turner, Otto Brunsels (d.1534) at Strasburg, Charles de L'Ecluse, known as Carolus Clusius (1526–1609) at Vienna and later Leyden, and Conrad Gesner (1516–65) at Basel and later Zurich, were active in the reformed church.[34] Renaissance botanists formed a closely knit scholarly community who shared dried plants, bulbs, seeds and knowledge, despite religious divisions across Europe (Plate 36).[35]

During his first period of exile, Turner also visited Switzerland, where he met Gesner,[36] the Professor of Natural History at Zurich.[37]

In 1543 Turner spent time in Basel, and the following year in Cologne, collecting plants in Germany. After this he travelled into Holland and East Friesland.[38] Whilst travelling, he visited apothecaries' gardens across Europe, noting their contents. In Antwerp he saw a 'Peonye' in the garden of Peter Coddenberg, whom Turner described as 'a faithful and learned apothecary'.[39] He also noted 'another little tree bringing forth pepper in clusters in Venice which [. . .] groweth green in the garden of Mappheus, the noble Physician'.[40]

On returning to England, Turner completed his second botanical book, *Names of Herbes,* dedicated to Somerset and published in 1548 'From your graces house at Syon'.[41] This book is the earliest authority to which the introduction of certain plants can be traced, and many indigenous British plants also date their record as natives from here.[42] During the years that Turner lived at Syon he continued his work of documenting the names, descriptions and habitats of plants as well as their nutritional and medicinal 'virtues'. The first part of his magnum opus, *A New Herball,* was published in 1551, while he was still living at Syon. Turner refers to Ghini on several occasions in his books. In his description of 'the herb called Lampsana' (Wild Radish) he wrote: 'When I was in Bologna, Lucas Ghinus, the reader of Dioscorides there, showed me the right Lampsanam, which afterward I have seen in many places of Germany in the corne field.'[43] After his return to England, Turner obtained some of the plants that he had found abroad. He is credited in William Aiton's *Hortus Kewensis* with the first record of English cultivation of more than forty plants.

In England, the Queen and her courtiers had their own physicians, who would have required access to a wide range of medicinal plants. As Turner observed, it was impossible for physicians to provide medical remedies unless they were able to correctly identify plants and obtain them. The logical way to achieve this would be to keep a

botanic garden. As the sixteenth century progressed, and houses were built by courtiers with ever more interest in nature and science, gardens developed to reflect these interests, both for practical purposes and as a means of demonstrating wealth and knowledge.

Turner's medical practice relied on a wide range of plants, as he made clear in setting out their 'virtues' in his *Herball*. To almost every one of the plants named he attributed beneficial medicinal properties. For example, Turner mentions a plant that he himself introduced: 'Wormwod pontyke' (Mugwort) 'groweth in no place of Englande, that ever I could se, saving only in my lordes gardyne at Syon, and that I brought out of Germany'.[44] Of 'Panike' (Foxtail Bristle-grass), which he probably also introduced, he wrote that 'I have not sene it in Englande, savyng in my Lordes gardine at Syon [. . .] it groweth in Italy and high Almany in the fieldes'.[45] His entry for 'Paulis betoni' (Heath Speedwell) states that 'Thys herbe groweth in Syon gardyn, and in diverse woddes not far from Syon wyth a whyte floure mixed with blewe'(Figure 57).[46] Bullwort, which Turner called 'Ami' (Figure 58) also grew at Syon, and he wrote: 'Thys herbe groweth in many gardynes in germany and in my lordes gardyne at Syone in England.'[47] He noted that 'Cisthus' (Rock-rose) 'groweth plenteously in Italy and one kind of cisthus groweth in my lords gardine in Syon'.[48] This was clearly unusual, because Turner commented: 'I have not heard as yit any englishe name for cistus, but for lak of other, it may be called cystbushe or ciste sage, of the lyknes that it hath with sage.'[49] Where a plant was newly introduced and not yet named, Turner invented a new name.

Each of Turner's three botanical works developed his subject as his knowledge and experience increased. His *Libellus de Re Herbaria* contains an alphabetical list of just 149 plants, with their names in Greek, Latin and English. He introduces the book by explaining his reason for writing it; despite his youth he considered it better that he

Of Paulis betoni,

Betonica Pauli,

hauyng both leues and ſtalkes ſo lyke peneryall that many both ofte ga-
ther it foꝛ peneryall,and beyng without all qualyte whyche can be per-
ceyued in taſte,ſauynge only a very lytell bytternes, after my iudgement
is the true Paulis betonye. Thys herbe groweth in Syon gardyn,and
in dyuerſe woddes not far from Syon wyth a whyte floure myꝛed with
blewe,and wyth a ſede lyke vnto burſa paſtoꝛis,

The properties of

Paulis Betony,

aulus Agineta, who only wꝛyteth of thys herbe, telleth no
other good pꝛopertie of thys herbe, but that it is good foꝛ the
diſeaſes of the kydneyes,

Byꝛche

Figure 57 *Illustration from William Turner's* A New Herball *of
'Paulis betoni' or Heath Speedwell, which Turner described as
growing both in Syon garden and in the woods nearby.*

Of Ami.

Ami.

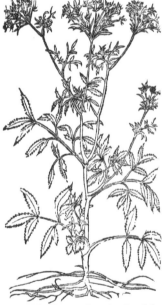

Ami is called both of grecians, and la tynes. amy .the Potecaries call it a meos in the genytyue case. it may be also called in Englyſhe ammi. Dioſco rides wryteth no more of the deſcryp tyone of Ammi, becauſe he thought it ſo commonly knowen in hys dayes, but theſe wordes. Ami hath muche ſmaller ſede, then Cumin: and reſem bleth organe in taſte. The herb, that is commonlye uſed for Ammi in all ſhoppes nowe a dayes: hath a longe grene ſtalke, full of lytle branches a bout the top, wyth long ſmall inden ted leues, & a whyte flour, and a buſ ſhy top lyke dyll, wyth a lytle bitter and hote ſede. Although thys may be uſed for ammi. and is one kynde of it: yet ther groweth in Italye a bet ter kynde, whyche I haue ſene. If we could haue plentye of that kynde, I wold counſell men to uſe it: and to leue thys, whyche we uſe common lye. for I fynde not the hete in thys ſede, that Galene requyreth. for he wryteth, that Ami is hote, and drye in the extremytye of the thyrde de gree. Howe be it, thys common ami is not to be diſpiſed. Thys herbe gro weth in many gardynes in germany and in my lordes gardyne at ſyone in England.

The vertues.

Ami is good agaynſte the gnawynge in the guttes, agaynſte the ſtoppynge of the water, agaynſte the biting of ſerpetes dronke with wine. It bringeth wemen theyr ſiknes. It myr ed with corroſyues made of the fyres called chantarydes, do help the ſtoppyng of a mans water. wyth hony it taketh away blew markes riſing of ſtrypes, wyth raſynes, or roſyne. In a perfume it purgeth the mother. Some hold, that wemen do ſouner conceyue: if they ſmel thys herbe, whē as the worke of conceptyone is in doynge.

Amomum.

C.iij. Amomum

Figure 58 *A page from William Turner's* A New Herball, *with the woodcut illustration of the herb 'Ami', now called Bullwort. As a doctor, Turner lists 'The Vertues', describing its medicinal uses.*

should attempt the arduous task, rather than that students should continue to be scarcely able to name three plants correctly:

> But seeing that nothing was taught and having the right means to bring it about, I boldly pursued a course which I thought difficult rather than let studious youth (who were scarcely acquainted with the names of three herbs correctly) continue to trust blindly.[50]

Turner's second botanical book, *Names of Herbes*, increased the number studied, listing 471 plants and giving brief details of their properties and where they were found growing. The first part of Turner's magnum opus, *A New Herball*, lists 186 plants, covering only those which fall at the beginning of the alphabet. The book is illustrated with woodcuts by the German herbalist, Leonard Fuchs (1501–66), whom Turner probably also met in Germany.[51] Fuchs held a chair as Professor of Medicine at Tübingen and had published a herbal under the title of *De Historia Stirpium* in 1542.[52] Part II of Turner's *A New Herball* was published in Cologne in 1562 and lists a further 319 plants. The third and final part was published in 1568. It lists 82 plants, bringing the total number named by Turner to 587. Turner's *Herball* provided physicians 'for the first time ... [with] a volume in their own tongue which gave them some reasonably accurate information on the plants available for their work'.[53]

The three parts of the *Herball* were corrected and published together in 1568. It is recorded in the preface of this edition that Turner met and talked with the then Princess Elizabeth in the gardens at Syon.[54] Dedicated to the 'most noble and learned Princesse in all kindes of good lerninge Quene Elizabeth',[55] the preface mentions his Latin conversation with the Queen and her favours to him:

> As for your knowledge in the Latin tonge xviii. yeares ago or more, I had in the Duke of Somersettes house (beynge his Physition at

that tyme) a good trial therof, when as it pleased your grace to speake Latin unto me.[56]

The plants named by Turner, which he calls 'Herbs', include both cultivated and wild plants. The term covers flowers and shrubs, vegetables and grain crops, trees, ferns, moss and even seaweed, although no mention is made of any fungi.[57] He also explicitly states of some plants that he has seen them overseas but has not seen them growing in England. For example, of 'Venus heyre', the Maidenhair Fern, he writes: 'I have seen this herb divers times in Italy, in pits and wells, but I could never find it, neither in Germany, nor in England.'[58]

The earliest physic gardens in England were in private hands. Turner was Dean of Wells from 1551 to 1554, and again from 1560 until his death in 1568. He kept a physic garden there, which would have supported his medical practice. He makes mention of the garden in *A New Herball*, under 'Scorpions Tayle' (Heliotrope) where he writes: 'I never sawe it growynge in Englande, nether in Germany, saving only in my garden in Collen, and in my garden at Wellis in Englande.'[59] He also mentions forays into the local countryside, where he noted: 'I have sene flax or lynt growyng wilde in Sommerset shyre, wythin a myle of Welles.'[60] Of 'Wall Penny Grasse' (Navelwort), he wrote: 'Thys herbe groweth in Welles in divers places of Summerset shyre in more plentye then ever I sawe in anye other place all my lyfe.'[61] Today, Wells Old Deanery Garden, entered through a door from Cathedral Green, has been restored by a group of volunteers, with a view to growing some of the plants listed by Turner.

From Turner's books, it is possible to derive a list of plants that he named as growing in gardens in England at the beginning of Elizabeth's reign, in total approximately 277 plants (Appendix). Excluding non-native plants and seaweeds, he named approximately 130 further plants

as growing in England in the wild. A combination of garden and wild plants might be expected to be included in an early botanic garden, to provide a range of medicinal *simples*. Initially only *simples*, i.e. medicinal plants, were grown. This suggests that the number of plants grown in such a garden in the early Elizabethan period was around 400.

Plant introductions

It is a world also to sée, how manie strange hearbs, plants, and
annuall fruits, are dailie brought unto us from the Indies, Americans,
Taprobane, Canarie Iles, and all parts of the world.

> RAPHAEL HOLINSHED, *The description and
> historie of England*, 1587.[62]

In the early Elizabethan period, then, there were only around 277 plants grown in English gardens, or perhaps up to 400 in a botanic garden. By the end of the period, this number had increased dramatically to more than a thousand plants, the number listed by John Gerard, who published a plant list of his gardens in Holborn: the *Catalogus arborum, fruticum, ac plantarum tam inigenarum, quam exoticarum, in horto Johannis Gerardi [. . .] nascentium.* This lists plants growing in Gerard's London garden in 1596 and 1599.[63] This huge expansion in the number of garden plants cultivated is well illustrated in contemporary paintings (Plate 37). Interest had expanded from the study of purely medicinal plants to botany in a far wider sense. Just four botanists are primarily credited with this massive extension in the cultivation of new plants: William Turner; Matthias de L'Obel (1538–1616); Hugh Morgan (*c*.1540–1613), Queen Elizabeth's apothecary; and John Gerard. By contrast, the *Hortus*

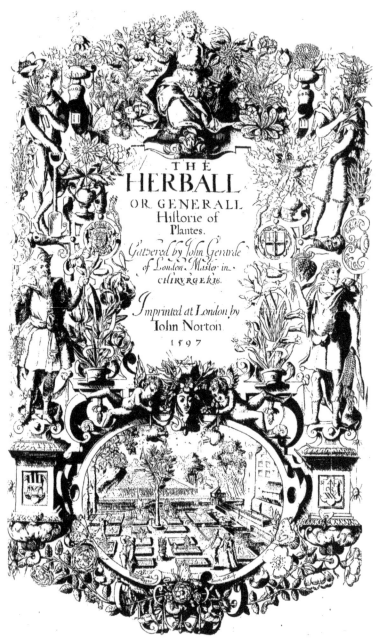

THE HERBALL OR GENERALL Hiftorie of Plantes.

Gathered by John Gerarde of London Master in CHIRVRGERIE.

Imprinted at London by Iohn Norton.
1597

Figure 59 *The title page from John Gerard's* The Herball, or Generall Historie of Plantes, *1597. At the top left is Gerard himself portrayed as Adam the gardener, holding a Pasque flower,* Pulsatilla vulgaris, *and a spade. He explains that he gave the Pasque flower its name because it flowers at Easter.*

Kewensis of William Aiton, published in 1789, lists approximately 5,600 plants grown in the gardens at that time, with the dates of plant introductions and the names of their introducers.[64] Today the Millennium Seed Bank at Kew conserves more than 39,100 species as seed samples.[65]

Gerard was a doctor, apprenticed to the Barber-Surgeons' Company. In 1586 the College of Physicians decided to establish a Physic Garden and Gerard was appointed its Curator. He was also superintendent of William Cecil's gardens in the Strand and at Theobalds. His major work, *The Herball, or Generall Historie of Plants,* was published in 1597 and dedicated to Lord Burghley (Figure 59). It contains about 1,800 woodcuts and lists more than 2,000 plants.[66] In *The Herball,* Gerard refers to the diversity of plants available by the end of the century:

> If delight may provoke mens labour, what greater delight is there than to behold the earth apparelled with plants, as with a robe of imbroidered worke, set with orient pearles and garnished with great diversitie of rare and costly jewels?[67]

These books provide the main record of plants grown in gardens in England by the end of Elizabeth's reign.

This increase in the number of plants was not restricted to just a few gardens, whether of doctors or courtiers. In *The description and historie of England,* published in 1587, Raphael Holinshed boasted about his own garden:

> For mine owne part, good reader, let me boast a litle of my garden, which is but small, and the whole *Area* thereof little above 300 foot of ground, and yet, such hath béene my good lucke in purchase of the varietie of simples, that notwithstanding my small abilitie, there are verie néere thrée hundred of one sort and other conteined

therein, no one of them being common or usuallie to bee had. If therefore my little plot, void of all cost in keeping be so well furnished, what shall we thinke of those of Hampton court, None such, Tibaults, Cobham garden, and sundrie other apperteining to diverse citizens of London.[68]

Turner and Gerard were doctors, and the primary reason for their interest in horticulture was in order to identify the medicinal value of each plant and to specify the ways in which each part could be used to treat medical conditions. Gerard referred to the importance of the study of plants:

Among the manifold creatures of God [. . .] that have all in all ages diversly entertained many excellent wits, and drawen them to the contemplation of the divine wisdome, none have provoked mens studies more, or satisfied their desires so much, as plants have done.[69]

Holinshed also emphasized the value of searching out new plants for medical use, even for the gardens of the elite:

Great thanks therefore be given unto the physicians of our age and countrie, who not onelie indevour to search out the use of such simples as our soile dooth yéeld and bring foorth, but also to procure such as grow elsewhere, upon purpose so to acquaint them with our clime, that they in time through some alteration received from the nature of the earth, maie likewise turne to our benefit and commoditie, and be used as our owne [. . .] And even like thankes be given unto our nobilitie, gentlemen, and others, for their continuall nutriture and cherishing of such home borne and forren simples in their gardens.[70]

Mortality rates from disease in the Elizabethan period were high and epidemics could cause a major crisis, especially in large towns where

major centres of population were vulnerable to infectious diseases.[71] Prevalent diseases included plague, smallpox, tuberculosis and malaria. The years 1557–9 were ones of terrible mortality, usually blamed on influenza, probably exacerbated by food shortage.[72] The great plague of 1563 in London, also following a bad harvest, killed more than 17,000 people, almost a quarter of the population. Another major outbreak in 1593 killed more than 10,000 people in London.[73] Ports were more at risk than inland areas, and London's vulnerability to disease was exceptional.[74]

As a consequence, there was great concern for the health and well-being of the Queen. She used a wide selection of medical personnel, and at least 15 physicians and 7 surgeons were attached to the royal household during the course of her reign.[75] Amongst the physicians at Court was a group who had London gardens and were well known for their cultivation of new plants. John Ryche, who became royal apothecary in 1576, was a renowned botanist who had some exotic plants growing in his garden. They included 'Organe' (Wild Marjoram), which 'ye brothe of it dronken with wyne is good for them that ar bitten of a serpent',[76] and of which Turner noted:

I never saw ye true Organ in England savyng in Master Ryches gardin in London whare as I saw many other good & strange herbes which I never saw any where elles in all England.[77]

Similarly of 'wild horehounde' (White Horehound), Turner wrote: 'I have sene one kind of this herbe growyng in London, in Maister Richardes gardin, but no where ellis in England.'[78] 'Wild mollen' or 'Sage mullen' (White Mullein) roots could 'heale the tuth ache if the teth be washed with their broth', and Turner states that: 'The wilde one groweth no where in England savinge in gardines. I have sene it of late in maister Riches gardin.'[79] This was presumably useful to treat the Queen, whose teeth and gums were constantly painful.[80] Of 'Thlaspi'

or 'triacle mustard' (Field Penny-Cress), which 'purgeth choler upwarde and downwarde', Turner wrote that it grew 'in England in moste plentye aboute Sion. In London it groweth in maister Riches gardin, and maister Morganes also'.[81] Of 'Gratiola' (Gratiole) or 'horse werye', which had the 'virtue' of being 'good for a dropsey' and when laid to a wound 'healeth it verye quickely and spedely', Turner described how he sent it to physicians in England:

> I have not sene Gratiolam growing in England, saving two rootes or thre that I set out of Brabant & gave unto maister Riche and maister Morgan, Apotecaries of London.[82]

'Master Morgan' was Hugh Morgan, who served the Queen as a yeoman apothecary from 1559, and who in 1583 was made principal apothecary to her household, a position he held until her death.[83] Morgan grew many specimens of rare plants, some collected by those who journeyed to Virginia, and others by exchanging seeds and samples with Continental apothecaries.[84] He had a large nettle-tree in his garden, which was impressive enough for Gerard to comment:

> This is a rare and strange tree [. . .] I have a small tree thereof in my garden. There is likewise a tree thereof in the garden under London wall, sometime belonging to M^r. *Gray*, an Apothecary of London; and another great tree in a garden neere Colman street in London, being the garden of the Queenes Apothecary at the impression hereof, called M^r. *Hugh Morgan*, a curious conserver of rare simples.[85]

James Garret was another apothecary and enthusiastic grower of new plants and gave samples to Gerard for his garden. Garret is credited in *Hortus Kewensis* with the first English cultivation of the tulip in 1577.[86] He became internationally renowned for his skill in propagating new varieties of tulip and was actively engaged in procuring and growing new plants from all over the world.[87] In his *Herball*, Gerard wrote:

Tulipa or the Dalmatian Cap is a strange and forrein floure, one of the number of the bulbed floures, whereof there be sundry sorts, some greater, some lesser, with which all studious and painefull Herbarists desire to be better acquainted, because of that excellent diversitie of most brave floures which it beareth.[88]

A painting by the French artist Jacques Le Moyne de Morgues *c*.1585 (Plate 38), illustrates a girl with her body decorated with a wide variety of flowers, including the recently introduced yellow and red tulips on her thighs. As well as tulips, Garret grew 'Our Ladies Slipper' (Lady's slipper orchid), another new introduction, of which Gerard commented: 'Ladies Slipper groweth upon the mountains of Germanie, Hungarie, and Poland. I have a plant thereof in my garden, which I received from M[r]. *Garret* Apothecarie, my very good friend' (Figure 60).[89] It can be seen, therefore, that the desire of classically trained physicians to acquire and cultivate new plants for medicinal use was a major reason for a large number of introductions.

Gardens of the Elizabethan period were expected to be productive as well as ornamental, and this is well illustrated, together with the importance of plants for medicine, by the contemporary diary of Lady Margaret Hoby (1570/1–1633). Written between 1599 and 1605, it gives clear insight into the daily life of an Elizabethan lady of high social status. Margaret was an only child and heiress to a substantial fortune. Although born into a gentry family, she was brought up in aristocratic circles and her diary reflects the life of an aristocratic lady with significant estates to manage. After her marriage in 1596, she lived at Hackness in North Yorkshire. The estate included the manor house, mills and extensive property in the surrounding districts.[90] Created from a former monastic settlement it had gardens, orchards and fish ponds.[91] The diary makes clear that, as her husband became increasingly engaged in public affairs, and spent lengthy periods away in York and London, he left

1 *Calceolus Mariæ.*
Our Ladies Slipper,

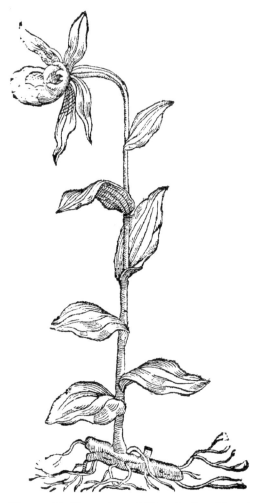

Figure 60 *Illustration of 'Our Ladies Slipper'*
orchid, from Gerard's Herball. *This was a rare*
wild plant, newly introduced into gardens, and
its medicinal 'vertues' were unknown to Gerard,
though he had an example in his own garden in
London.

Margaret to her life at Hackness. It reveals how she saw the garden as her own domain. On 2 May 1600, the entry reads: 'after I had dined I went into my Garden, and was their busie tell 5 a clok', while on 26 May she was 'busie in my garden all the day allmost'.[92] On 5 April 1605 'all the day I was busie in the Gardin, and after I went to privatt praier & readinge' but the following day 'I bestoed to much time in the garden, and therby was worse able to performe sperituall dutes'.[93]

The produce of Margaret Hoby's garden, like those of most houses with large estates and households, was both practical and for her private pleasure, including flowers, herbs and food. On 5 October 1603, she wrote:

> We had in our Gardens a second sommer, for Hartechokes bare twisse, whitt Rosses, Read Rosses: and we, havinge sett a musk Rose the winter before, it bare flowers now. I thinke the Like hath seldom binn seene: it is a great frute yeare all over.[94]

In common with other estates, there was a herb garden for medicinal purposes, which Margaret utilized in the absence of any local doctors. In April 1601, she recorded:

> After privat praier I was busie about the house, and dressed my sarvants foot and another poore mans hand, and talked with others that Came to aske my Counsill: after, I went into the Garden, and gave some hearbes unto a good wiffe of Erley for his garden.[95]

A part of her daily life was to tend to those in need of wound dressing, and her diary frequently notes how, after prayers and breakfast, 'I dressed my patients'. On 1 February 1600, she 'dressed a poore boyes legge that was hurt, and Jurdens hand'.[96] These ministrations certainly utilized plants from her herb garden, and the following day she wrote 'I rede of the arball' (Herbal), which she presumably referred to for information on appropriate herbal treatments for her patients.[97] This

could have been Turner's *New Herball,* or more likely Gerard's recently published *Herball.*

In addition to the medical community's interest in gardens, there was a desire amongst garden owners to fill their gardens with exotic imported plants in order to demonstrate their wealth and to display riches brought from foreign lands. Holinshed wrote:

> There is not almost one noble man, gentleman, or merchant, that hath not great store of these floures, which now also doo begin to wax so well acquainted with our soiles, that we may almost accompt of them as parcell of our owne commodities. They have no lesse regard in like sort to cherish medicinable hearbs fetched out of other regions néerer hand: insomuch that I have séene in some one garden to the number of three hundred or foure hundred of them, if not more: of the halfe of whose names within fortie yéeres passed we had no maner knowledge.[98]

There were two main sources for the plants brought into new cultivation. The first was from England, where wild plants not previously documented by Turner as growing in gardens were collected. Gerard was known to seek and collect such new specimens, as he described in his *Herball:*

> The Lancashire Asphodill groweth in moist and marish places neere unto the towne of Lancaster, in the moorish grounds there, as also neere unto Maudsley and Martom, two villages not farre from thence; where it was found by a worshipfull and learned Gentleman, a diligent searcher of simples, and fervent lover of plants, Master *Thomas Hesket,* who brought the plants thereof unto me for the increase of my garden.[99]

Such wild plants were frequently new discoveries to the medical profession, and Gerard was forced to concede that of the 'yellow

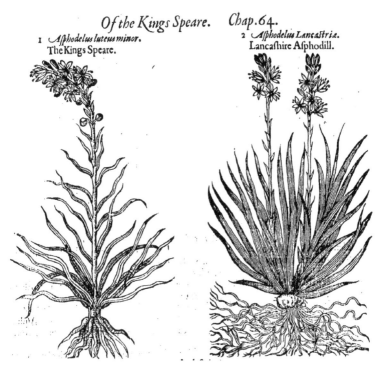

Of the Kings Speare. Chap.64.

1 *Aſphodelus luteus minor.*
The Kings Speare.

2 *Aſphodelus Lancaſtriæ.*
Lancaſhire Aſphodill.

Figure 61 *'The Kings Speare' and 'Lancashire Asphodill', from Gerard's Herball. Gerard gave Kings Speare its name and wrote that they were now in great plenty in London gardens. The 'Lancashire Asphodil' was found by Thomas Hesketh near Lancaster and sent to Gerard for 'the increase' of his garden.*

Asphodill' (*Asphodeline Lutea*, given the name King's Spear by Gerard) and the Lancashire Asphodill (*Narthecium ossifragum*): 'It is not yet found out what use there is of either of them in nourishment or medicines' (Figure 61).[100] To other plants discovered growing wild, Gerard did attribute useful medicinal properties, such as 'Land Caltrops' (*Tribulus terrestris*), which 'if it be drunke in wine it is a remedie against poisons', and which he describes:

It groweth plentifully in Spain in the fieldes: [. . .] it is also found in most places of Italy & Fraunce; I found it growing in a moist

medow adioyning to the wood or Park of Sir *Frances Carew*, neere
Croidon, not far from London, and not elsewhere; from whence I
brought plants for my garden.[101]

The second source of new garden plants were more exotic specimens
introduced to England from overseas. Holinshed described how so
many new plants were being discovered:

> If you looke into our gardens annexed to our houses, how
> woonderfullie is their beautie increased, not onelie with floures, [. . .]
> but also with rare and medicinable hearbes sought up in the land
> within these fortie yeares: [. . .] How art also helpeth nature in the
> dailie colouring, dubling and inlarging the proportion of our floures,
> it is incredible to report: for so curious and cunning are our gardeners
> now in these daies, that they presume to doo in maner what they list
> with nature, and moderate hir course in things as if they were hir
> superiours. It is a world also to sée, how manie strange hearbs, plants,
> and annuall fruits, are dailie brought unto us from the Indies,
> Americans, Taprobane, Canarie Iles, and all parts of the world.[102]

Holinshed observed that the New World, especially the Caribbean
and South America, was the source of many of these plants, as Gerard
also made clear:

> The golden Thistle of Peru, called in the west Indies, *Fique del
> Inferno*, a friend of mine brought it unto me from an Island there
> called Saint Iohns Iland, among other seeds [. . .] and [it] prospereth
> very well in my garden.[103]

Again, in terms of the plant's medicinal value, Gerard had to confess
that: 'The vertues hereof are yet unknowne unto me.'[104] Many new
plants also came from the Middle and Near East. Of 'the Broader leaved
Mock-Privet' (*Phyllirea latifolia*), which had the 'vertue' of 'Being
chewed in the mouth they heale the ulcers thereof', Gerard wrote:

These plants do grow in Syria neere the city Ascalon, and were found by our industrious *Pena* in the mountaines neere Narbone and Montpelier in France: the which I planted in the garden at Barn-Elmes neere London, belonging to the right Honourable the Earle of Essex: I have them growing in my garden likewise.[105]

Of Crown Imperials (*Fritillaria Imperialis*), also newly introduced, Gerard wrote that 'this plant likewise hath been brought from Constantinople amongst other bulbous roots, and made denizens in our London gardens, whereof I have great plenty'. Gardeners were competing to obtain and grow attractive new plants and since Gerard was responsible for the gardens of William Cecil at Theobalds and the Strand, it is likely that the plants grown there reflected the rich variety in his own garden.

Another nobleman known for his passion for exotic plants was Edward la Zouche, Eleventh Baron Zouche. When Matthias de L'Obel returned to settle in London in 1590 he won a position as supervisor of Zouche's gardens in Hackney.[106] L'Obel was a Flemish botanist who also attended Luca Ghini's botanical course at Pisa. He moved to England in 1567 and his herbal *Stirpium adversaria nova*, written with his friend Pierre Pena, was published in London in 1571. This had entries on around 1,300 plants. L'Obel later moved back to Antwerp to practise medicine and was appointed court physician in Delft to William I, Prince of Orange, until the latter's assassination in 1584. L'Obel moved back to England around 1590 and, as well as being supervisor of Lord Zouche's gardens in Hackney, he acted as his private physician. Turner's work was far from complete in listing native English plants, and L'Obel is responsible for more than 80 'first records' of native plants in his *Stirpium*.[107] He also collaborated with John Gerard, cataloguing Gerard's garden in Holborn. In 1607 he was appointed the official 'botanographer' (i.e. responsible for describing plants) to James I.[108]

Zouche's gardens, on which he spent considerable sums, were filled with plants that he had obtained on his travels in the 1580s and 1590s, some of which originated in the Middle East and Turkey.[109] L'Obel records, amongst other plants, that Zouche brought back two small white tulips, a winter crocus and a *Colchicum,* as well as a number of lilies.[110] Zouche gave seeds of some of the new plants to his friend Gerard, who looked to their medicinal properties. Of the 'Thornie Apple' (Jimson weed), Gerard wrote:

> There is another kinde heereof altogither greater than the former, whose seeds I received of the right Honorable the Lord *Edward Zouch*; which he brought from Constantinople, and of his liberalitie did bestow them upon me, as also many other rare & strange seeds; and it is that Thorn apple that I have dispersed through this land, whereof at this present I have great use in chirurgerie, as well in burnings and scaldings, as also in virulent and maligne ulcers, apostemes, and such like.[111]

The outstanding mathematician and scientist, Thomas Harriot, also gives a tantalizing glimpse of a further source of exotic imports, from Elizabethan exploration of North America. Harriot studied at Oxford from 1577 and in 1583 joined the household of Sir Walter Raleigh as an instructor in the mathematical problems of astronomy and navigation.[112] There he gave classes in Raleigh's preparations for the voyage of five ships led by Sir Richard Grenville, the first (unsuccessful) attempt at English settlement in the New World.[113] Harriot was then a member of Grenville's expedition to Virginia in 1585, his duties being to make astronomical observations and advise on navigation for the voyage.[114] From July 1585, together with painter and draughtsman John White, he spent a year surveying and mapping the coastline around Roanoke in Virginia, where the colonists settled, and recording the flora and fauna, returning to England with Sir Francis Drake in

1586.[115] The first colonists believed that God had a special plan for the new colonies to serve as a light to the nations, and that their preordained task was to build a garden in the wilderness, 'to re-create Eden in the New World' (Figure 62).[116]

While in Virginia, Harriot compiled a detailed 'Chronicle', of which nothing remains but an abstract, first published in 1588, entitled *A Briefe and True Report of the New Found Land of Virginia*. A second edition was published in 1590 with engravings by Theodor de Bry after the drawings of John White. Harriot wrote of the 'Enterprise for the inhabitting and planting in Virginia', describing in the first part of his *Report* 'Marchantable commodities' of which the settlers could produce excess quantities 'as by way of trafficke or exchaunge with our owne nation of England'.[117] These included 'grasse Silke', 'Worme silke', flax and hemp, grapes for wine and walnuts for oil.[118] Of the town of Pomeiock, beside the sea along the coast from Roanoke, Harriot observed that 'the contrye abowt this plase is soe fruit full and good, that England is not to bee compared to yt'.[119]

Amongst the novel New World plants that Harriot found in Virginia was:

> another great hearbe in forme of a Marigolde, about sixe foot in height; the head with the floure is a spanne in breadth. Some take it to be *Planta Solis*: of the seedes hereof they make both a kinde of bread and broth.[120]

The first record of cultivation of the sunflower is attributed by *Hortus Kewensis* to Gerard in 1596.[121] However, given Harriot's comments, it seems very likely that he would have brought seeds back to England ten years earlier (Figure 63). There was, as today, competition to grow the tallest sunflower and Gerard reported his as 'fourteen foote in my garden', although claims were made in Spain and Italy for much taller plants.[122]

Figure 62 *Illustration showing Adam and Eve by Theodore de Bry, from Thomas Harriot,* A Brief *and* True Report of the New Found Land of Virginia, *1590. De Bry uses this illustration to show how the first English settlers toiled and planted in Virginia. Like Adam and Eve, they showed great self-sufficiency in providing for their own needs, re-creating Eden in the New World.*

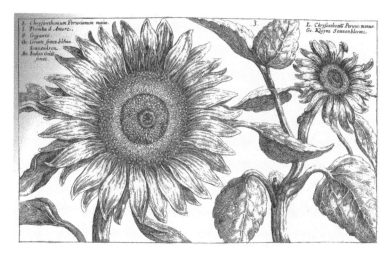

Figure 63 *Illustration of 'The Greater and Lesser Sunflower' from Crispin de Passe the Younger,* Hortus Floridus, *1614. A novel import from the New World, the sunflower was grown in English gardens from the end of the sixteenth century.*

The plant named *Metaquesunnauk,* (the Prickly Pear or Indian Fig) was described by Harriot as:

> a kinde of pleasaunt fruite almost of the shape & bignes of English peares, but that they are of a perfect red colour as well within as without. They grow on a plant whose leaves are verie thicke and full of prickles as sharpe as needles.[123]

The first record of its cultivation is attributed by *Hortus Kewensis* to Gerard in 1596 (Figure 64).[124] Gerard had obtained his specimen from the Mediterranean, where it had been introduced earlier, and he wrote:

> This plant groweth in all the tract of the East and West Indies, and also in the country Norembega, now called Virginia, from whence it hath beene brought into Italy, Spaine, England, and other coontries: in Italy it sometimes beareth fruit, but more often in Spaine, and never as yet in England, although I have bestowed great pains and cost in keeping it from the iniury of our cold climate.[125]

Of the prickly Indian Fig tree. *Chap.*128.

1 *Ficus Indica.* *Fructus.*
 The Indian Fig tree. The fruit.

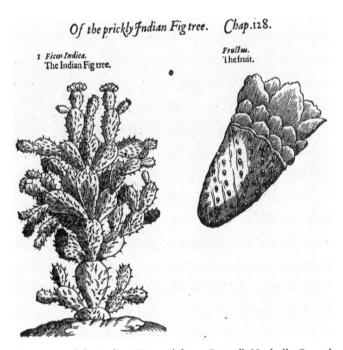

Figure 64 *'The Indian Fig tree' from Gerard's* Herball. *Gerard described this exotic, newly-introduced plant as 'a tree made of leaves, without body or boughes'. He reported that the juice from the leaves was 'excellent good against ulcers', but that it had not borne fruit in the cold English climate.*

However, it again seems distinctly possible that the plant could have been brought to England by Harriot ten years earlier.

Nor were new plant introductions limited to herbs, flowers and shrubs. As Holinshed observed:

And even as it fareth with our gardens, so dooth it with our orchards, which were never furnished with so good fruit, nor with such varietie as at this present. For beside that we have most delicate apples, plummes, peares, walnuts, filberds, &c: and those of sundrie sorts, planted within fortie yéeres passed, in comparison of which most of the old trées are nothing woorth: so have we no lesse store

of strange fruit, as abricotes, almonds, peaches, figges, corne trees in noble mens orchards. I have seene capers, orenges, and lemmons, and heard of wild olives growing here, beside other strange trees, brought from far, whose names I know not.[126]

In total, the number of new plants introduced to English gardens in the Elizabethan period was almost 600, some brought from the wild in England and others from overseas. Some of these were probably restricted to the gardens of the medical community but, as Holinshed makes clear, many more were extensively cultivated in gardens both large and small. Gardens were transformed in their appearance in the late sixteenth century in an unprecedented manner, to delight the senses as well as to improve health and well-being.

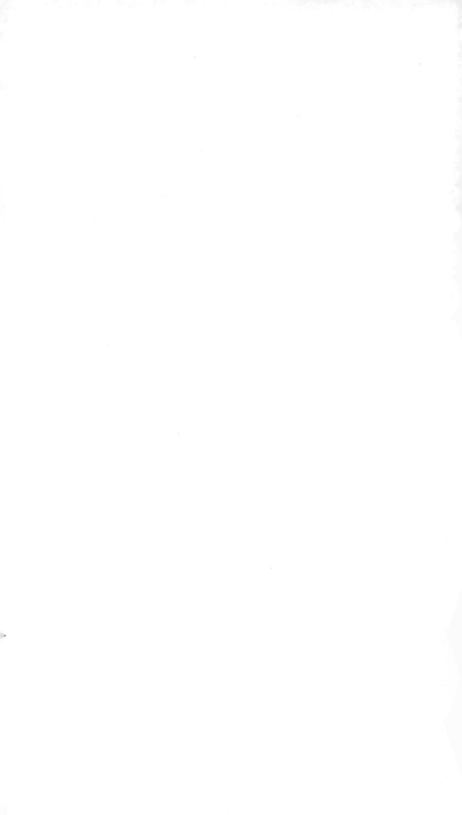

7

Masques and royal entertainments

> *What mask? what music? How shall we beguile*
> *The lazy time, if not with some delight?*
> WILLIAM SHAKESPEARE, *A Midsummer Nights' Dream*, 5.1.

The use of display in the Court had been prominent since the fifteenth century and this tradition of courtly magnificence was continued by Elizabeth throughout her reign, beginning with her entry into London for her coronation (Figure 65). In January 1559 she made a public procession from the Tower of London to Westminster, accompanied by a large entourage, with her courtiers and their horses all richly arrayed in crimson velvet. As she processed through the city, heralded by trumpets and watched by the people as she passed, there were pageants, speeches and music along the route:

On the 14th she came in a chariot from the Tower, with all the Lords and Ladies, all in crimson velvet, and their horses trapped with the same; and Trumpeters in scarlet gowns blowing their trumpets, and all the Heralds in their coat armour; the streets were laid over with gravel. The City was at very great charge to express

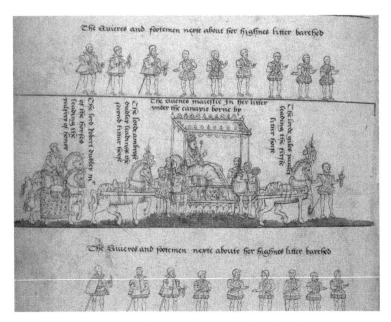

Figure 65 *Queen Elizabeth in procession the day before her coronation in 1559. The Queen, accompanied by her Court, began her reign with a display of courtly magnificence, as had been traditional since the fifteenth century.*

their love and joy, in the magnificent scaffolds and pageants they had erected, in adorning the conduits, appointing musick, preparing speeches and verses to be said to her; which the Queen took very well, and promised to remember it.[1]

Furthermore, as a young attractive Queen of 25 years of age, Elizabeth loved music, dancing and entertainment. And the passion endured: even as an elderly lady during the Twelfth Night revels of 1599, she was reported to have danced three or four galliards. This love of spectacle and excitement led to the revival of folk festivals, morris dances and May games. Again, her love of these festivities continued, and she went a-Maying in Highgate in 1601 and Lewisham in 1602.[2] Holinshed's *Chronicles* describe how:

The court of England, which necessarilie is holden alwaies where the prince lieth, is in these daies one of the most renowmed and magnificent courts that are to be found in Europe [. . .] you shall not find manie equall thereunto, much lesse one excelling.[3]

Courtly display was central to the cultural climate of Elizabethan England, in which art, literature, music, painting and building were not so much a reflection of the social and political order as a part of it. Such display and entertainment can be seen on the Queen's progresses, as well as at her palaces, as her hosts sought to entertain her at their country houses in royal style. There was a continuation of the tradition of pageantry, which although rooted in the Middle Ages found new life in the Renaissance, with the introduction of characters from Classical mythology. As the Queen travelled the country she was greeted by mythical characters at every turn. As Chambers explains, she went about her public affairs 'in a constant state of make-believe, with a sibyl lurking in every courtyard and gateway, and a satyr in the boscage of every park'.[4]

Elizabeth's entertainments on her progresses had one thing in common: they were filled with compliments to her person, reflecting her cult status.[5] They incorporated themes of often lavish spectacle, of Classical allusion, of praise directed towards her, as well as the excitement and amusement she craved. They offered a combination of script and spontaneity, with the Queen and her courtiers both on show and at play. The Elizabethans were not creating artificial play worlds but were, instead, transforming the real one, filling the landscape with adventure. Each progress became a Quest and her courtiers, meeting the requirement to create amusements and entertain her, seized the opportunity.

The Court usually left London in the spring, when the weather was fine and the countryside entering the season of growth. The Queen

Figure 66 *'The Month of April', from Edmund Spenser,* The Shepheardes Calender, *1579. The Queen is entertained in a pastoral landscape by the Muses, blending an outdoor entertainment with a classical theme.*

could ride in an open carriage, her desire to be seen by the people equally as important as her desire to view the state of the realm. The transition from the cold winter months spent in the City to the warmer months spent travelling through the countryside enabled a change in the form and style of the entertainments presented to her, which were perfectly suited to outdoor activities. This romance and welcome of the new season was expressed both in literature and in entertainments.

The illustration for the April eclogue of Spenser's poem, *The Shepheardes Calender*, published in 1579 (Figure 66), shows the Queen, promoted to the status of a goddess herself, outside in a rural setting with the Muses singing and playing to her. Calliope, the chief of the Muses, leads the others to meet her:

I see *Calliope* speede her to the place,
Where my Goddesse shines:
And after her the other Muses trace,
with their Violines.
Bene they not Bay braunches, which they doe beare,
All for *Elisa*, in her hand to weare?
So sweetely they play,
And sing all the way,
That it a heauen is to heare.[6]

The country-house revels presented to Elizabeth in these spring and summer months were more varied and far less formal than the Accession Day tilts, presentations at the universities, or civic entries into towns and cities which she otherwise enjoyed. Her rural hosts frequently contrived to surprise her with devices and masques, catching her as she walked through their gardens or rode in their parks. Their spectacles, speeches and music were situated mainly outdoors (Plate 39). In the presentation of such entertainments, time was suspended. At Kenilworth in 1575, the narrator tells us that the clock on Caesar's Tower was deliberately stopped.[7] The Queen entered a realm of romantic associations, where the whole of the castle and its landscape was conceived in the spirit of mediaeval romance involving a white-robed Sibyl and the Lady of the Lake. Fictions are turned into realities, using the gardens and landscape as natural settings for their performances.

Unconfined by a particular formal occasion or a particular location, the country entertainments were free to make use of the gardens and parks in imaginative ways (Figure 67). The whole landscape became a stage, inhabited by gods and goddesses from Greece or Rome, by knights, shepherds or wild men. The dramatic events created an interplay between art and life, where real people encountered denizens

Figure 67 An Allegorical Party, *David Vinckboons I, c.1604. This illustrates courtly entertainments of music, dancing and feasting in a formal garden setting.*

of myth and romance, in a setting of gardens, meadows and woodland. They brought to life fictions, which were planted in the very design of the gardens and landscape.

Entertainments not only took place outside, they were deeply connected to the countryside through the characters who appeared as mythological gods and played the parts of rustics closely associated with the natural world. At Elvetham, the goddesses who welcomed Elizabeth were the Hours, fruitful goddesses of the seasons, and the Graces, who preceded Elizabeth, strewing flowers in her path, while Nereus, god of the sea, inhabited the lake. Sylvanus, god of the woods, appeared at Kenilworth in 1575 and Elvetham in 1591. At Bisham in 1592, Elizabeth was greeted by a Wild Man emerging from the woods, while the daughters of her hostess were dressed as shepherdesses.

Many of the Queen's progresses took her through countryside filled with sheep, and references are frequently made in the literature of the Renaissance to a rural bliss, reflective of Virgil, which in turn was played out in many of the entertainments presented to her on her travels. When Sir Philip Sidney wrote *Arcadia* for his young sister Mary, Countess of Pembroke, he was staying with her at Wilton. He probably began it soon after returning from his diplomatic mission to Vienna in June 1577.[8] In its pastoral scenes with the 'sweetnesse of the ayre'[9] and Arcadian shepherds are reflected both the Renaissance return to the Classical idea of Arcadia as a place of tranquillity away from the stresses of Court life and also the reality of the countryside around Wilton. Indeed Sidney, in Virgilian style, portrayed himself under his Greek name Philisides as a shepherd in the Arcadian landscape of a Wilton springtime:

The ladd *Philisides*
Lay by a rivers side,
In flowry fielde a gladder eye to please:
His pipe was at his foote
His lambs were him besides[. . .]

Tell me you flowers faire
Cowslipp & Columbine,
So may your Make this wholsome springtime aire
With you embraced lie,
And lately thence untwine.[10]

Sidney visited Wilton for a prolonged stay in 1580, when he was in temporary disfavour at Court due to his opposition to the Queen's marriage to the Duc d'Anjou. The first manuscript of *Arcadia* was probably completed during that stay[11] and it is likely that Sidney was influenced by the landscape around him as he wrote. His description

of Arcadia could equally be a description of the Wilton countryside, reflecting the romance perceived in a pastoral landscape:

> There were hilles which garnished their proud heights with stately trees: humble valleis, whose base estate semed comforted with refreshing of silver rivers: medowes, enameld with all sortes of eypleasing floures: thickets, which being lined with most pleasant shade, were witnessed so too by the cherefull disposition of many wel-tuned birds: each pasture stored with sheep feeding with sober security [. . .] here a shepherd's boy piping as though he should never be old; there a young shepherdess knitting and withal singing, and it seemed that her voice comforted her hands to work and her hands kept time to her voice's music.[12]

As well as its Classical references, *Arcadia* evidences Sidney's understanding of the relationship between nature and art, naming seventeen different varieties of trees, only a few of which have a technical use, and identifying the cultural meanings assigned to each species.[13] John Aubrey mentions that Sidney, when composing *Arcadia*, wrote 'in his table book, though on horseback'[14] making it among the first literary works known to have been composed, at least in part, outdoors.[15] Since the outdoors in question were the gardens and wider landscape at Wilton, his text may mirror the reality that he saw around him. The Queen was entertained there by the Earl of Pembroke in 1574, and would have appreciated for herself this Arcadian landscape.

Greetings

Let Fame describe your rare perfection,
Let Nature paint your beauties glory,
Let Love engrave your true affection,

Let Wonder write your vertues story:

By them and Gods must you be blazed,

Sufficeth men they stand amazed.

From the Speeches to Queen Elizabeth at Sudeley, 1592.[16]

Against such a background of courtly magnificence and display, the arrival of the Queen and her entourage was an eagerly anticipated event, albeit probably with some apprehension on the part of her host. At the beginning of her visit, there was usually a ceremonial greeting to welcome her, which was both a formal part of the occasion and an opportunity for the scene to be set for the other entertainments planned during her stay. These greetings took a number of forms and were set anywhere from several miles away to the entrance of the house and gardens, depending on what impression the host sought to make. But they all made use in one way or another of the landscape to greet the Queen and her Court.

Thus, when she arrived at Wilton on 3 September 1574, she was received by the Earl of Pembroke 'accompanyed with many of his honourable and worshipfull friends, on a fayre, large and playne hill [. . .] about five miles from Wilton' in the heart of the landscape Sidney called Arcadia.[17] The Earl had with him:

a good band of men in all their livery coates [. . .] the Queenes Grace stayed on the southerne hill untill all were past, looking and viewing them as they past by; and when her Majesty entered in att the outer gate of Wilton House, a peale of ordnance was discharged on Roulingtoun; and without the inner gate the Countesse, with divers Ladyes and Gentlewomen, meekly received her Highnesse. This utter [outer] court was beset on bothe sides the way with the Earles men as thicke as could be standing one by another, through which lane her Grace passed in her chariott, and lighted at the inner gate.[18]

Here the symbolic impact of the greeting is clear: by meeting the Queen five miles from the house, but still on his estate, and assembling a large number of liveried retainers, the Earl emphasizes his power and status. But it is also a very traditional greeting.

By contrast, George Gascoigne's *Princely Pleasures*, published in 1575, records the entertainments at Kenilworth that summer. The Queen's entrance to the castle was a slow procession, interspersed with a series of events at each stage of the formal entry. These began with her encounter with the prophetess Sibylla, who was in an arbour in the park. When the Queen arrived, Sibylla stepped out with a welcoming address:

> All hayle, all hayle, thrice happy Prince; I am *Sibylla* she,
> Of future chaunce, and after happ, forshewing what shall be.
> And now the dewe of heavenly gifts full thick on you doth fall,
> Even so shall Vertue more and more augment your years withal
> [. . .]
> If perfect peace then glad your minde, he joyes above the rest
> Which doth receive into his house so good and sweet a guest.[19]

As the Queen proceeded towards the castle, at the first gate she was heralded by six trumpeters and met by Hercules the Porter, who, 'overcome by viewe of the rare beutie and princely countenance of her Majesty', presented her his club and keys with these words:

> Come, come, most perfect Paragon; passe on with joy and blisse:
> Most worthy welcome Goddes guest, whose presence gladdeth all.[20]

At Kenilworth, rather than being greeted by a display of armed force, the Queen was welcomed with poetry, praise, mythological characters and music – probably a good deal more to her taste.

There was a carefully devised literary greeting at Bisham, where the Queen visited Lady Russell from 11 to 13 August 1592.[21] The speeches

on her arrival were presented as the Queen travelled through the landscape of the estate. She was met 'At the top of the Hill going to Bissam, the Cornets sounding in the Woods, a Wilde Man came forth'.[22] Also on the hill were Pan and two Virgins, Sybilla and Isabella, parts played by Lady Russell's daughters, Elizabeth and Anne, who were described in the Wild Man's speech as 'chast Nymphes'.[23] Probably Lady Russell herself devised the entertainment and this was the first occasion on which English noblewomen took speaking roles in a quasi-dramatic performance.[24] At the date of the Queen's visit Lady Russell was seeking suitable positions for her daughters, then aged 18 and 16 respectively. Although well born, educated and attractive, the early death of their father meant that they did not have dowries commensurate with their rank. Lady Russell's best chance of enhancing their marriageable value was to get them appointed maids of honour to the Queen.[25] This is very clearly the meaning of the greeting, which like all such events was carefully scripted and choreographed. The virtue of chastity would be essential for a maid of honour.

The record describes how 'At the middle of the Hill sate Pan, and two Virgins keeping sheepe, and sowing in their samplers, where her Majestye stayed'. Pan addresses the two girls: 'I love you both, I know not which best; and you both scorne me, I know not which most', to which Sybilla replies 'Alas, poor Pan! Looke how he looketh, Sister, fitter to drawe in a harvest wayne, then talk of love to chaste Virgins', again emphasizing to the Queen the girls' virtue.[26] Isabella was sewing in her sampler 'Roses, egletine, harts-ease, wrought with Queenes stitch'.[27] The choice of roses and eglantine for the embroidery was clearly a tribute to the Queen, being her personal emblems. Sybilla's speech then addressed the Queen with the customary compliments, touching on the debate between Art and Nature, and crediting Elizabeth for bringing peace and plenty. The references to sheep and corn paint a picture of Bisham as a place of rural tranquillity and agricultural prosperity:

This way commeth the Queene of this Islande, the wonder of the
world, and Nature's glory [...] In whom Nature hath imprinted
beauty, not art paynted it; in whome Wit hath bred learning, but
not without labour; Labour brought forth wisedome, but not
without wonder. By her it is (Pan) that all our carttes that thou seest
are laden with corne.[28]

Again, the welcome was extended across the landscape on the approach
to the house. The record continues: 'At the bottome of the hill, entering
into the house, Ceres with her Nymphes, in a harvest cart, meet her
Majesty, having a crown of wheat-ears with a jewell'.[29] This was no
doubt an expensive gift and Ceres, a part played by Lady Russell, sang
a song conceding her title as Queen of Heaven to Elizabeth in her cult
persona as Cynthia. Ceres was the Roman goddess of grain, the name
linked with the concept of creation, and in origin Ceres was the divine
power that produced living things and made them grow.[30] She had an
association with marriage, when the wedding torch was carried in her
honour.[31] One of her primary attributes was a *corona spicea*, or crown
made of wheat stalks. The cult of Ceres and her daughter Proserpina,
the young chaste maiden and mature fertile mother, encouraged the
virtues of fertility and chastity.[32] So, in evoking Ceres, Lady Russell was
able to combine allusions to the virtue of chastity in upper-class
women and simultaneously demonstrate the fertility of the land in the
plenty of the Bisham corn harvest.

Lady Russell was successful in her campaign to place her daughters
at Court and they were finally made maids of honour to the Queen in
1597, with the intervention of Lord Burghley. She was successful, too,
in arranging a good marriage for Anne, who, on 16 June 1600, married
Henry Somerset, Lord Herbert and heir of the Earl of Worcester.[33] The
Queen herself attended, carried aloft to the wedding at St Martin's
Ludgate in a 'curious chair' provided by Lord Cobham, her floral

canopy of estate carried by courtiers, as shown in the Procession Picture (Figure 68).[34]

An equally common device to using figures from Classical mythology was the use of rustics in rural masques. When the Queen visited Lord and Lady Chandos at Sudeley Castle in Gloucestershire (Figure 69) for three days in September 1592, actors dressed as shepherds greeted her, calling her 'the Worldes Wonder, that leades England into every land, and brings all lands into England'.[35] 'An olde Shepheard' gave her a lock of white wool, representing her as the Virgin Queen, and described to her the hills and valleys of the Cotswolds:

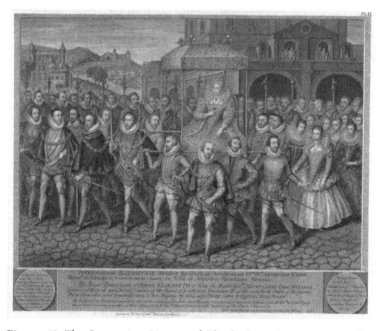

Figure 68 The Procession Picture of Elizabeth I, *George Vertue after Robert Peake the Elder, c.1601. Elizabeth is borne aloft beneath her canopy of estate, embroidered with flowers, carried on the shoulders of her courtiers. The event is the marriage of Henry Somerset, Lord Herbert and Lady Anne Russell on 16 June 1600. The bride, in white, follows the Queen.*

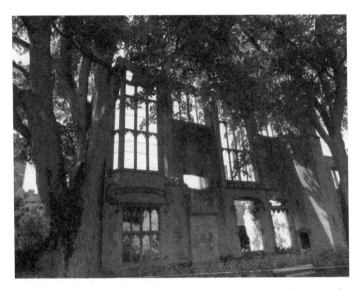

Figure 69 *The ruins of the Presence Chamber, Sudeley Castle, Gloucestershire, where the Queen stayed on three occasions. The royal apartments on the upper floor overlooked the gardens.*

Your Highnes is come into Cotshold, an uneven country [. . .] These hills afoorde nothing but cottages, and nothing we can present to your Highnes but Shephards. The country healthy and harmeles; a fresh aier, where there are no dampes, and where a black sheep is a perilous beast [. . .] This lock of wooll, Cotsholdes best fruite, and my poore gifte, I offer to your Highnes; in which nothing is to be esteemed, but the whiteness, Virginitie's colour; nor to be expected but duetye, Shephard's Religion.[36]

This greeting by shepherds both emphasizes the area's importance for wool production and conforms to pastoral conventions in the mould of *Arcadia*. Cotswolds' inhabitants are humble and respectful, but loyal to the Queen – perfect subjects. The form may be less literary than the use of deities, but the greeting no less sets the host's agenda and is equally scripted.

Entertainments

What pageantry, what feats, what shows,
What minstrelsy, and pretty din.

WILLIAM SHAKESPEARE, *Pericles*, 5.1.

Like first greetings of the Queen, principal entertainments during her stay offered many different spectacles, making full use of the gardens, lakes and groves of her hosts. So at Kenilworth in 1575, when Leicester was still trying to win the hand of the Queen, he used the landscape around the castle to create a magical world of legend. At her arrival Elizabeth encountered the Lady of the Lake, who acknowledged: 'The Lake, the Lodge, the Lord, are yours for to command.'[37] The pageant on the lake involved more mythological characters, including Triton 'in likenesse of a mermaid' and Protheus, sitting on the back of a dolphin, 'within the which dolphyn a consort of musicke was secretely placed'.[38] The Heron House was used to represent the Lady of the Lake's castle.

By contrast, the entertainment offered by Leicester at Wanstead in Essex, three years later, was on a relatively modest scale. Leicester had leased Wanstead House from Lord Rich in 1576–7, and purchased it in 1578.[39] In the same year, he bought around thirty pictures, most of them for the newly acquired Wanstead, probably towards the entertainment of the Queen there.[40] The portrait of Elizabeth by Marcus Gheeraerts the Elder, reputed to show the garden at Wanstead in the background, was painted around 1580 (Plate 40). For the Queen's visit in May 1578, Leicester's nephew, Philip Sidney, composed his first known literary work, a masque called *The Lady of May*. The text describes how: 'Her most excellent Majesty walking in Wanstead Garden, as she passed down into the grove, there came suddenly among the train one apparelled like an honest man's wife of the country.'[41] This juxtaposition of garden and grove – a similar

arrangement to Gorhambury and Holdenby – allowed the masquers to make use of the wider landscape beyond the confines of the formal garden. It is an entertainment rooted in its garden setting but populated with rustics, not deities.

The country lady who approaches the Queen as she walks through the garden explains that she has only one daughter, the Lady of May, who has two suitors, 'both equally liked of her, both striving to deserve her'.[42] She asks the Queen to choose between the two. The Lady of May, kneeling before the Queen, tells her own story:

> Do not think, sweet and gallant lady, that I do abase myself thus much unto you because of your gay apparel; for what is so brave as the natural beauty of flowers? nor because a certain gentleman hereby seeks to do you all the honour he can in his house; that is not the matter; he is but our neighbour, and these be our own groves.[43]

The 'gay apparel' with the 'natural beauty of flowers' describes what the Queen is shown as wearing in the Wanstead Portrait. This is perhaps a reference to the Roman festival of Floralia, dedicated to Flora, goddess of flowers and the season of spring. The festival was held at the beginning of May, and women were permitted to wear normally forbidden gay costumes. The 'certain gentleman hereby' is Leicester, and the Lady of May calls the Queen 'the beautifullest lady these woods have ever received'.[44] She introduces Therion, the forester, who is livelier and steals her venison but who has violent rages, and Espilus, the shepherd, richer, mild and innocent. Therion may be Leicester, and Espilus may represent Sir Christopher Hatton (Plate 41), two suitors of Elizabeth. Therion comes from the Greek meaning 'wild beast', which relates to Leicester's badge of a bear, and Espilus comes from the Greek meaning 'felt-presser', hence one who handles wool, which is a description of a hatter, alluding to Hatton. Leicester, called Master Robert of Wanstead, seeks to pledge his loyalty and devotion to the

Queen through the device of the masque. Espilus and Therion sing their parts to music. But the Queen chooses Espilus/Hatton, and the entertainment then ends with the conceit that the Lady of May hopes the flourishing of May will long represent the Queen's life.

Sir Henry Lee used the landscape at Woodstock in Oxfordshire for the entertainment of the Queen in 1575 and again in 1592. Woodstock remained a royal palace, and Lee, whose own house at Ditchley was only 4 miles away, was Keeper of Woodstock and therefore responsible for Elizabeth's entertainment there. In 1575, a few weeks after the Kenilworth shows, the Queen spent over a month in residence at Woodstock, from late August until early October. At that time, Lee was at an early stage in his career in royal service, and the entertainments – relatively low key compared with Kenilworth and for which he had only two weeks' notice – sought to impress the Queen with his loyalty and chivalry. He was also, of course, entertaining her in her own house. Lee made much use of the park and gardens for her amusements, creating masques that involved the oak trees, many of which still remain.

Here, for the first time, the Queen of England met her own alter ego, the Fairy Queen, face to face. The Fairy Queen rules over a landscape of mediaeval romance, inhabited by hermits, knights and princesses. She arrived with six children in a 'wagon of state', and addressed Elizabeth with verses while the Queen banqueted high in the treehouse in the park, and musicians played in a chamber beneath:

> As I did roame abroade in wooddy range,
> In shade to shun the heate of Sunny day:
> I met a sorrowing knight in passion strange
> by whom I learned, that coasting on this way
> I should ere long your highnesse here espie,
> To whom who beares a greater love than I.[45]

Elizabeth visited Woodstock again in September, 1592 and during that time made a brief visit to Lee's house at Ditchley.[46] The painting of the Queen known as the 'Ditchley Portrait', by Marcus Gheeraerts the Younger, was commissioned by Lee for her visit (Plate 6). It shows Elizabeth standing on a globe of the world, on the map of England, with her feet on Oxfordshire. The stormy sky with the clouds parting to reveal sunshine and the inscriptions on the painting, make it plain that the portrait's symbolic theme is forgiveness. It probably commemorates the elaborate symbolic entertainments that Lee organized for the Queen's visit to Ditchley, which had a very autobiographical flavour. Lee had retired as Queen's Champion in 1590 and was living with his mistress, Anne Vavasour, formerly a maid of honour who had been disgraced and imprisoned ten years earlier for having the illegitimate child of the Earl of Oxford. Though there is little evidence that Lee was out of favour because of this relationship, he made this 'fault' the main part of the first day's entertainment, thereby putting the Queen in a magnanimous light: she could have exacted revenge for his misalliance but was twice as glorious for disdaining to do so.[47]

Lee created a place of romance for Elizabeth, who lived, during her visit, among knights, fairies, hermits and shepherds who immersed her in an alternative reality.[48] These entertainments took place outside, for the record describes the first speech by 'the knight that had charge of the grove', who must have stopped the Queen as she approached it. He warns her against entering, which 'yealds nothinge els but syghes & mornfull songes/ of hopeless people by their haples tryall'.[49] Reference is again made to the Fairy Queen, who has turned the knights into trees, the ladies into leaves, and cast the olde Knighte into 'a deadlie sleepe'.[50] But the Fairy Queen refuses to be daunted by the warnings and it is her constancy that enables her to pass through in safety and free the sleeping knight.

The first three books of Spenser's *Faerie Queene* were published in 1590, and the association of Elizabeth with the Fairy Queen retained currency at Court. In the Ditchley entertainment, this is followed by 'The olde Knightes Tale', in which the Queen is addressed as 'O mortall substance of immortall glorie', and reference is made to the story begun at Woodstock in 1575:

> Not far from hence, nor very long agoe,
> The fayrie Queene the fayrest Queene saluted
> That ever lyved (& ever may shee soe);
> What sportes and plaies, whose fame is largelie bruted.[51]

The Queen enters the enchanted grove to find Lee, the 'olde Knighte', in a spellbound sleep or trance, having been punished by the Fairy Queen for failing to look after enchanted pictures entrusted to his care. Lee, unlike Leicester, knows that he cannot attain the Queen whom he loves. The Old Knight is overtaken by 'a stranger ladies thrall',[52] a reference to Lee's relationship with Anne Vavasour.

On the final day's entertainment, in a continuation of the story from Woodstock seventeen years earlier, Lee played the part of Loricus, the custodian of the Crowned Pillar, who is dying. The Queen performs a miracle, and restores him to health. In his 'Legacye', Lee encompasses an entire Elizabethan landscape for her pleasure, transforming Ditchley into 'The Manor of Love':

> The Legacye.
> Item. I bequethe (to your Highnes) THE WHOLE MANNOR
> OF LOVE, and the appurtenaunces thereunto belonging:
> (Viz.) Woodes of hie attempts,
> Groves of humble service,
> Meddowes of greene thoughtes,
> Pastures of feeding fancies,
> Arrable Lande of large promises,

Rivers of ebbing & flowing favours,

Gardens hedged about with private, for succorie, & bordered with
 tyme:

Of greene nothing but hartesease, drawen in the perfect forme of a
 true lovers knott.[53]

The entertainments at Woodstock and Ditchley both featured a place
out of romance rather than the real world, in which the Queen herself
is a figure of romance. This is perhaps appropriate for Sir Henry Lee
as the Queen's Champion and organizer of the Accession Day
tournaments, in which knights donned elaborate costumes and
assumed heroic characters. The estate is privileged over the outside
world, and Lee creates a fairy tale sealed off from its surroundings.[54]

Hunting and coursing

Over hill, over dale,

Thorough bush, thorough brier,

Over park, over pale.

 WILLIAM SHAKESPEARE, *A Midsummer Night's Dream*, 2.1.

Hunting was a very popular sport for the elite of Elizabethan England,
and a frequent form of entertainment for the Queen and Court on
progress, which by definition made use of the wider landscape. Most
large country estates would have had a hunting park, enclosed with
pales and stocked with deer. Parks are shown on maps of the period as
enclosed with pales, and the map of the Earl of Southampton's park at
Titchfield in Hampshire also shows the dog kennels (Figure 70).
Wealthy Elizabethans saw a park as complementary to their
magnificent houses and gardens and, because it was very expensive to
keep the requisite horses, dogs and servants, it was a good

Figure 70 *A detail from a Map of Titchfield, Hampshire, 1610. The park is enclosed by wooden pales and there are dog kennels near the chain of fish ponds.*

advertisement of wealth and status. Deer parks were an important element of the wider landscape, and they were used just as much as gardens for entertainment (Figure 71). During the Queen's stay of almost three weeks at Kenilworth in July 1575 there were at least three days which included 'a great hunting'.[55] Kenilworth park had bowers as well as arbours and seats, and Laneham described it:

> A goodlie Chase: wast, wyde, large and full of red Deer and other statelie gamez for hunting: beautified with manie delectabl, fresh & vmbragioous Boow[r]z, Arberz, Seatz, and walks, that with great art, cost, & diligens wear very pleazauntly appointed.[56]

When the Queen visited Cowdray in August 1591 her host, Viscount Montague, used the pleasures of hunting to entertain her and she was celebrated as Diana, goddess of the hunt. Early on the Monday morning of her 6-day stay she 'took horse with all her Traine, and rode into the Parke: where was a delicate Bowre prepared, under which

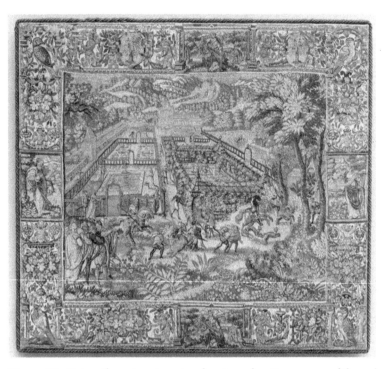

Figure 71 *Sixteenth century tapestry showing a hunting scene and formal gardens. The hunters are on horseback, accompanied by dogs.*

were placed her Highnes Musitians'.[57] There, she was presented with a bow and the musicians sang to her, while she shot at the deer:

> Goddesse and Monarch of his [t]his happie Ile,
> vouchsafe this bow which is an huntresse part
> Your eies are arrows though they seeme to smile
> which never glanst but gald the stateliest hart,
> Strike one, strike all, for none at all can flie,
> They gaze you in the face although they die.[58]

Although the association of Elizabeth with the chaste Diana was used as part of her complex cultural imagery from early in her reign, symbolic of her virginal power, the practical use of this image in a

hunting pageant allowed Montague both to pay her courtly compliment and at the same time to offer her one of her favourite pastimes.

The perception of hunting as entertainment meant that buildings called 'standings' were often constructed in parks, as places from which to view the sport. Sometimes these were large, permanent structures, such as those at Petworth, Sussex and Bisham. Neither of these remains, although they are illustrated on old maps. The hunting tower at Chatsworth, built in the 1580s, four storeys high, and the lodge at Newark Park in Gloucestershire, built around 1554, were constructed of stone and do survive. However, most early standings were built of timber, such as that in Epping Forest, built in 1543 and now called Queen Elizabeth's Hunting Lodge.[59]

Other standings were purely temporary, as was the case at Cowdray. Such buildings were often covered with green boughs, for the double purpose of shading the company from the heat of the sun and for protection in case of foul weather. The standing illustrated in George Gascoigne's *The Noble Arte of Venerie* is an open-topped wooden platform, raised above the ground (Figure 72). Before the hunt, it was customary to present the hart's fewmets (droppings) to the Queen on a bed of leaves for her examination, the moistness of the fewmets indicating the quality of the venison. It was then for the Queen to choose which hart to hunt.[60] At other times the entertainment took the form of hunting on horseback. Gascoigne illustrates how, once she had selected her hart, the Queen was entreated to mount her horse and to pursue the deer:

> So that voutsafe, (O noble Queene) with speede,
> To mount on horse, that others may ensue,
> Untill this Hart be rowzde and brought to view.[61]

Another variant on hunting as entertainment and spectacle was coursing, in which deer were pursued by dogs and brought down in front of spectators. At Cowdray, the Queen 'aboute six of the clocke

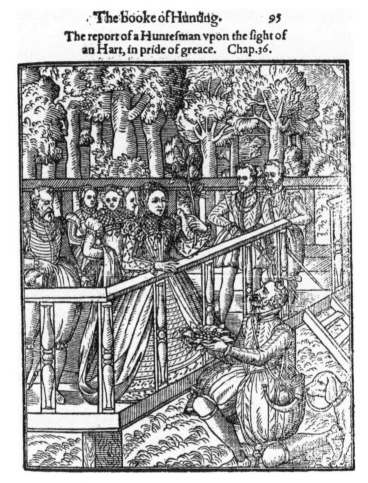

Figure 72 *'The report of a Huntesman', from George Gascoigne,* The Noble Arte of Venerie, *1577. The huntsman, kneeling before the Queen, presents her with the hart's fewmets on a bed of leaves.*

in the evening from a Turret sawe sixteene Buckes (all having fayre lawe) pulled downe with Greyhoundes in a laund'.[62] 'Laund' means the same as a lawn, in the sense of a plain extended between woods.[63] Similarly at Wilton in 1574, 'after dinner the rayne ceased for a while, during which tyme many deare coursed with greyhounds were

overturned; soe, as the tyme served, great pleasure was shewed' and 'her Majesty was boeth merry and pleasant'.[64]

Wild fowl and small game could also be hunted with a hawk. The expense of falconry made the sport a symbol of high status, loved by Elizabeth as much as hunting with dogs (Figure 73). The art of training and flying hawks to catch other birds was a pastime generally followed

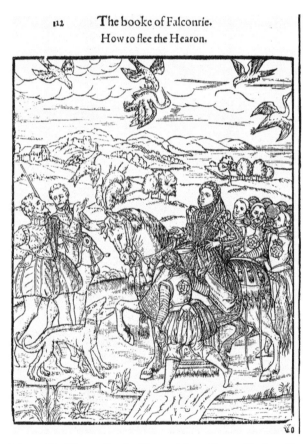

Figure 73 *'How to flee the Hearon', from George Turberville, The Booke of Faulconrie or Hawking, 1575. The Queen enjoyed the high-status sport of falconry as much as other forms of hunting. She is shown on horseback surrounded by her courtiers, watching as hawks swoop on a heron.*

by the nobility in England and on the continent. The birds were considered as ensigns of nobility and no action could be reckoned more dishonourable to a man of rank than to give up his hawk.[65] Ladies not only accompanied gentlemen in hawking but often practised it by themselves.[66]

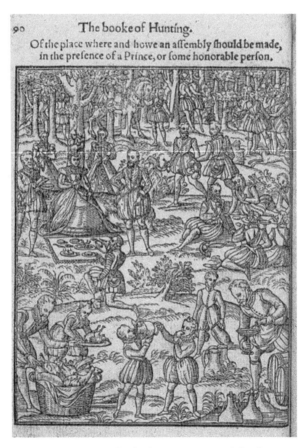

Figure 74 *Queen Elizabeth at a picnic whilst hunting, Gascoigne's* The Noble Arte of Venerie, *1577. The Queen sits on a 'grassye banke' under the shade of a tree, attended by members of her court. Gascoigne recommends careful selection of the location, to offer 'fresh and fragrant flowers' and 'sweetest singing byrdes'.*

After the hunt there was often a picnic as part of the entertainment (Figure 74). In *The Noble Arte of Venerie*, written in the same year as the Kenilworth visit (in which he took part), Gascoigne describes the selection of a suitable place:

This place must of it selfe, afforde such sweete delight,
And eke such shewe, as better may content the greedie sight:
Where sundry sorts of hewes, which growe vpon the ground,
May seeme (indeede) such Tapystry, as we (by arte) have found.
Where fresh and fragrant flowers, may skorne the courtiers cost,
Which daubes himselfe with Syvet, Muske, and many an
 oyntment lost.
Where sweetest singing byrdes, may make such melodye,
As *Pan,* nor yet *Apollos* arte, can sounde such harmonye.[67]

This careful choice of a location for a hunting picnic, with consideration of fragrant flowers and birdsong, reflects the Elizabethan appreciation of sensory satisfaction, in the wider parkland landscape as well as in enclosed gardens.

Farewell

O come againe, world's star-bright eye,
Whose presence doth adorne the skie.
O come againe, sweet beauties Sunne:
When thou art gone, our joys are done.

> *The Honorable Entertainment gieven to the Quene's*
> *Majestie, in Progresse, at Elvetham in Hampshire, by*
> *the Right Hon'ble the Earle of Hertford,* 1591.[68]

The final part of the ceremonial events on every progress visit – and an essential element of the etiquette of the entire occasion – was the

Farewell. It is clear that a sorry departure was equally as important to contrive as a gladsome welcome. At the Queen's departure from Harefield in 1602, a character called Place was 'attyred in black mourning apparrell', and the speech conveys many of the elements of a formal farewell:

> I am this Place, which at your comming was full of joy; but now at your departure am as full of sorrow. I was then, for my comfort, accompanied with the present cheerful Time; but now he is to depart with you; and, blessed as he is, must ever fly before you [. . .] I could wish myself like the inchaunted Castle of love, to hould you here for ever.[69]

The Queen spent one night at Chiswick, on 28–9 July 1602, where she visited Sir William Russell. The speeches for the occasion were written by John Lyly, and fulsomely express the grief and sadness of her departure:

> Here is the World now, when you are gone there is none. My Master yt yesternight was amazed with Joy is now with greef astonished. In his Judgment hee foretold his fortunes, that Happines would light on him like lightning, a flash & a farewell [. . .] that a Night would seem to you a yeare of wearysommnes, though a yeare for your abode would have been to him shorter than a night.[70]

The same elements of praise and purported sadness can be seen upon the Queen's departure from Elvetham in September 1591, which had undoubtedly been a success. Here the Farewell, like the greeting, was conveyed as Elizabeth made her way across the landscape:

> It was a most extreame rain, and yet it pleased hir Majesty to behold and hear the whole action. On the one side of her way, as she passed through the parke, there was placed, sitting on the Pond side,

Nereus and all the sea-gods [. . .] and on her left hand Sylvanus and his company: in the way before her, the three Graces, and the three Howres: all of them on everie side wringing their hands, and shewing signe of sorrow for her departure, he being attired as at the first, saving that his cloak was now black, and his garland mixed with ugh branches, to signify sorrow.[71]

After this, as she passed through the park gate, there was 'a consort of musicions hidden in a bower' who sang a little ditty called 'Come againe'.[72] Apparently 'Her Majestie was so highly pleased with this and the rest, that she openly said to the Earle of Hertford, that the beginning, processe and end of his entertainment, was so honorable, she would not forget the same'.[73] As Elvetham well illustrates, Farewells were no less effective than greetings in the praises of the Queen, lamenting the sad departure of a very welcome guest.

For the Farewell at the end of Elizabeth's sojourn at Kenilworth in 1575, the parting speeches were given as she was still hunting in the park: 'The Queenes Majestie hasting her departure from thence, the Earle commanded Master Gascoigne to devise some farewel worth the presenting.'[74] In the masque, Gascoigne himself played the part of Sylvanus, god of the woods, professing himself to have charge of the woods and wilderness:

Your Majesty being so highly esteemed, so entirely beloved, and so largely endued by the Celestial Powers [. . .] what joy and comfort conceived in your presence, and what sorrowe and greef sustained by likelihoode of your absence [. . .] since you first arrived in these coastes.[75]

Sylvanus then led the Queen into a grove, where 'diverse of her most earnest and faithfull followers have bin converted into sundrie of these plants'.[76] In the ensuing masque she is given the role of Zabeta,

who has punished her courtiers and transformed them into trees, a reference to Ovid's *Metamorphoses*:

Behold, gracious Lady, this old Oke; the same was many years a faithfull follower and trustie servant of hers named *Constance* [. . .] a strange and cruel metamorphosis [. . .] she converted his contrarie *Inconstancie* into yonder Popler, whose leaves move and shake with the least breathe or blast [. . .] also shee dressed *Vaineglory* in his right colours, converting him into this Ash-tree, which is the first of my plants that buddeth and the first likewise that casteth leaf [. . .] Vaineglory may well begin hastily, but seldom continueth long [. . .] Againe, she hath well requited that busie elfe *Contention* whom she turned into this Bramble Bryer [. . .] And as for that wicked wretch *Ambition,* she dyd by good right condemn him into this braunch of Ivy, the which can never clyme on high nor flourish without the helpe of some other plant or tree.[77]

Acknowledging that these punishments are justified, Sylvanus explains that there are two remaining metamorphoses, for which he asks her compassion. These are for 'two sworne brethren, which long time served hyr', called Deepedesire and Dewedesert, the personas of Leicester and Gascoigne, who have been turned into a holly bush and a laurel tree.

The closing moments of Sylvanus' farewell bring the Queen to the holly bush, which masquerades as the transformed Deepedesire. This part may have been taken by Leicester himself, who is so clearly represented by his deep desire for the hand of the Queen. Sylvanus explains that Zabeta had 'caused him to be turned into this Hollybush; and as he was in this life and worlde, continually full of compunctions, so he is now furnished on every side with sharpe pricking leaves, to prove the restlesse prickes of his privie thoughts'.[78] The account continues:

At these words her Majestie came by a close arbor, made all of Hollie; and while Sylvanus pointed to the same, the principal bush shaked. For therein were placed both strange musicke, and one who was there appointed to represent Deepedesire.[79]

So Leicester, as Deepedesire, spoke his parting words to her from the holly bush:

Vouchsafe, O comely Queene, yet longer to remaine,
Or still to dwell among us here! O Queene commaunde againe
This Castle and the Knight, which keeps the same for you;
These woods, these waves, these foules, these fishes, these deere
 which are your due!
Live here, good Queene, live here; you are amongst your friends;
Their comfort comes when you approach, and when you part it
ends.[80]

Then 'the consort of musicke sounded' and Deepedesire sang a parting song, to lament her departure. And so the visit ended, as it began, with an encounter in the landscape, poetry and Ovidian allusions, mingled with praise of the Virgin Queen.

8

Afterword

Royall Astraea makes our day
Eternall with her beames, nor may
Grosse darkenesse overcome her;
I now perceive why some doe write,
No countrie hath so short a night,
As England hath in sommer.

SIR JOHN DAVIES, 'Hymn VI, To the Nightingale', in
Hymnes of Astraea in acrosticke verse, 1599, v.3.

Queen Elizabeth continued to make summer progresses throughout
her life, enjoying the houses and gardens of her hosts. Even in the
later years of her reign, despite her age, she remained determined
to continue making such extended tours. A letter from Sir Charles
Danvers to the Earl of Southampton in 1599 illustrates her resolve:

> The progress was first appointed to Wimbleton, to my Lord Keeper's
> at Parford, to my Lord Treasurer's at Horsley, to Otelands, and so to
> Windsor, but by reason of an intercepted letter, wherein the giving
> over of long voyages was noted to be sign of age, it hath been
> resolved to extend the progress to Basing and so to Wilton, and
> unto Wimbleton the Queen goes on Tuesday next.[1]

Although in practice she did not visit Wilton that year, the intention was clear. In 1602, the year before her death, Elizabeth relinquished her plans for a last progress to Bristol when bad weather deterred the Court from travel, but still insisted on a final progress to Surrey.[2]

In total, during her 45-year reign, the Queen visited more than 400 hosts.[3] Her love of spending time out of doors in the garden remained with her until her last days (Figure 75). Just a fortnight before her

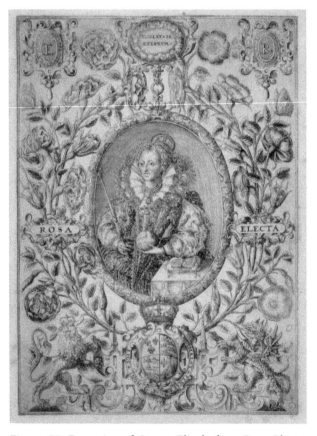

Figure 75 *Engraving of Queen Elizabeth as* Rosa Electa, *William Rogers, c.1590–1600. This illustration of the Queen in her later years shows her surrounded by a border of roses reflecting her enduring association with the flower.*

death, at Richmond Palace on 24 March 1603, at the beginning of her final illness, Sir Robert Cecil wrote:

> I must confess to you that she hath been so ill disposed as I am fearful that the continuance of such accidents should bring her Majesty to future weakness and danger of that I hope mine eyes shall never see. Although she hath good appetite, and neither cough nor fever, yet she is troubled with a heat in her breasts and dries in her mouth and tongue, which keeps her from sleep, greatly to her disquiet. This is all, whatsoever you hear otherwise. She never kept her bed, but was, within these three days, in the garden.[4]

After the Queen's death, Thomas Newton wrote a poetical discourse, *Atropoïon Delion, or, The death of Delia with the teares of her funerall*, which expresses the pleasure of the gardens at the river palaces of Whitehall, Greenwich and Richmond:

> If any place of pleasure or delight,
> As Garden, Mount, or Vale, by River's side,
> Had fed her vitall spirits, with their sight;
> Then would not I have moorn'd, nor *Delia* di'de.
> The whitest seat I had, my *Delia* had it.
> The greenest Palace of my brest's support,
> The richest Mount (the richest hands had made it)
> Was hers, where she did lastly keepe her Court.[5]

With the Queen's death, the Golden Age of Gloriana had reached its end. As Sir Roy Strong expresses it: 'The image of the garden as Gloriana's glass was shortly to be destroyed.'[6] But the association of Elizabeth with gardens remained a part of her memorial vocabulary. *Eliza's Funerall* by Henry Petowe begins:

Then withered the Primrose of delight,
Hanging the head o're Sorowes garden wall:
When you might see all pleasures shun the light,
And live obscuer at *Eliza's* fall.
Her fall from life to death, oh stay not there!
Thogh she were dead, the shriltong'd trump of heaven
Rais'd her againe, think that you see her heere:
Even heere, oh where? not heere, shee's hence bereaven
For sweet *Eliza* in *Elizium* lives,
In ioy beyond all thought. Then weepe no more,
Your sighing weedes put off, for weeping gives
(Wayling her losse) as seeming to deplore
Our future toward fortunes, morne not then:
You cease a while but now you weepe agen.[7]

Elizabeth was, after all, Queen of England by Divine Right. And her device was a golden rose.

Notes

Epigraph

1 Edmund Spenser, *The Faerie Queene Disposed into twelve books, Fashioning XII. Morall vertues* (London, 1596), II, x, 76, 6–9.

Chapter 1 Introduction

1 Sir John Davies, *Hymnes of Astraea in acrosticke verse* (London, 1599), 'Hymne IX, To Flora' v. I.

2 Henry James, *Selected Letters*, ed. Leon Edel (Cambridge, MA and London, 1987), 31.

3 Thomas Dekker, *The Pleasant Comedie of Old Fortunatus* [. . .] (London, 1600), The Prologue at Court, 1–4.

4 John Gerard, *The Herball or Generall Historie of Plantes. Gathered by Iohn Gerarde of London Master in Chirurgerie* (London, 1597), 'To the courteous and well-willing Readers'.

5 Thomas Hoby, *The Travels and Life of Sir Thomas Hoby, Kt. of Bisham Abbey, written by Himself: 1547–1564*, ed. Edgar Powell (London, 1902), xi.

6 'Venice: May 1557, 11–15', *Calendar of State Papers Relating to English Affairs in the Archives of Venice and other Libraries of Northern Italy, Volume 6: 1555–1558*, ed. Rawdon Brown (London, 1877), 1041–95.

7 Edmund Spenser, *The Faerie Queene Disposed into twelve books, Fashioning XII. Morall vertues* (London, 1590), The Letter to Raleigh.

8 Ibid., I, i, 3, lines 2–3.

9 Ibid., VI, x, 28, lines 1–3.

10 William Howard Adams, *The French Garden 1500–1800* (New York, 1979), 10.

11 Charles VIII, *Lettres de Charles VIII*, ed. Paul Pelissier, Vol. IV (Paris, 1903), 187–8. Trans. author from original: *Vous ne pourriez croire les beaulx jardins que j'ay eu en cette ville, car, sur ma foy, il semble qu'il n'y faille que Adam et Eve pour en faire ung paradis terrestre, tant ils sont beaulx et plains de toutes bonnes et singulières choses, comme j'espère vous en compter dès que je vous voye. Et avecques ce j'ay trouvé en ce pays des meilleurs paintres, et auxdits vous envoyerés pour faire aussi beaulx planchiers qu'il est possible, et ne sont les planchiers de Bauxe, de Lyon et d'autres lieux de France en rien approchans de beaulté et richesses ceux d'icy. Pourquoy je m'en fourniray et les mèneray avecques moi pour en faire à Amboise.*

12 André de La Vigne and Octavien de Saint-Gelais, *Le Vergier d'honneur* [. . .] (Paris, *c*.1512), n.p.

13 Dominique de La Tour, 'Castle of Kings', in *Château d'Amboise* (Paris, 2006), 28.

14 Jonathan Woolfson, *Padua and the Tudors: English Students in Italy 1485–1603* (Cambridge, 1998), 16–17.

15 William Camden, *Annales: The True and Royall History of the famous Empresse Elizabeth Queene of England France and Ireland &c.* [. . .] *are exactly described* (London, 1625), 378.

16 David Starkey, *Elizabeth* (London, 2001), 12.

17 Holinshed, *The third volume of Chronicles* [. . .] (London, 1587), 850.

18 Simon Thurley, *The Royal Palaces of Tudor England: Architecture and Court Life 1460–1547* (New Haven, CT and London, 1993), 1, 50, 68.

19 Ibid., 1.

20 Edmund Spenser, *The Shepheardes Calender Conteyning twelue aeglogues proportionable to the twelue monethes. Entitled to the noble and vertuous Gentleman most worthy of all titles both of learning and chevalrie M. Philip Sidney.* (London, 1579), Aprill.v.12.

21 Sir Philip Sidney, *The Countess of Pembroke's Arcadia: (The Old Arcadia)*, ed. Katherine Duncan-Jones (Oxford, 2008), 131.

Chapter 2 Knot gardens, mazes and arbours

1 Barnabe Barnes, *Parthenophil and Parthenophe Sonnettes, madrigals, elegies and odes* (London, 1593), Sonnet XXVII.

2 John Gerard, *The Herbal or General History of Plants: The Complete 1633 Edition as Revised and Enlarged by Thomas Johnson* (New York, 1975), 597.

3 Ibid., 599.

4 Thomas Hill, *The Gardeners Labyrinth [. . .]* (London, 1577), 24.

5 Francis Bacon, 'Of Gardens', in *The Essays*, ed. John Pitcher (London, 1985), 199.

6 Jonathan Woolfson, *Padua and the Tudors: English Students in Italy 1485–1603* (Cambridge, 1998), 246.

7 Gary Bell, 'Hoby, Sir Philip (1504/5–1558)', *Oxford Dictionary of National Biography* (London, 2004), online edn. Jan 2008, www.oxforddnb.com/view/article/13413 (accessed 28 April 2017).

8 Thomas Hoby, *The Travels and Life of Sir Thomas Hoby, Kt. Of Bisham Abbey, written by Himself: 1547–1564*, ed. Edgar Powell (London, 1902), 127.

9 Victoria Leatham, Jon Culverhouse and Eric Till, *Burghley* (Ketteringham, 2010), 9.

10 Marie Loughlin, Sandra J. Bell and Patricia Brace, eds, *The Broadview Anthology of Sixteenth Century Poetry and Prose* (Peterborough, ON, 2012), 169.

11 Ibid.

12 Hoby, *The Travels*, 129.

13 Ibid.

14 Paula Henderson, *The Tudor House and Garden* (New Haven, CT and London, 2009), 26–8.

15 Mary Hill Cole, *The Portable Queen: Elizabeth I and the Politics of Ceremony* (Amherst, MA, 1999), 209–10.

16 Mark Girouard, *Elizabethan Architecture: Its Rise and Fall, 1540–1640* (New Haven, CT and London, 2009), 190.

17 Martin Andrews, 'Theobalds Palace: The Gardens and Park', *Garden History*, Vol.21, No.2 (Winter, 1993), 129–49 (130, 135).

18 The National Archives, Kew: E317/Herts/26.

19 Gervase Markham, *The English Husbandman [. . .]* (London, 1613), Chapter XVI.

20 Thomas Fale, *Horologiographia The art of dialling [. . .]* (London, 1593), 1.

21 Hill, *The Gardeners Labyrinth*, 24.

22 Markham, *The English Husbandman*, Chapter XVI.

23 Robert Laneham, *Robert Laneham's Letter: Describing a part of the Entertainment unto Queen Elizabeth at the Castle of Kenilworth in 1575*, ed. F.J. Furnivall (London, 1907), 50.

24 Ibid.

25 Ibid.

26 Hill, *The Gardeners Labyrinth*, Table of chapters.

27 Markham, *The English Husbandman*, Chapter XVII.

28 Francesco Colonna, *Hypnerotomachia Poliphili: The Strife of Love in a Dream* (1499), trans. Joscelyn Godwin (London, 1999; repr. 2005), 318.

29 John Cloake, *Palaces and Parks of Richmond and Kew, Volume I (The Palaces of Shene and Richmond)* (Chichester, 1995), 61.

30 Colonna, *Hypnerotomachia Poliphili*, 318–19.

31 Ibid., 319.

32 Ibid., 320–1.

33 Ibid., 321.

34 Ibid., 323.

35 William Camden, *Remaines of a Greater Worke, concerning Britaine [. . .]* (London, 1605), 158.

36 Markham, *The English Husbandman*, Chapter XVII.

37 Ibid.

38 John Lyly, *Campaspe, played before the Queenes Maiestie on Newyeares day at night, by her Maiesties children and the children of Paules* (London, 1584), III, iv.

39 Markham, *The English Husbandman*, Chapter XVII.

40 Ibid.

41 Nicholas Breton, 'A strange description of a rare Garden plot', in R.S. of the Inner Temple, *The Phoenix Nest [. . .]* (London, 1593).

42 Robin Whalley and Anne Jennings, *Knot Gardens and Parterres: A History of the Knot Garden* (London, 1998; repr. 2008), 38, 40.

43 Rembert Dodoens, *A Niewe Herball, Or Historie of Plantes [. . .]*, trans. Henry Lyte (London, 1578), 699.

44 Thomas Hill, *A most briefe and pleasaunte treatise [. . .]* (London, [1558?]).

45 Thomas Hill, *The Arte of Gardening [. . .]* (London, 1608), 15.

46 Ibid., 10.

47 Ben Jonson, *The Complete Poems*, ed. George Parfitt (London, 1988), XCIII.

48 Hill, *The Gardeners Labyrinth*, Title page.

49 Anthony Blunt, *Art and Architecture in France 1500–1700*, 4th edn (Harmondsworth, 1980), 143.

50 P.A.F. van Veen, 'Introduction', in Hans Vredeman de Vries, *Hortorum Viridariorumque elegantes et multiplices formae, ad architectonicae artis normam affabre delineatae* (Antwerp, 1587; repr. Amsterdam, 1980).

51 Anthony Watson, *Magnificae et plane regiae domus quae vulgo vocatur Nonesuch brevis et vera descriptio* (1582?) Trinity College, Cambridge, MS R.7.22, para.61, taken from Martin Biddle, 'The Gardens of Nonsuch: Sources and Dating,' *Garden History*, Vol.27, No.1 (Summer 1999), 145–83 (174).

52 Thomas Platter, *Thomas Platter's Travels in England 1599*, trans. and ed. Clare Williams (London, 1937), 197.

53 William Lawson, *A new orchard and garden [. . .]* (London, 1618), Chapter XVII.

54 Cristina Malcolmson, 'William Herbert's Gardener: Adrian Gilbert', in *George Herbert's Pastoral: New Essays on the Poet and Priest of Bemerton*, ed. Christopher Hodgkins (Cranbury, NJ, 2010), 113.

55 Ibid., 115.

56 John Taylor, *A new discouery by sea, with a vvherry from London to Salisbury. Or, a voyage to the West, the worst, or the best That e're was exprest* (London, 1623), C3.

57 Andrew Eburne, 'The Passion of Sir Thomas Tresham: New Light on the Gardens and Lodge at Lyveden', *Garden History*, Vol.36, No.1 (Spring 2008), 114–34, (123).

58 Ibid., 124.

59 Ibid., 121.

60 George Peele, *The Works of George Peele*, ed. A.H. Bullen, 2 vols (London, 1888), II, 309–10.

61 Thomas Hill, *The Gardener's Labyrinth* (1577), ed. Richard Mabey (Oxford, 1988), 45.

62 Ibid.

63 Ibid.

64 Ibid., 97.

65 Ibid., 47.

66 William Turner, *The Names of Herbes, by William Turner A.D 1548,* ed. James Britten (London, 1881; repr. Milton Keynes, 2010), 75.

67 William Turner, *A New Herball: Part II* (1562), ed. George Chapman and Marilyn Tweddle (Manchester, 1989; repr. Cambridge, 1995), 309.

68 Hill, *The Gardener's Labyrinth*, ed. Mabey, 47.

69 Bacon, 'Of Gardens', 199.

70 Hill, *The Gardener's Labyrinth,* ed. Mabey, 46–7.

71 Bacon, 'Of Gardens', 199.

Chapter 3 Fountains and water gardens

1 Edmund Spenser, *The Faerie Queene Disposed into twelve books, Fashioning XII. Morall vertues* (London, 1590), II. XII. 60.

2 Francis Bacon, 'Of Gardens', in *The Essays*, ed. John Pitcher (London, 1985), 200.

3 Sir Philip Sidney, *The Countesse of Pembrokes Arcadia, written by Sir Philippe Sidnei* (London, 1590), 10.

4 Ibid., 63.

5 Ibid., 62.

6 Thomas Hoby, *The Travels and Life of Sir Thomas Hoby, Kt. Of Bisham Abbey, written by Himself: 1547–1564*, ed. Edgar Powell (London, 1902), 129.

7 Paula Henderson, *The Tudor House and Garden* (New Haven, CT and London, 2009), 95.

8 Naomi Miller, 'Fountains as Metaphor', in *Fountains Splash and Spectacle: Water and Design from the Renaissance to the Present*, eds Marilyn Symmes and Kenneth Breitch (London, 1998), 66.

9 Hoby, *The Travels*, 45.

10 Zdeněk Brtnický z Valdštejna ('Baron Waldstein'), *The Diary of Baron Waldstein: A Traveller in Elizabethan England*, trans. G.W. Groos (London, 1981), 159.

11 Anthony Watson, *Magnificae et plane regiae domus quae vulgo vocatur Nonesuch brevis et vera descriptio* (1582?) Trinity College, Cambridge, MS R.7.22, para.61, taken from Martin Biddle, 'The Gardens of Nonsuch: Sources and Dating', *Garden History*, Vol.27, No.1 (Summer 1999), 145–83, (174).

12 Thomas Platter, *Thomas Platter's Travels in England 1599*, trans. and ed. Clare Williams (London, 1937), 191.

13 John Nichols, *The Progresses and Public Processions of Queen Elizabeth*, 3 vols (London, 1823), III, 250–1.

14 Sir John Harington, *An anatomie of the metamorpho-sed Aiax [. . .]* (London, 1596).

15 Lodovico Ariosto, *Orlando furioso in English heroical verse, by Iohn Haringto[n]* (London, 1591), XLII, 71.

16 Robert Laneham, *Robert Laneham's Letter: Describing a part of the Entertainment unto Queen Elizabeth at the Castle of Kenilworth in 1575*, ed. F.J. Furnivall (London, 1907), 52, 53.

17 Paul Hentzner, 'Travels in England', in Paul Hentzner and Robert Naunton, *Travels in England* (1612) and *Fragmenta Regalia* (1641) (London, 1892; repr. Gloucester, 2010), 14.

18 Valdštejna, *Diary of Baron Waldstein*, 83.

19 Ibid.

20 Ibid.

21 *The History of the King's Works*, ed. Howard Colvin and others, 6 vols (London, 1963–82), IV, 144.

22 Valdštejna, *Diary of Baron Waldstein*, 147.

23 Frederick, Duke of Wirtemberg, *A True and Faithfull Narrative of the Bathing Excursion [. . .]* (1602), trans. William Brenchley Rye, *in England as seen by Foreigners in the days of Elizabeth and James the First* (London, 1865), 19.

24 Colvin, ed., *The History of the King's Works*, IV, 107–8.

25 Christopher Marlowe, *Dido Queen of Carthage*, IV, v.

26 Ben Jonson, 'To Penshurst', 31–8.

27 John Norden, *Speculum Britanniae [. . .]* (London, 1593), 37.

28 Mark Girouard, *Elizabethan Architecture, Its Rise and Fall, 1540–1640* (New Haven, CT and London, 2009), 13.

29 Historic England list entry 1000228.

30 *Survey of Lands of William First Earl of Pembroke*, ed. Charles R. Straton, 2 vols (Oxford, 1909), I, lx.

31 Sidney, *The Countesse of Pembrokes Arcadia* (1590), 10.

32 Francis Bacon, *The Works of Francis Bacon,* eds James Spedding, Robert Leslie Ellis and Douglas Denon Heath, 14 vols (1868; repr. Cambridge, 2011), XI, 76.

33 Ibid., 76–7. Bacon's Pond Garden is discussed in detail in Paula Henderson, 'Sir Francis Bacon's Water Gardens at Gorhambury', *Garden History*, Vol.20 No.2 (Autumn 1992), 116–31.

34 John Aubrey, *Brief Lives,* ed. Richard Barber (Woodbridge, 1982), 30.

35 Valdštejna, *Diary of Baron Waldstein*, 87.

36 Hentzner, *Travels in England*, 22.

37 Joshua Sylvester, *Bartas: his devine weekes and workes translated: [. . .]* (London, 1605), 135.

38 J. Hanford and S. Watson, 'Personal Allegory in the Arcadia: Philisides and Laelius', *Modern Philology*, XXXII (August 1934), 1–10.

39 Katherine Butler, *Music in Elizabethan Court Politics* (Woodbridge, 2015), 116.

40 John Nichols, *The Progresses and Public Processions of Queen Elizabeth I*, eds Elizabeth Goldring and others, 5 vols (Oxford, 2014), V, 293.

41 Mary Hill Cole, *The Portable Queen: Elizabeth I and the Politics of Ceremony* (Amherst MA, 1999), 182–98.

42 www.pastscape.org.uk. NMR SP 81 NW 7.

43 Paul Everson and Sandy Kidd, 'Quarrendon: How the Elizabethans Revolutionised Garden Design', *Current Archaeology*, 218 (May 2008), 31–5 (33, 34).

44 Conrad Heresbach, *Foure bookes of husbandry [. . .] Newely Englished, and increased, by Barnabe Googe, Esquire* (London, 1577), 49.

45 Hoby, *The Travels*, 129.

46 William Lawson, *A new orchard and garden [. . .]* (London, 1618), 58.

47 Thomas Churchyard, *The worthines of Wales [. . .]* (London, 1587), B3.

48 'Cecil Papers: September 1602, 11–20', *Calendar of the Cecil Papers in Hatfield House, Volume 12: 1602–1603*, ed. R.A. Roberts (London, 1910), 366–89.

49 Hentzner, *Travels in England*, 22.

50 Laneham, *Robert Laneham's Letter*, 6–7.

51 Nichols, *The Progresses* (1823), III, 111.

52 Ibid., 110, 111.

53 Ibid., 111.

54 Ibid., 101.

55 Ibid., 108.

56 Ibid., 118.

57 Laneham, *Robert Laneham's Letter*, 2.

58 Ibid., 6.

59 Ibid., 6–7.

60 Ibid., 12.

61 Ibid., 3.

62 Ibid., 34.

63 William Shakespeare, *A Midsummer Night's Dream*, II, 1, 146–54.

64 Ibid., II, 1, 533–6.

Chapter 4 Dining *Al Fresco* and banqueting

1 Christopher Marlowe, *Hero and Leander*, Sestiad I, 85–6.

2 Curtis Charles Breight, 'Caressing the Great: Viscount Montague's Entertainment of Elizabeth at Cowdray, 1591', *Sussex Archaeological Collections*, 127 (1989), 147–66 (162).

3 Ben Jonson, *Song to Celia*, 1–8.

4 Breight, 'Caressing the Great', 162.

5 Ibid.

6 Ibid.

7 'Venice: May 1559', *Calendar of State Papers Relating to English Affairs in the Archives of Venice and other Libraries of Northern Italy, Volume 7: 1558–1580*, eds Rawdon Brown and G. Cavendish Bentinck, 38 vols (London, 1890), 79–94.

8 Ibid.

9 John Strype, *Annals of the Reformation [. . .]* 4 vols (London, 1709–31; repr. Oxford, 1824), I, Part i, 288–9.

10 John Nichols, *The Progresses and Public Processions of Queen Elizabeth*, 3 vols (London, 1823), I, 306.

11 E.K. Chambers, *The Elizabethan Stage*, 4 vols (Oxford, 1923; repr. Oxford, 1961), I, 16.

12 'The Banqueting House', *Survey of London: Volume 13: St Margaret, Westminster, Part II: Whitehall I*, eds Montague Cox and Philip Norman (London, 1930), 116–39.

13 Harleian MS. 293, f.217., in Chambers, *The Elizabethan Stage*, I, 16.

14 Ibid.

15 Harleian MS. 293, f. 217., in 'The Banqueting House', *Survey of London: Volume 13*.

16 Extract from an unpublished MS. written in 1578, in Nichols, *The Progresses*, I, 409.

17 Ibid., 524.

18 Robert Laneham, *Robert Laneham's Letter: Describing a part of the Entertainment unto Queen Elizabeth at the Castle of Kenilworth in 1575*, ed. F.J. Furnivall (London, 1907), 32–3.

19 Raphael Holinshead, *Chronicle of England, Ireland and Scotland*, as quoted in Esmé Cecil Wingfield-Stratford, *The Lords of Cobham Hall* (London, 1959), 64.

20 J.W. Cunliffe, 'The Queenes Majesties Entertainment at Woodstocke', *Proceedings of the Modern Language Association*, Vol. 26, No.1 (1911), 92–141 (97).

21 Edmund Spenser, *The Faerie Queene, The Faerie Queene Disposed into twelve books, Fashioning XII. Morall vertues* (London, 1590), II. xii. 53–5.

22 Gervase Markham, *Countrey contentments, or The English huswife [. . .]* (London, 1623), 126.

23 Ibid., 60.

24 Ibid., 60–1.

25 Ibid. 62.

26 Ibid., 63.

27 Ibid.

28 George Gascoigne, *The noble arte of venerie or hunting [. . .]* (London, 1575), The Commendation.

29 Markham, *Countrey contentments*, 126–7.

30 'The borough of Southwark: Manors', *A History of the County of Surrey: Volume 4*, ed. H.E. Malden (London, 1912), 141–51.

31 'Cecil Papers: 1551', *Calendar of the Cecil Papers in Hatfield House, Hertfordshire, Volume 1: 1306–1571*, ed. R.A. Roberts (London, 1883), 82–94.

32 Laneham, *Robert Laneham's Letter*, 32.

33 Robert Dudley, Earl of Leicester, *Household Accounts and Disbursement Books of Robert Dudley, Earl of Leicester, 1558–61, 1584–86*, ed. Simon Adams (Cambridge, 1995), 145, 146.

34 Anon., *A closet for ladies and gentlewomen. [. . .]* (London, 1608), 4–5.

35 Thomas Dekker, *The batchelars banquet [. . .]* (London, 1603).

36 Sir Hugh Plat, *Delightes for ladies [. . .]* (London, [1600?]), B2.

37 John Gerard, *The Herball or Generall historie of plantes [. . .]* (London, 1597), 1089.

38 Gervase Markham, *The English huswife [. . .]* (London, 1615), 78.

39 Anthony Munday, *A banquet of daintie conceits [. . .]* (London, 1588).

40 Anon., *A closet for ladies and gentlewomen*, 33.

41 George Puttenham, *The arte of English poesie. [. . .]* (London, 1589), 47.

42 Mark Girouard, *Elizabethan Architecture: Its Rise and Fall, 1540–1640* (New Haven, CT and London, 2009), 105.

43 David Burnett, *Longleat: The Story of an English Country House* (Wimborne Minster, 1978, repr. 2009), 38.

44 Ibid.

45 Mark Girouard, *Life in the English Country House: A Social and Architectural History* (New Haven, CT and London, 1978), 107.

46 Girouard, *Elizabethan Architecture*, 106.

47 www.pastscape.org.uk. NMR TQ 26 SW 106.

48 Anthony Watson, *Magnificae et plane regiae domus quae vulgo vocatur Nonesuch brevis et vera description* (1582?), Trinity College, Cambridge, MS R. 7.22, trans. by Martin Biddle in 'The Gardens of Nonsuch: Sources and Dating', *Garden History*, Vol.27, No.1 Tudor Gardens (Summer 1999), 145–83 (177).

49 Strype, *Annals*, I, i, 289–90.

50 Nichols, *The Progresses*, I, 75.

51 Nichols, *The Progresses*, II, 59–60.

52 Ibid., 59.

53 Zillah Dovey, *An Elizabethan Progress: The Queen's Journey into East Anglia, 1578* (Stroud, 1996), 107.

54 Ibid., 115.

55 John Craig, 'North, Roger, second Baron North (1531–1600)', *Oxford Dictionary of National Biography*, Oxford University Press, 2004, online edn. Jan 2008 www.oxforddnb.com/view/article/20312, (accessed 24 April 2017).

56 Joseph Bettey, 'Sir John Young, Dame Joan Young and the Great House in Bristol', *Transactions of the Bristol and Gloucestershire Archaeological Society*, 134 (2016), 221–30 (226).

57 Nichols, *The Progresses*, I, 400.

Chapter 5 Groves, wildernesses, mounts and grottoes

1 A.B. 'Of this Garden of the Muses', 13–14, in John Bodenham, *Bel-vedere or The Garden of the Muses* (London, 1600).

2 Ovid, *The fyrst fower bookes of P. Ouidius Nasos worke, intitled Metamorphosis, translated oute of Latin into Englishe meter by Arthur Golding Gent [. . .]* (London, 1565).

3 Ovid, *Metamorphosis*, The fyrst booke, fol.2.

4 Helen Cooper, 'Location and Meaning in Masque, Morality and Royal Entertainment', in *The Court Masque,* ed. David Linley (Manchester, 1984), 144.

5 https://www.royalcollection.org.uk/collection/403446 (accessed 1 May 2017).

6 Michael Drayton, *Idea the shepheards garland. Fashioned in nine eglogs [. . .]* (London, 1593), The Third Eglog.

7 Ibid., 68.

8 William Shakespeare, *A Midsummer Night's Dream*, II. 1.

9 Helen Estabrook Sandison, 'Introduction', in Arthur Gorges, *The Poems of Sir Arthur Gorges*, ed. Helen Estabrook Sandison (Oxford, 1953), xxix.

10 Arthur Gorges, *The Poems*, 125.

11 Lazarus Pyott, *The second booke of Amadis de Gaule [. . .]. Englished by L.P.* (London, 1595), Book II, Chapter XI.

12 Ovid, *Metamorphoses,* trans. A.D. Melville (Oxford, 1986; repr. 2008), III. 176–9.

13 Anthony Watson, *Magnificae et plane regiae domus quae vulgo vocatur Nonesuch brevis et vera description* (1582?), Trinity College, Cambridge, MS R. 7.22, trans. by Martin Biddle in 'The Gardens of Nonsuch: Sources and Dating', *Garden History*, Vol. 27, No.1, Tudor Gardens (Summer, 1999), 145–83 (176).

14 Ovid, *Metamorphoses,* III, 154–65.

15 Watson, *Magnificae*, 176.

16 Ibid., 177.

17 Zdeněk Brtnický z Valdštejna ('Baron Waldstein'), *The Diary of Baron Waldstein: A Traveller in Elizabethan England*, trans. G.W. Groos (London, 1981), 159–61.

18 Watson, *Magnificae*, 177.

19 Valdštejna, *Diary of Baron Waldstein*, 160.

20 Paul Hentzner, 'Travels in England', in Paul Hentzner and Robert Naunton, *Travels in England* (1612) *and Fragmenta Regalia*, (1641) (London, 1892; repr. Gloucester, 2010), 14.

21 John Nichols, *The Progresses and Public Processions of Queen Elizabeth*, 3 vols (London, 1823), III, 92.

22 Anon., *The speeches and honorable entertainment giuen to the Queenes Maiestie in progresse, at Cowdrey in Sussex, by the right honorable the Lord Montacute. 1591* (London, 1591), 5.

23 www.treeregister.org/pdf/Champion (accessed 15 June 2016).

24 www.pastscape.org.uk. NMR SU 92 SW 43.

25 Sylvie Nail, *Forest Policies and Social Change in England* (New York, 2008), 25.

26 Anon., *The speeches and honorable entertainment*, 6.

27 Ibid., 6, 7.

28 Ibid., 5, 6.

29 Valdštejna, *Diary of Baron Waldstein*, p. 87.

30 Anon., *The speeches and honorable entertainment*, 6, 7.

31 Ovid, *Metamorphoses,* VII, 623–5.

32 Nichols, *The Progresses*, I, 494, 502.

33 Nichols, *The Progresses*, III, 111, 114.

34 Ibid., 135, 137.

35 Ovid, *Metamorphoses,* VIII, 738–50.

36 Bruce R. Smith, 'Landscape with Figures', in *Renaissance Drama: New Series, VIII* (1977), ed. Leonard Barkan (Evanston, IL, 1977), 101.

37 Kenneth Robert Olwig, *Landscape, Nature and the Body Politic: From Britain's Renaissance to America's New World* (Madison, WI, 2002), 131.

38 Isaiah 51.3.

39 Olwig, *Landscape, Nature and the Body Politic*, 133.

40 R.O.A.M. Lyne, 'Introduction', in Virgil, *The Eclogues and the Georgics*, trans. C. Day Lewis (1963 and 1940) and ed. R.O.A.M. Lyne (Oxford, 1983; repr. 2009), xv.

41 Virgil, *Eclogue* I, 66.

42 Virgil, *Georgics* IV, 127–34.

43 Watson, *Magnificae*, 174–5.

44 Ibid., 175.

45 Ibid., 176.

46 Ibid.

47 Ibid., 175.

48 Francis Bacon, 'Of Gardens', in *The Essays*, ed. John Pitcher (London, 1985), 199.

49 Ibid., 201.

50 Nichols, *The Progresses*, II, 59.

51 William Lawson, *A new orchard and garden. [. . .]* (London, 1618), Chapter XVII.

52 Edward Hyams, *A History of Gardens and Gardening* (London, 1971), 144.

53 Roy Strong, *The Renaissance Garden in England* (London, 1979), 53.

54 Simon Thurley, *Somerset House: The Palace of England's Queens 1551–1692* (London, 2009), 98.

55 Edmund Spenser, *The Faerie Queene Disposed into twelve books, Fashioning XII. Morall vertues* (London, 1590), III, vi, 43, 44, 46.

56 Roy Strong, *The English Renaissance Miniature* (London, 1983), 110.

57 Roy Strong, *The Tudor and Stuart Monarchy: Pageantry, Painting, Iconography*. 3 vols (Woodbridge, 1995), II, 234.

58 George Peele, 'The Honour of the Garter', in *The Works of George Peele: Collected and edited, with some account of his life and writings*, ed. Alexander Dyce, 2 vols (London, 1829), II, 317.

59 Paula Henderson, *The Tudor House and Garden* (New Haven, CT and London, 2009), 127.

60 Bacon, 'Of Gardens', 200, 202.

61 Mavis Batey, *The Historic Gardens of Oxford and Cambridge* (London, 1989), 78–9. Karin Seeber, 'Ye Making of Ye Mount: Oxford New College's Mount Garden Revised', *Garden History*, Vol.40, No.1 (Summer 2012), 3–16 (3).

62 Timothy Mowl and Clare Hickman, *The Historic Gardens of England: Northamptonshire* (Stroud, 2008), 39.

63 Jill Husselby and Paula Henderson, 'Location, Location, Location! Cecil House in the Strand', *Architectural History*, Vol.45 (2002), 159–93 (176).

64 For a full discussion of the gardens at Bindon Abbey, see Timothy Mowl, *The Historic Gardens of England: Dorset* (Stroud, 2003), 15–25.

65 Landesbibliothek Kassell, MS. Hass. 68 fols 70v–72r. Quoted in Roy Strong, 'Sir Francis Carew's Garden at Beddington', in *England and the Continental Renaissance: Essays in Honour of J.B. Trapp*, eds Edward Chaney and Peter Mack (Woodbridge, 1990), 233.

66 Valdštejna, *Diary of Baron Waldstein*, 165.

67 Thomas Coryat, *Coryat's Crudities [. . .]* (1611) 2 vols (Glasgow, 1905), II, 36.

68 Landesbibliothek Kassell, MS. Hass. 68 fols 70v–72r.

69 *England as seen by Foreigners in the days of Elizabeth and James the First*, ed. and trans. William Brenchley Rye (London, 1865; repr. Boston, MA, 2005), 62.

70 Landesbibliothek Kassell, MS. Hass. 68 fols 70v–72r.

71 Ibid.

72 Frederick, Duke of Wirtemberg, *A True and Faithful Narrative of the Bathing Excursion [. . .]* (1602) in *England as seen by Foreigners*, ed. and trans. Brenchley Rye, 44.

73 Valdštejna, *Diary of Baron Waldstein*, 83.

74 W.H. Hart, 'The Parliamentary Surveys of Richmond, Wimbledon and Nonsuch, in the County of Surrey, A.D. 1649', *Surrey Archaeological Collections, Volume V* (London, 1871), 106–7.

Chapter 6 Botany, medicine, and plant introductions

1 Edmund Spenser, *The Faerie Queene Disposed into twelve books, Fashioning XII. Morall vertues* (London, 1590), III. VI. 30.

2 Francis Bacon, 'Of Gardens', in *The Essays*, ed.by John Pitcher (London, 1985), 197.

3 John Prest, *The Garden of Eden: The Botanic Garden and the Re-Creation of Paradise* (New Haven, CT and London, 1981), 9.

4 Ibid., 30, 31, 33.

5 Ibid., 9.

6 Andrew Cunningham, 'The Bartholins, the Platters and Laurentius Gryllus: The *peregrinatio medica* in the Sixteenth and Seventeenth Centuries', in *Centres of Medical Excellence? Medical Travel and Education in Europe, 1500–1789*, eds Ole Peter Grell, Andrew Cunningham and Jon Arrizabalaga (Farnham, 2010), 13.

7 Paul F. Grendler, *The Universities of the Italian Renaissance* (Baltimore, MD, and London, 2001; repr. 2004), 314, 325, 351.

8 Ibid., 343.

9 Ibid., 344.

10 Ibid., 343.

11 Agnes Arber, *Herbals: Their Origin and Evolution* (Cambridge, 1912; repr. 1990), 272.

12 Grendler, *The Universities of the Italian Renaissance*, 345.

13 Ibid., 347.

14 Ibid.

15 Paula Findlen, *Possessing Nature: Museums, Collecting and Scientific Culture in Early Modern Italy* (Berkeley and Los Angeles, CA, 1994), 166.

16 Catrien Santing, 'Pieter van Foreest and the Acquisition and Travelling of Medical Knowledge in the Sixteenth Century', in *Centres of Medical Excellence?* eds Grell, Cunningham and Arrizabalaga, 156.

17 Spenser, *The Faerie Queene*, III. VI. 35.

18 Grendler, *The Universities of the Italian Renaissance*, 347.

19 Ibid., 74.

20 Ibid., 348.

21 Edward Hyams and William MacQuitty, *Great Botanical Gardens of the World* (London, 1969), 19, 21.

22 Ibid., 23.

23 Stephen Lock, John M. Last and George Dunea, eds, *The Oxford Illustrated Companion to Medicine* (Oxford, 2001), 379.

24 Prest, *The Garden of Eden*, 1, 42.

25 Ibid., 1.

26 Ibid., 1, 6.

27 William Turner, *A New Herball: Parts I, II, and III* (1551, 1562 and 1568), eds George T.L. Chapman and Marilyn N. Tweddle (Manchester, 1989; repr. Cambridge, 1995), I, 213.

28 Charles Raven, *English Naturalists from Neckham to Ray: A Study of the Making of the Modern World* (Cambridge, 1947; repr. 2010), 48.

29 William Turner, *Libellus de Re Herbaria Novus* (1538), ed. Benjamin Daydon Jackson (London, 1877), i.

30 Whitney R.D. Jones, *William Turner: Tudor Naturalist, Physician and Divine* (London and New York, 1988), 7.

31 Margaret Pelling and Charles Webster, 'Medical Practitioners', in *Health, Medicine and Mortality in the Sixteenth Century*, ed. Charles Webster (Cambridge, 1979), 190.

32 Grendler, *The Universities of the Italian Renaissance*, 351.

33 Turner, *Libellus*, iii.

34 Leah Knight, *Of Books and Botany in Early Modern England: Sixteenth Century Plants and Print Culture* (Farnham and Burlington, VT, 2009), 57.

35 Grendler, *The Universities of the Italian Renaissance*, 351.

36 Turner, *Libellus*, ii.

37 Arber, *Herbals*, 111.

38 Turner, *Libellus*, ii.

39 Turner, *A New Herball: Part II*, 474, 496.

40 Ibid., 507.

41 Turner, *The Names of Herbes* (1548), ed. James Britten (London, 1881; repr. Milton Keynes, 2010), 6.

42 James Britten, 'Preface', in Turner, *Names of Herbes*, v, vi.

43 Turner, *A New Herball: Part II*, 411.

44 Turner, *A New Herball: Part I*, 29.

45 Turner, *Names of Herbs,* 59.

46 Turner, *A New Herball: Part I*, 95.

47 Ibid., 55.

48 Turner, *Names of Herbs*, 28.

49 Turner, *A New Herball: Part I*, 144.

50 Turner, *Libellus,* Title page. Trans. author from: *Sed quu cernerem doctos nihil istiusmodi moliri, consilium esse duxi potius audacter huius modi rem quamlibet arduam tentare quam ut studiosa iuuentus (que vix tria herbarum nomina recte callet) ut antea cecutiat committere.*

51 Turner, *A New Herball: Part I*, 9.

52 Arber, *Herbals*, 64.

53 John Gilmour quoted in Stuart Max Walters, *The Shaping of Cambridge Botany* (Cambridge, 1981), 8.

54 Turner, *A New Herball: Part I*, 10.

55 Turner, *The first and seconde partes of the herbal of William Turner [. . .]* (Cologne, 1568), Dedication.

56 Ibid.

57 Turner, *A New Herball: Part II*, 394.

58 Turner, *A New Herball: Part I*, 40.

59 Turner, *A New Herball: Part II,* 50.

60 Ibid., 102.

61 Ibid., 361.

62 Raphael Holinshed, *The first and second volumes of Chronicles [. . .]* (London, 1587), 209.

63 John Gerard, *Catalogus arborum [. . .]* (London, 1596). John Gerard, *Catalogus arborum [. . .]* (London, 1599).

64 Patrick Taylor and others, eds, *The Oxford Companion to the Garden* (Oxford, 2006), 4.

65 www.kew.org/science/collections/seed-collection (accessed 12 April 2017).

66 Marja Smolenaars, 'Gerard, John (*c.*1545–1612)', *Oxford Dictionary of National Biography*, (Oxford, 2004); online edn, Oct 2008, www.oxforddnb.com/view/article/10555 (accessed 2 Oct 2016).

67 John Gerard, *The Herball or Generall Historie of Plantes. [. . .]* (London, 1597), The Epistle Dedicatorie.

68 Holinshed, *The first and second volumes of Chronicles*, 210.

69 Gerard, *The Herball*, The Epistle Dedicatorie.

70 Holinshed, *The first and second volumes of Chronicles*, 210.

71 Paul Slack, 'Mortality Crises and Epidemic Disease in England 1485–1610', in *Health, Medicine and Mortality in the Sixteenth Century*, ed. Webster, 17.

72 Andrew B. Appleby, 'Diet in Sixteenth Century England: Sources, Problems, Possibilities', in *Health, Medicine and Mortality in the Sixteenth Century*, ed. Webster, 115.

73 A. Lloyd Moote and Dorothy C. Moote, *The Great Plague: The Story of London's Most Deadly Year* (Baltimore, MD, 2004), 10.

74 Slack, 'Mortality Crises and Epidemic Disease in England', 20.

75 Elizabeth Jane Furdell, *The Royal Doctors 1485–1714: Medical Personnel at the Tudor and Stuart Courts* (Rochester, NY, 2001), 73.

76 Turner, *A New Herball: Part II,* 162.

77 Ibid., 161.

78 Ibid., 320, 321.

79 Ibid., 345.

80 Furdell, *The Royal Doctors*, 91.

81 Turner, *A New Herball: Part II*, 328.

82 Turner, *A New Herball: Part III*, 669.

83 Furdell, *The Royal Doctors*, 90.

84 Ibid.

85 Gerard, *The Herball*, 1308.

86 William Aiton, *Hortus Kewensis; or, a Catalogue of the Plants Cultivated in the Royal Botanic Garden at Kew*, 3 vols (London, 1789), I, 435.

87 Deborah Harkness, *The Jewel House: Elizabethan London and the Scientific Revolution* (New Haven, CT and London, 2007), 39.

88 Gerard, *The Herball*, 137.

89 Ibid., 277.

90 Lady Margaret Hoby, *The Private Life of an Elizabethan Lady: The Diary of Lady Margaret Hoby, 1599–1605*, ed. Joanna Moody (Stroud, 1998), xxxii.

91 Ibid., xxxii, xxxiv.

92 Ibid., 80, 85.

93 Ibid., 211.

94 Ibid., 194.

95 Ibid., 145.

96 Ibid., 58.

97 Ibid.

98 Holinshed, *The first and second volumes of Chronicles*, 209.

99 Gerard, *The Herball*, 89.

100 Ibid.

101 Ibid., 1066.

102 Holinshed, *The first and second volumes of Chronicles*, 209.

103 Gerard, *The Herball*, 994.

104 Ibid.

105 Ibid., 1209.

106 Harkness, *The Jewel House*, 25.

107 Arber, *Herbals*, 90.

108 D.E. Allen, 'L'Obel, Mathias de (1538–1616)', *Oxford Dictionary of National Biography*, (Oxford, 2004); online edn, May 2010, www.oxforddnb.com/view/article/66084 (accessed 1 October 2016).

109 Louis A. Knafla, 'Zouche, Edward la, eleventh Baron Zouche (1556–1625)', *Oxford Dictionary of National Biography*, (Oxford, 2004); online edn, Jan 2008, www.oxforddnb.com/view/article/30301 (accessed 3 October 2016).

110 Anna Parkinson, *Nature's Alchemist: John Parkinson, Herbalist to Charles I* (London, 2007), 112, 113.

111 Gerard, *The Herball*, 347.

112 Paul Hulton, 'Introduction', in Thomas Harriot, *A Briefe and True Report of the New Found Land of Virginia* (Frankfurt, 1590; repr. Mineola, NY, 1972), viii.

113 John Stillwell, *Mathematics and its History* (New York, 1989), 332.

114 Hulton, 'Introduction', ix.

115 Stillwell, *Mathematics and its History*, 143.

116 Walter S.H. Lim, *The Arts of Empire: The Poetics of Colonialism from Ralegh to Milton* (London and Cranbury, NJ, 1998), 99.

117 Harriot, *A Briefe and True Report*, 5, 6.

118 Ibid., 7, 9.

119 Ibid., 52.

120 Ibid., 14, 15.

121 Aiton, *Hortus Kewensis*, III, 248.

122 Maggie Campbell-Culver, *The Origin of Plants: The People and Plants that Shaped Britain's Garden History Since the Year 1000* (London, 2001), 160.

123 Harriot, *A Briefe and True Report*, 18.

124 Aiton, *Hortus Kewensis*, II, 153.

125 Gerard, *The Herball*, 1330.

126 Holinshed, *The first and second volumes of Chronicles*, 210.

Chapter 7 Masques and royal entertainments

1 John Nichols, *The Progresses and Public Processions of Queen Elizabeth*, 3 vols (London, 1823; repr.1961), I, 35.

2 E.K. Chambers, *The Elizabethan Stage*, 4 vols (Oxford, 1923), IV, 113, 115.

3 Raphael Holinshed, *The first and second volumes of Chronicles [. . .]* (London, 1587), 196.

4 Chambers, *The Elizabethan Stage*, I, 107.

5 Ian Dunlop, *Palaces and Progresses of Elizabeth I* (London, 1962), 120.

6 Edmund Spenser, *The Shepheardes Calender [. . .]* (London, 1579), Aprill.v. 17.

7 Robert Laneham, *Robert Laneham's Letter: Describing a part of the Entertainment unto Queen Elizabeth at the Castle of Kenilworth in 1575*, ed. F.J. Furnivall (London, 1907), 55.

8 Katherine Duncan-Jones, 'Introduction', in Sir Philip Sidney, *The Countess of Pembroke's Arcadia (The Old Arcadia)*, ed. Katherine Duncan-Jones (Oxford, 2008), vii.

9 Sir Philip Sidney, *The Countesse of Pembrokes Arcadia, written by Sir Philippe Sidnei* (London, 1590), 11.

10 Sir Philip Sidney, *The Countesse of Pembrokes Arcadia, Written by Sir Philip Sidney Knight. Now since the first edition augmented and ended* (London, 1593), 'The ladd Philisides' (1580) Lib.3. 1–5, 40–4.

11 Duncan-Jones, ed., 'Introduction', vii.

12 Sidney, *The Countesse of Pembrokes Arcadia* (1593), 4.

13 Todd A. Borlik, *Ecocriticism and Early Modern English Literature: Green Pastures* (New York and Abingdon, 2011), 79.

14 John Aubrey, *Brief Lives* (1680), ed. Richard Barber (Woodbridge, 1975; repr. 1982), 290.

15 Borlik, *Ecocriticism and Early Modern English Literature*, 79.

16 Nichols, *The Progresses*, III, 140.

17 Extract from an unpublished MS. written in 1578, taken from Nichols, *The Progresses*, I, 409.

18 Nichols, *The Progresses*, I, 409.

19 Ibid., 486–7.

20 Ibid., 490–1.

21 Mary Hill Cole, *The Portable Queen: Elizabeth I and the Politics of Ceremony* (Amherst, MA, 1999), 197, 198.

22 Nichols, *The Progresses*, III, 131.

23 Ibid.

24 Peter Davidson and Jane Stevenson, 'Elizabeth I's Reception at Bisham', in *The Progresses, Pageants, & Entertainments of Queen Elizabeth I*, eds Jane Elisabeth Archer, Elizabeth Goldring and Sarah Knight (Oxford, 2007), 208, 209.

25 Ibid., 208.

26 Nichols, *The Progresses*, III, 132, 133.

27 Ibid., 134.

28 Ibid.

29 Ibid., 135.

30 Barbette Stanley Spaeth, *The Roman Goddess Ceres* (Austin, TX, 1996), 1, 2.

31 Ibid., 5.

32 Ibid., 11, 13.

33 Roy Strong, *The Cult of Elizabeth: Elizabethan Portraiture and Pageantry* (London, 1977; repr. 1987), 26–9.

34 Ibid., 29.

35 Nichols, *The Progresses*, III, 143.

36 Ibid., 136–7.

37 Nichols, *The Progresses*, I, 492.

38 Ibid., 500.

39 Robert Dudley, Earl of Leicester, *Household Accounts and Disbursement Books of Robert Dudley Earl of Leicester, 1558–1561, 1584–1586*, ed. by Simon Adams (Cambridge, 1995), 26.

40 Elizabeth Goldring, 'Portraiture, Patronage and the Progresses', in *The Progresses, Pageants, and Entertainments of Queen Elizabeth I*, eds Jayne Elisabeth Archer, Elizabeth Goldring and Sarah Knight (Oxford, 2007), 184.

41 Sir Philip Sidney, *The Major Works*, ed. Katherine Duncan-Jones (Oxford, 1989; repr. 2008), 5.

42 Ibid.

43 Ibid., 7.

44 Ibid., 8.

45 J.W. Cunliffe, 'The Queenes Maiesties Entertainment at Woodstocke', *Proceedings of the Modern Language Association*, Vol. 26, No. 1 (1911), 92–141 (98).

46 Hill Cole, *The Portable Queen*, 198.

47 Sue Simpson, *Sir Henry Lee (1533–1611): Elizabethan Courtier* (London, 2016), 85.

48 Rachel Kapelle, 'Predicting Elizabeth: Prophecy on Progress', in *Medieval and Renaissance Drama in England, Volume 24,* ed. S.P. Cerasano (Madison, WI, 2011), 91.

49 Jean Wilson, *Entertainments for Elizabeth I* (Woodbridge, 1980), 126.

50 Ibid., 131.

51 Ibid., 130.

52 Ibid., 131.

53 Ibid., 141–2.

54 Kapelle, 'Predicting Elizabeth', 91, 92.

55 Joseph Strutt, *The Sports and Pastimes of the People of England from the Earliest Period* (1801), ed. J. Charles Cox (London, 1903), xlvii, xlviii.

56 Laneham, *Robert Laneham's Letter*, 2.

57 Anon., *The speeches and honorable entertainment given to the Queenes Maiestie in Progresse, at Cowdrey in Sussex, by the right Honorable the Lord Montacute. 1591* (London, 1591), 3.

58 Ibid., 4.

59 www.pastscape.org.uk. NMR TQ 39 SE 43.

60 Evelyn Philip Shirley, *Some Account of English Deer Parks: With Notes on the Management of Deer* (London, 1867), 43.

61 George Gascoigne, *The noble arte of venerie or hunting [. . .]* (London, 1575), 94.

62 Anon., *The speeches and honorable entertainment*, 4.

63 William Shakespeare, *The Plays of William Shakespeare, Volume the Sixth*, ed. Samuel Johnson and George Steevens (London, 1778), 489.

64 Nicholls, *The Progresses*, I, 409 .

65 Strutt, *Sports and Postimes*, 21.

66 Ibid., 24, 27.

67 Gascoigne, *The noble arte of venerie or hunting*, 91.

68 Nichols, *The Progresses*, III, 121.

69 John Lyly, *The Complete Works of John Lyly*, ed. Richard Warwick Bond, 3 vols (Oxford, 1902), I, 496–7.

70 John Lyly (attrib.), *Queen Elizabeth's Entertainment at Mitcham*, ed. Leslie Hotson (New Haven, CT, 1953), p. 36.

71 Nichols, *The Progresses*, III, 119.

72 Ibid., 120.

73 Ibid.

74 Nichols, *The Progresses*, I, 515.

75 Ibid.

76 Ibid., 519.

77 Ibid.

78 Ibid., 520.

79 Ibid., 520–1.

80 Ibid., 522.

Chapter 8 Afterword

1 From: 'Cecil Papers: July 1599, 16–31', *Calendar of the Cecil Papers in Hatfield House, Volume 9: 1599*, ed. R.A. Roberts (1902), 234–56.

2 Mary Hill Cole, *The Portable Queen: Elizabeth I and the Politics of Ceremony* (Amherst MA, 1999), 21.

3 Ibid., 26.

4 'Introduction', *Calendar of the Cecil Papers in Hatfield House, Volume 12: 1602–1603*, ed. R.A. Roberts (London, 1910), v–xxx.

5 Thomas Newton, *Atropoïon Delion, or, The death of Delia with the teares of her funerall [. . .]* (London, 1603).

6 Roy Strong, *The Renaissance Garden in England* (London, 1979), 71.

7 Henry Petowe, *Elizabetha quasi vivens Eliza's funerall. A fewe Aprill drops, showred on the hearse of dead Eliza. Or The funerall teares af [sic] a true hearted subiect. By H.P.* (London, 1603), Verse I.

Dramatis personae

The following are the owners of leading houses and gardens that are referred to in the text, many of whom were also hosts to the Queen. It is not a list of all owners of important Elizabethan gardens, nor does it include other houses and gardens that they may have owned, but which are not referred to in the text.

Sir Nicholas Bacon (1510–79)
Lawyer, made Lord Keeper and Privy Councillor on Elizabeth's accession. Brother-in-law of William Cecil, Lord Burghley. House: Gorhambury, Hertfordshire.

Francis Bacon (1561–1626), Viscount St Albans (from 1618)
Son of Sir Nicholas Bacon. Lawyer and later (1618) Lord Chancellor, also a philosopher and writer. Houses: Twickenham, Middlesex and Gorhambury, Hertfordshire.

William Brooke (1527–97), Tenth Baron Cobham
Nobleman and a close friend of William Cecil, he was a soldier, occasional ambassador, Privy Councillor and, for one year, Lord Chamberlain. House: Cobham Hall, Kent.

Anthony Browne (1528–92), First Viscount Montague
Catholic nobleman, who held offices under Mary but was out of favour under Elizabeth. House: Cowdray, Sussex.

Giles Brydges (1548–94), Third Baron Chandos
Nobleman and Lord Lieutenant of Gloucestershire. House: Sudeley Castle, Gloucestershire.

Sir Francis Carew (1530–1611)
From a prominent gentry courtier family, and a cousin of Queen Elizabeth. However, he never held government office. House: Beddington, Surrey.

Richard Carew (1555–1620)
Gentry family, prominent in Cornwall, and an antiquary, author and translator. House: Antony, Cornwall.

William Cecil (1520/21–1598), First Baron Burghley
Secretary of State 1558–72 and thereafter Lord High Treasurer. A Privy Councillor throughout the reign, Cecil was Elizabeth's chief adviser, most important minister and one of the most powerful men in the country. Houses: Burghley House, Lincolnshire, Theobalds, Hertfordshire, and Cecil House in London.

Robert Cecil (1563–1612), First Earl of Salisbury (from 1605)
Son by the second wife of William Cecil, Lord Burghley. Secretary of State and Privy Councillor from 1590 to Queen Elizabeth and later to King James I. House: Pymms, Hertfordshire. He inherited Theobalds in 1598, which he later exchanged with King James for Hatfield House.

Thomas Cecil (1542–1623), First Earl of Exeter (from 1605)
Son by the first wife of William Cecil, Lord Burghley. He lacked the political skills of his half-brother Robert, and was not prominent in government. Houses: Wimbledon House, Surrey and Burghley, Lincolnshire, which he inherited from his father in 1598.

Edward Clinton (1512–85), Ninth Baron Clinton and Saye, First Earl of Lincoln (from 1572)

Lord Admiral, soldier, Privy Councillor and a leading courtier in the reigns of Edward VI and Mary as well as Elizabeth. House: West Horsley, Surrey.

Sir Anthony Cooke (1505/6–76)

JP and Sheriff of Essex, occasionally at Court, he was a tutor to Edward VI and ensured that his four daughters received a humanist education. He was father in law of William Cecil, Nicholas Bacon and Thomas Hoby. He moved abroad during the reign of Mary, and though he returned in 1559 he held no further office. House: Gidea Hall, Essex.

Elizabeth Cooke (1528–1609), Lady Hoby-Russell

Daughter of Sir Anthony Cooke. Married Thomas Hoby in 1558. After his death in 1566, she married in 1574 Lord John Russell, heir to the Earl of Bedford. House: Bisham Abbey, Berkshire.

Sir William Cordell (1522–81)

Lawyer, Master of the Rolls, Privy Councillor under Mary, Speaker of the House of Commons in 1558. House: Melford Hall, Suffolk.

Robert Dudley (1532–88), Earl of Leicester

Royal favourite, Privy Councillor, Master of the Horse, general and a great landowner in the Midlands and North Wales. Houses: Kenilworth, Warwickshire and Wanstead, Essex.

Sir Thomas Egerton, later First Viscount Brackley (1540–1617)

A lawyer, who served successively as Solicitor General, Attorney General and Master of the Rolls; made a Privy Councillor and Lord Keeper in 1596, and Lord Chancellor by James I in 1603. House: Harefield, Middlesex.

Henry Fitzalan (1512–80), Twelfth Earl of Arundel

Leading nobleman and courtier under Henry VIII, Edward VI and Mary. Remained a Privy Councillor but distrusted by Elizabeth. He

travelled widely in Europe in the 1560s. House: Nonsuch, Surrey, which he bought from Mary and bequeathed to his son-in-law John, First Baron Lumley.

John Gerard (*c.*1545–1612)

Herbalist, Surgeon and Superintendant of William Cecil, Lord Burghley's gardens at Theobalds and Cecil House in London. House in Holborn, London.

Sir Thomas Gresham (*c.*1518–79)

Wealthy merchant and financier who, in 1565, founded the Royal Exchange. House: Osterley, Middlesex.

Sir John Harington (1560–1612)

Courtier and the Queen's godson, soldier, poet and writer who translated Ariosto's *Orlando Furioso*. House: Kelston, Somerset.

Sir Christopher Hatton (*c.*1540–91)

A favourite of the Queen, Privy Councillor and for a time Captain of her Guard. Appointed Lord Chancellor in 1587. House: Holdenby, Northamptonshire.

William Herbert (1506/7–70), First Earl of Pembroke

Nobleman, a Privy Councillor and soldier under Henry VIII, Edward VI, Mary and Elizabeth. Created Earl of Pembroke in 1551. House: Wilton, Wiltshire.

Henry Herbert (after 1538–1601), Second Earl of Pembroke and Mary Sidney Herbert (1561–1621)

Lord President of Wales from 1586 and Lord Lieutenant of eleven counties. Succeeded his father as Earl of Pembroke in 1570. Married in 1577 Mary Sidney, sister of Sir Philip Sidney, writer and literary patron. House: Wilton, Wiltshire.

Sir Philip Hoby (1505–58)

A courtier and ambassador who travelled extensively in Europe. He was Master General of the Ordnance and Privy Councillor during the reign of Edward VI, and was again abroad 1554–6. Half-brother of Sir Thomas Hoby. House: Bisham Abbey, Berkshire.

Sir Thomas Hoby (1530–66)

From a gentry background, he travelled extensively in Europe, was translator of Castiglione's *The Courtier,* and ambassador to France, where he died. Married Elizabeth Cooke in 1558, so brother-in-law of William Cecil and Nicholas Bacon. House: Bisham Abbey, Berkshire.

Lady Margaret Hoby (1570/1–1633)

Heiress of a considerable fortune in Yorkshire, she was married three times: to Walter Devereux, son of the Earl of Essex; to Thomas Sidney, brother of Sir Philip Sidney; and Thomas Hoby, son of Sir Thomas Hoby. House: Hackness, Yorkshire.

Thomas Howard (1520–82), First Viscount Bindon

Second son of the Third Duke of Norfolk, politician and Vice Admiral of Dorset. Created Viscount Bindon in 1559. House: Bindon Abbey, Dorset.

Sir Henry Lee (1533–1611)

Master of the Ordnance and Queen's Champion. Houses: Quarrendon, Buckinghamshire, Ditchley, and Woodstock (as Keeper), Oxfordshire.

John Lumley (*c.*1533–1609), First Baron Lumley

Nobleman, out of favour with Elizabeth and a committed Catholic. Houses: Nonsuch, Surrey, inherited from his father-in-law the Earl of Arundel in 1580.

Roger North (1531–1600), Second Baron North

Nobleman, soldier, ambassador and, from 1596, a Privy Councillor and Treasurer of the Household. House: Kirtling, Cambridgeshire.

Henry Percy (1564–1632), Ninth Earl of Northumberland

Nobleman of an old family with extensive estates, also a scholar and patron of Thomas Harriot. Houses: Syon, Middlesex and Petworth, Sussex.

Sir Edward Phelips (*c*.1555–1614)

Lawyer and MP, Speaker of the House of Commons in 1604. House: Montacute, Somerset.

Sir Walter Raleigh (1554–1618)

Courtier, royal favourite, succeeded Hatton as Captain of the Guard. Lord Lieutenant of Cornwall. House: Sherborne, Dorset.

Sir William Russell, later Baron Russell of Thornhough (*c*.1553–1613)

Son of the Earl of Bedford, a courtier, soldier in the Netherlands (and friend of Sir Philip Sidney), and Lord Deputy of Ireland 1594–7. House: Chiswick, Middlesex.

Edward Seymour (1539?–1621), Second Earl of Hertford

Nobleman, son of Edward Seymour, Duke of Somerset. In 1560 attracted the Queen's displeasure by secretly marrying Lady Catherine Grey, a potential heir to the throne. Imprisoned until 1563 and thereafter remained out of favour. Houses: Elvetham, Hampshire and Amesbury Abbey, Wiltshire.

Sir Henry Sharington (*c*.1518–81)

Wiltshire gentry and MP. House: Lacock Abbey, Wiltshire, inherited from his brother Sir William Sharington in 1553.

Sir Henry Sidney (1529–86)

A soldier and administrator, he served for many years in Ireland, including as Lord Deputy 1565–71 and 1575–8. A Privy Councillor,

he also served as President of the Council of the Marches, residing at Ludlow Castle. Brother-in-law of the Earl of Leicester and father of Sir Philip Sidney and Mary Sidney, Countess of Pembroke. House: Penshurst, Kent.

Sir Philip Sidney (1554–86)

Poet, courtier and soldier, author of *Arcadia*. Owned no houses himself but associated with Penshurst, Kent (owned by his father Sir Henry Sidney) and Wilton, Wiltshire (his sister Mary, Countess of Pembroke).

William Somerset (1526/7–89), Third Earl of Worcester

Nobleman and soldier, the only peer who resided mainly in Wales. In the 1560s he moved his principal residence from Chepstow to Raglan Castle. House: Raglan Castle, Monmouthshire.

Edward Somerset (1550–1628), Fourth Earl of Worcester

Nobleman, Earl Marshal and Lord Privy Seal under James I. House: Raglan Castle, Monmouthshire.

Elizabeth Talbot (1527?–1608), Countess of Shrewsbury

Also known as 'Bess of Hardwick', she married four times and rose to the highest levels of the nobility and great wealth. Houses: Chatsworth and Hardwick Hall, both Derbyshire.

Sir John Thynne (1512/13–80)

Steward from 1536 to 1552 for Edward Seymour, Earl of Hertford and then Duke of Somerset. He accumulated extensive estates and wealth for himself. House: Longleat, Wiltshire.

Sir Thomas Tresham (1543–1605)

Catholic recusant gentry, imprisoned on several occasions; also accused of harsh estate management. Houses: Lyveden New Bield and Rushton Hall, both Northamptonshire.

William Turner (*c.*1509–68)

Physician and botanist. An ardent reformer, he travelled and studied in Europe during a period of exile in the 1540s. He returned as chaplain and physician to the Duke of Somerset at Syon, and later served twice as Dean of Wells, 1551–3 and 1560–4, where he established a physic garden.

Sir Edward Unton (1534–82) and Sir Henry Unton (*c.*1558–96)

Sir Edward was a landowner and MP who travelled in Europe when younger. His son, Sir Henry, was a soldier and on several occasions ambassador to France, who also toured extensively in France and Italy when younger. Houses: Wadley, Berkshire and Langley, Oxfordshire.

Henry Wriothesley, Second Earl of Southampton (1545–81)

He reached his majority and took control of his estates in 1566, but as a Catholic was out of favour and briefly imprisoned in the period 1569–73. Thereafter he received some marks of favour but was rarely at Court. Son-in-law of Viscount Montague. House: Titchfield, Hampshire.

Sir John Young (1519–89)

From a gentry family, an MP who was knighted by the Queen when she visited Bristol in 1574. House: The Great House, Bristol.

Edward la Zouche (1556–1625), Eleventh Baron Zouche

Nobleman who travelled widely in Europe when younger, a diplomat in the 1590s, and President of the Council of Wales and a Privy Councillor under James I. A passionate horticulturalist and plant collector. House: Hackney, Middlesex.

Appendix: Plants grown in gardens in England in the early Elizabethan period

References are to documentary evidence of plants described by William Turner as growing in gardens in England, or plants listed by Turner and confirmed by other contemporary sources as garden plants where Turner is not specific. Some plants are included although not listed by Turner, as evidence for their cultivation as garden plants is provided by other contemporary sources. Where the reference in the Appendix shows only Turner publications, this indicates that Turner confirmed the plant growing in gardens in England. Where another publication is listed in the reference, that provides the contemporary confirmation of the plant growing in gardens.

Identification of Modern English Names and Scientific Names are taken from William Turner, *A New Herball,* or from *Fromond.*

Abbreviation primary source

Names William Turner, *The Names of Herbes by William Turner A.D. 1548,* ed. James Britten (London, 1881; repr. Milton Keynes, 2010).

Herball	William Turner, *A New Herball,* Parts I (1551), II (1562), and III (1568), ed. by George T.L. Chapman and Marilyn N. Tweddle (Manchester, 1989; repr. Cambridge, 1995).
Crafte of Graffynge	Anon., *The crafte of graffynge & plantynge of trees* ([London?], [1518?]) (Unpaginated).
Banckes' Herball	Anon., *Here begynnyth a newe mater, the whiche sheweth and treateth of ye vertues [and] proprytes of herbes, the whiche is called an herball Cum gratia [and] privilegio a rege indulto* ([London] [1525]).
Hill	Thomas Hill, *A most briefe and pleasaunte treatise [. . .]* (London, [1558]) (Unpaginated).
Tusser	Thomas Tusser, *Thomas Tusser: 1557 Floruit. His Good Points of Husbandry,* ed. by Dorothy Hartley (London: Country Life, 1931).
Labyrinth	Thomas Hill, *The Gardeners Labyrinth [. . .]* (London, 1577).
Fromond	John H. Harvey, 'Garden Plants of around 1525: the Fromond List', *Garden History,* Vol.17, No.2 (Autumn, 1989), pp. 122–34.

Turner's English Name or Early Modern Name	Modern English Name	Scientific Name	Reference
Abrecok or Hasty peche tree	Apricot	*Prunus armeniaca* L.	*Herball* Part II p.441
Affodyll, the right	Asphodel	*Asphodelus* L., Species of	*Herball* Part I p.223
Agrimonie	Agrimony	*Agrimonia eupatoria* L.	*Herball* Part I p.314 *Fromond* p.127
Alecoste or Coste or Costemary	Costmary	*Tanacetum balsamita* L.	*Herball* Part III p.747 *Fromond* p.128
Alexander	Alexanders	*Smyrnium olusatrum* L.	*Herball* Part II p.471 *Hill* Chapter viii *Fromond* p.127
Alcakeng or Wynter cheries	Chinese Lantern	*Physalis alkekengi* L.	*Names* p.75
Alleluya or Wodsore or Wodsorrell	Wood-sorrel	*Oxalis acetosella* L.	*Herball* Part II p.482 *Fromond* p.132
Almond Tree	Almond	*Prunus amygdalus* Batsch	*Names* p.12 *Herball* Part I p.230 *Crafte of Graffynge* *Fromond* p.127

Turner's English Name or Early Modern English Name	Modern English Name	Scientific Name	Reference
Amy or Ami or Ammi	Bullwort	*Ammi majus* L.	*Herball* Part I p.231
Angelica	Garden Angelica	*Angelica archangelica* L.	*Herball* Part III p.728
Anyse or Anis	Anise	*Pimpinella anisum* L.	*Herball* Part I p.235 *Fromond* p.127
Apple Tree	Apple	*Malus Domestica* Borkh.	*Herball* Part II p.440 *Crafte of Graffynge*
Apple Tree, Crab	Crab Apple	*Malus Sylvestris* (L.) Miller	*Herball* Part II p.440
Arbor winde or Great winde or Withwinde	Hedge Bindweed	*Calystegia sepium* (L.) R. Br.	*Herball* Part II p.576
Archangell, rede	Red Dead-nettle	*Lamium purpureum* L.	*Herball* Part II p.386 *Fromond* p.130
Archichock	Globe Artichoke	*Cynara scolymus* L.	*Names* p.23 *Herball* Part I p.263 *Fromond* p.127
Areche or Oreche, Garden	Garden Orache	*Atriplex hortensis* L.	*Names* p.18 *Herball* Part I p.248 *Fromond* p.130

Turner's English Name or Early Modern Name	Modern English Name	Scientific Name	Reference
Aron or Rampe or Coccowpynt	Lords-and-Ladies	*Arum maculatum* L.	*Herball* Part I p.242
Arssmart or Culerage	Knotgrass, Species of, Water pepper	*Polygonum hydropiper* L. now *Persicaria hydropiper* (L.) Delabre	*Herball* Part I p.289 *Fromond* p.132
Asarabacca or Follfoote	Asarabacca	*Asarum europaeum* L.	*Names* p.16 *Herball* Part I p.244
Avenes	Wood Avens	*Geum urbanum* L.	*Herball* Part II p.389 *Tusser* p.152 *Fromond* p.127
Axfiche or Axsede or Axwurt	Crown vetch	*Securigera varia* (L.) Lassen	*Herball* Part II p.563
Balsamine	Balsam Apple	*Momordica* L., Species of	*Herball* Part III p.733
Bank cresses	Winter-cresses	*Barbarea* R.Br., Species of	*Herball* Part II p.404 *Fromond* p.128
Barley, Duche	Six-rowed Barley	*Hordeum vulgare* L.	*Herball* Part II p.396
Barley, Wheat or Darnel	Darnel	*Lolium temulentum* L.	*Herball* Part II p.431
Basil	Garden Basil	*Ocimum basilicum* L.	*Herball* Part II p.469 *Hill* Chapter viii *Fromond* p.127

Turner's English Name or Early Modern Name	Modern English Name	Scientific Name	Reference
Bastard Saffron	Safflower	*Carthamus tinctorius* L.	*Names* p.29 *Herball* Part I p.282 *Fromond* p.131
Beane	Broad Bean	*Vicia faba* L.	*Herball* Part I p.315 *Hill* Chapter viii
Beane of Egypt	Bean of Egypt	*Nelumbo nucifera* Gaertner	*Herball* Part I p.283 *Hill* Chapter viii
Berberes	Berberis	*Berberis vulgaris* L.	*Names* p.58
Berefoote or Herbe syter wurte	Green Hellebore or Stinking Hellebore (Bearsfoot)	*Helleborus viridis* L. (?) *Helleborus foetidus* L. (?)	*Herball* Part I p.284 *Fromond* p.132
Betes, Black and White Betes	Beet	*Beta vulgaris* L.	*Herball* Part I p.250 *Hill* Chapter viii *Fromond* p.127
Betonie	Betony	*Stachys officinalis* (L.) Trev. St. Leon	*Herball* Part I p.251 *Labyrinth* Part II p.169 *Fromond* p.127
Bistorta or Twisewrithen or Docke Bistorte	Common Bistort	*Polygonum bistorta* (L.) Samp.	*Names* p.83 *Herball* Part III p.732 *Fromond* p.127

Turner's English Name or Early Modern Name	Modern English Name	Scientific Name	Reference
Blete or Blites	Goosefoot	*Chenopodium* L., Species of, or *Blitum bonus-henricus* (L.) Rchb.	*Names* p.20 *Herball*, Part I, p.253 *Fromond* p.129
Blewbottle or Blewblaw	Bluebottle	*Centaurea cyanus* L.	*Herball* Part I p.297 *Tusser* p.153 *Fromond* p.128
Borage	Borage	*Borago officinalis* L.	*Herball* Part I p.256 *Hill* Chapter i *Fromond* p.127
Boxe	Box	*Buxus sempervirens* L.	*Herball* Part I p.259
Bramble bush or Blaak berrye bush	Bramble	*Rubus fruticosus* L. agg.	*Herball* Part II p.547 *Hill* Chapter iii
Branke Ursine	Bearȝ-breeches	*Acanthus* L., Species of	*Names* p.8 *Herball* Part I p.220
Brionye	White Bryony	*Bryonia dioica* Jacq.	*Herball* Part II p.600 *Labyrinth* Part I p.22
Brode calfe snoute or Yelow calfys snowte	?	?	*Names* p.14 *Herball* Part I p.238

Turner's English Name or Early Modern Name	Modern English Name	Scientific Name	Reference
Bugle	Bugle	*Ajuga reptans* L.	*Names* p.83 *Fromond* p.127
Bukkes beard or Gotes beard	Goat's-beard	*Tragopogon pratensis* L.	*Herball* Part I p.249
Bulles or Bullestertre or Wild plum	Bullace	*Prunus domestica* subsp. *instititia* (L.) Bonnier and Layens	*Herball* Part II p.527
Burnet	Salad Burnet	*Sanguisorba minor* Scop.	*Herball* Part III p.731 *Fromond* p.127
Cabbage Cole	Cabbage	*Brassica oleracea* L. *capitata*	*Herball* Part I p.253 *Fromond* p.127
Calamynte	Calamint	*Calamintha ascendens* Jordan (*officinalis*)	*Names* p.22 *Herball* Part I p.259 *Fromond* p.128
Camomyle or Camamel	Chamomile	*Chamaemelum nobile* L. All.	*Herball* Part I p.236 *Fromond* p.128
Cardo Benedictus	Blessed Thistle	*Cnicus benedictus* L.	*Names* p.18 *Herball* Part III p.735
Caruwayes	Caraway	*Carum carvi* L.	*Herball* Part I p.264 *Fromond* p.128

Turner's English Name or Early Modern Name	Modern English Name	Scientific Name	Reference
Casshes	Cow Parsley	*Anthriscus sylvestris* (L.) Hoffm.	*Herball* Part II p.459
Centory	Common Centaury	*Centaurium erythraea* Rafn.	*Herball* Part I p.266
Cherry	Cherry	*Prunus*, Species of	*Crafte of Graffynge*
Chervell	Chervil	*Anthriscus cerefolium* (L.) Hoffm.	*Herball* Part III p.735 *Hill* Chapter viii *Fromond* p.128
Chesnut tree	Sweet chestnut	*Castanea sativa* Miller	*Herball* Part I p.265
Chikewede	Common Chickweed	*Stellaria media* (L.) Villars	*Herball* Part I p.226 *Fromond* p.128
Ciche or Ciche Pease	Chick Pea	*Cicer arietinum* L.	*Herball* Part I p.274
Cinkfoly or Cinqufoile	Marsh Cinquefoil	*Potentilla palustris* (L.) Scop.	*Herball* Part II p.537 *Tusser* p.154
Cistsage or Bushsage Cystbushe or Ciste sage	Rock-rose	*Cistus* L., Species of	*Names* p.28 *Herball* Part I p.278
Citron tree	Citron tree	*Citrus medica* L.	*Herball* Part II p.443 *Tusser* p.154
Clare or Horminum or Orminum	Clary	*Salvia sclarea* L.	*Herball* Part II p.475 *Fromond* p.128

Turner's English Name or Early Modern Name	Modern English Name	Scientific Name	Reference
Clare, Wild or Wild horminum or orminum	Wild Clary	*Salvia verbenaca* L.	*Herball* Part II p.475 *Fromond* p.130
Cole or Kolwurts	Kale	*Brassica oleracea* L. *acephala*	*Herball* Part I p.253 *Fromond* p.128
Coloquintida	Bitter Cucumber or Colocynth	*Citrullus colocynthis* Schrad.	*Herball* Part I p.295
Columbine	Columbine	*Aquilegia vulgaris* L.	*Herball* Part III p.729 *Fromond* p.128
Columbyn gentyle	Garden Columbine	*Aquilegia vulgaris* L. *flore pleno*	*Fromond* p.128
Common Dragon	Dragon Arum	*Dracunculus vulgaris* Schott	*Names* p.34 *Herball* Part I p.305 *Fromond* p.129
Common Sperage	Garden Asparagus	*Asparagus officinalis* L.	*Names* p.17 *Herball* Part I p.246
Commyn	Cumin	*Cuminum cyminum* L.	*Herball* Part I p.295 *Hill* Chapter viii
Cornell tree	Cornelian cherry	*Cornus mas* L.	*Names* p.30 *Herball* Part I p.287

Turner's English Name or Early Modern Name	Modern English Name	Scientific Name	Reference
Coryandre or Colander or Corion	Coriander	*Coriandrum sativum* L.	*Herball* Part I p.286 Hill 1558 Chapter vii *Fromond* p.128
Cost	Sweet Maudlin	*Achillea ageratum* L.	*Names* p.37 *Fromond* p.128
Cotton thystell or Ote thystell	Globe-thistle	*Echinops* L., Species of	*Names* p.8 *Herball* Part I p.220
Coweslippe or Pagle	Cowslip	*Primula veris* L.	*Herball* Part III p.767
Cucumber	Cucumber	*Cucumis sativus* L.	*Herball* Part I p.290 Hill Chapter vii *Fromond* p.128
Cucumbers, Wylde	Squirting Cucumber	*Ecballium elaterium* (L.) A. Rich	*Names* p.31 *Herball* Part I p.292
Cyve or Civet or Chive	Chives	*Allium schoenoprasum* L.	*Names* p.39 *Herball* Part II p.388 *Fromond* p.128
Cypresse, Cypres tre	Cypress	*Cupressus Sempervirens* L.	*Names* p.32 *Herball* Part I p.296

Turner's English Name or Early Modern Name	Modern English Name	Scientific Name	Reference
Daffadyl, Whyte or Whyte laus tibi	Pheasant's-eye Daffodil	*Narcissus poeticus* L.	*Names* p.55 *Herball* Part II p.462
Daffadil, Yellow	Daffodil	*Narcissus pseudonarcissus* subsp. *pseudonarcissus* L.	*Herball* Part II p.462
Dandelion	Dandelion	*Taraxacum officinale* F.H. Wigg.	*Herball* Part II p.403 *Fromond* p.128
Dasey or Banwurt	Daisy	*Bellis perennis* L.	*Names* p.19 *Herball* Part I p.250 *Fromond* p.128
Dede nettle or Archangelica	White Dead-nettle	*Lamium album* L.	*Herball* Part II p.410 *Tusser* p.154 *Fromond* p.127
Devils bite or Ofbiten or Off bitten	Devil's-bit Scabious	*Succisa pratensis* Moench	*Herball* Part III p.748 *Fromond* p.131
Dittani or Peperwurt	Dittander	*Lepidium latifolium* L.	*Herball* Part II p.422 Hill Chapter viii *Fromond* p.128
Dockes	Docks	*Rumex* L., Species of	*Herball* Part II p.549

Turner's English Name or Early Modern Name	Modern English Name	Scientific Name	Reference
Dogges onion or Dogleke	Star-of-Bethlehem	Ornithogalum angustifolium Boreau	Names p.57 Herball Part II p.476 Tusser p.153
Dyll	Dill	Anethum graveolens L.	Herball Part I p.235 Hill Chapter viii Fromond p.128
Eglentine or Swete Brere	Sweet Briar	Rosa rubiginosa L.	Names p.33 Herball Part I p.299
Elder tree or Boure tree	Elder	Sambucus nigra L.	Names p.69 Herball Part II p.554 Hill Chapter iii
Elecampane	Elecampane	Inula helenium L.	Herball Part II p.403 Fromond p.129
Elm tree	English Elm	Ulmus procera Salisb.	Herball Part II p.604 Crafte of Graffynge
Elm tree	Wych Elm	Ulmus glabra Hudson	Herball Part II p.604 Crafte of Graffynge

Turner's English Name or Early Modern Name	Modern English Name	Scientific Name	Reference
Endive or White endive or Garden succory or Hardewes	Chicory	*Cichorium* L., Species of	*Names* p.44 *Herball* Part II p.403 *Fromond* p.129
Englyshe golangal	Galingale	*Cyperus longus* L.	*Names* p.33 *Herball* Part I p.300 *Fromond* p.129
Eyebrighte	Eyebright	*Euphrasia* L., Species of	*Herball* Part III p.740 *Tusser* p.154 *Fromond* p.129
Fenegreke	Fenugreek	*Trigonella foenum-graecum*	*Herball* Part II p.384 *Fromond* p.129
Fenel or Fenkel	Fennel	*Foeniculum vulgare* Miller	*Names* p.38 *Herball* Part II p.383 *Fromond* p.129
Feverfew or Fetherfew	Feverfew	*Tanacetum parthenium* (L.) Schultz-Bip.	*Herball* Part II p.489 *Tusser* p.153
Figge tree	Fig	*Ficus carica* L.	*Names* p.37 *Herball* Part II p.379

Turner's English Name or Early Modern Name	Modern English Name	Scientific Name	Reference
Filipendula	Dropwort	*Filipendula vulgaris* Moench	*Herball* Part III p.741 *Fromond* p.129
Fleaseed or Fleawurt	Glandular Plantain	*Plantago psyllium* L.	*Herball* Part II p.530
Flour delyce, blue or Blue aris	Bearded Iris	*Iris germanica* L.	*Herball* Part II p.404 *Banckes' Herball*
Flour delyce, yellow or Yellow aris	Yellow Iris	*Iris pseudacorus* L.	*Herball* Part II p.404
Floure Amor or Floure Gentle	Amaranth	*Amaranthus* L., Species of	*Herball* Part I p.230 *Labyrinth* p.37 *Tusser* p.156
French broume or Spanish brome	Spanish Broom	*Spartium junceum* L.	*Names* p.76 *Herball* Part II p.579
French lavander or Spanish lavandar or Cassidonia	French Lavender	*Lavandula stoechas* L.	*Herball* Part II p.583 *Fromond* p.132
French Mallowe or Tree mallow	Tree Mallow	*Lavatera arborea* L.	*Herball* Part II p.435
Fumitory or hollowewort	Common Fumitory	*Fumaria officinalis* L.	*Herball* Part I p.262
Galega or Gotis rue	Goat's-rue	*Galega officinalis* L.	*Herball* Part III p.741

Turner's English Name or Early Modern Name	Modern English Name	Scientific Name	Reference
Garden carot	Carrot	*Daucus carota* L. subsp. *Sativa*	*Names* p.60 *Herball* Part II p.490 *Fromond* p.128
Garden cresses or Garden kars	Garden Cress	*Lepidium sativum* L.	*Names* p.55 *Herball* Part II p.467 *Fromond* p.128
Garden vynde or Manered vynde	Grape-vine	*Vitis vinifera* L.	*Herball* Part II p.603 *Fromond* p.132
Garleke, Common garden	Garlic	*Allium sativum* L.	*Names* p.10 *Herball* Part I p.224 *Fromond* p.129
Gelouer or Gelyfloure, Wylde	Pink	*Dianthus* L., Species of	*Names* p.22 *Herball* Part I p.261 *Hill* Chapter viii *Fromond* p.128
Gelover, Blue stock or Purple stock or Queen's Gilliflowers	Dame's-violet	*Hesperis matronalis* L.	*Herball* Part II p.597 *Hill* Chapter viii

Turner's English Name or Early Modern Name	Modern English Name	Scientific Name	Reference
Gelover, White stock	Hoary Stock	*Matthiola incana* (L.) R. Br.	*Herball* Part II p.597 *Hill* Chapter viii
Germander	Wall Germander	*Teucrium chamaedrys* L.	*Names* p.26 *Herball* Part I p.270 *Fromond* p.129
Gourde	Marrow	*Cucurbita pepo* L.	*Herball* Part I p.293 *Hill* Chapter viii
Gourdes	Gourd	*Lagenaria vulgaris* Ser.	*Fromond* p.129
Gratiola, Herbe gratius, Horse werye	Gratiole	*Gratiola officinalis* L.	*Herball* Part III p.742
Graymile or Graymill or Grummel	Common Gromwell	*Lithospermum officinale* L.	*Herball* Part II p.429 *Tusser* p.154 *Fromond* p.129
Great lunarye or Shawbubbe	Honesty	*Lunaria*, Species	*Names* p.85 *Herball* Part III p.753
Great selendine	Greater Celandine	*Chelidonium majus* L.	*Herball* Part II p.395 *Labyrinth* Part II p.177
Groser Bushe or Goosebery Bush	Gooseberry Bush	*Ribes uva-crispa* L.	*Names* p.88 *Fromond* p.129

Turner's English Name or Early Modern Name	Modern English Name	Scientific Name	Reference
Hartis tunge	Hart's-Tongue	*Phyllitis scolopendrium* (L.) Newman	*Herball* Part II p.500 *Fromond* p.129
Hasell tree or Fylberde tree or Garden nutt tree	Hazel	*Corylus avellana* L.	*Names* p.31 *Herball* Part I p.288
Hawthorne or Whytethorne	Hawthorn	*Crataegus monogyna* Jacq.	*Herball* Part II p.582 *Crafte of Graffynge*
Hellebor, Black	Black Hellebore	*Helleborus niger* L.	*Herball* Part II p.593 *Fromond* p.129
Henbane	Henbane	*Hyoscyamus niger* L.	*Herball* Part I p.226 *Fromond* p.129
Herbe Git or Nigella romana	Fennel Flower	*Nigella sativa* L.	*Names* p.40 *Herball* Part II p.390
Herb ive or Crowfoote plantne	Buck's-horn Plantain	*Plantago coronopus* L.	*Herball* Part I p.288 *Fromond* p.129
Herb Trinite or Noble liverwurte	Liverwort	*Hepatica nobilis* Schreber	*Herball* Part III p.764 *Labyrinth* Part I p.30
Holleke	Shallot (?)	*Allium cepa* L. var.	*Herball* Part I p.267

Turner's English Name or Early Modern Name	Modern English Name	Scientific Name	Reference
Holy Oke or Lesse(r) garden mallow	Hollyhock	*Alcea rosea* L.	*Herball* Part II p.435 *Banckes' Herball*
Honysuckle or Wodbynde	Honeysuckle	*Lonicera periclymenum* L.	*Herball* Part II p.493 *Tusser* p.154
Hoppes	Hop	*Humulus lupulus* L.	*Names* p.49 *Herball* Part II p.433
Horehounde, Blake or H. Synkynge	White Horehound	*Marrubium vulgare* L.	*Herball* Part I p.249 *Fromond* p.129
Hysope	Hyssop	*Hyssopus officinalis* L.	*Names* p.43 *Herball* Part II p.399
Iasme or Iesamin or Gethsamine	Jasmine	*Jasminum* L., Species of	*Names* p.44 *Herball* Part II p.400
Indishe peper or Pepper	Pepper	*Capsicum* L., Species of	*Names* p.63 *Herball* Part II p.506
Indishe millet or Turkish millet or Ried millet	Maize	*Zea mays* L.	*Herball* Part II p.456

Turner's English Name or Early Modern Name	Modern English Name	Scientific Name	Reference
Langdebefe or Thistelles	Thistle, Sp.	*Cirsium* Miller, Species of	*Herball* Part I p.142 *Herball* Part II p.580 *Hill* Chapter i *Fromond* p.129
Larkyshele or Larks Foot	Larkspur	*Consolida ajacis* (L.) Schur (?)	*Herball* Part I p.295 *Tusser* p.153
Laurel tree or Bay tree	Bay	*Laurus nobilis* L.	*Names* p.47 *Herball* Part II p.418 *Fromond* p.127
Lavander, Lavander spyke	Garden Lavender	*Lavandula x intermedia* Lois	*Herball* Part III p.745
Lavander cotten	Lavender Cotton	*Santolina chamaecyparissus* L.	*Tusser*, p.152 *Hill* Chapter vi
Leke or French leke	Leek	*Allium porrum* L.	*Names* p.65 *Herball* Part II p.523 *Hill* Chapter vii *Fromond* p.129
Lettes or Lettuce	Garden Lettuce	*Latuca sativa* L.	*Herball* Part II p.409 *Fromond* p.130

Turner's English Name or Early Modern Name	Modern English Name	Scientific Name	Reference
Lily	Madonna Lily	*Lilium candidum* L.	*Herball* Part II p.427 *Hill* Chapter viii *Fromond* p.130
Long horehound or Catmynt or Nepe	Garden Catmint	*Nepeta species* L.	*Herball* Part I p.259 *Herball* Part II p.582 *Fromond* p.130
Lovage	Lovage	*Levisticum officinale* W.D.J. Koch	*Names* p.85 *Fromond* p.130
Lupine or Fig beane	Lupin	*Lupinus albus* L.	*Herball* Part II p.434 *Labyrinth* Part I p.57 *Fromond* p.130
Lycores	Liquorice	*Glycyrrhiza glabra* L.	*Herball* Part II p.392
Madder	Wild Madder	*Rubia peregrina* L. *and Rubia tinctorum* L.	*Herball* Part II p.546 *Fromond* p.127
Mallow, garden or Maw	Mallow	*Malvaceae*	*Names* p.50 *Herball* Part II p.435 *Fromond* p.130
Mandrage or Mandrag	Mandrake	*Atropa mandragora* L.	*Names* p.51 *Herball* Part II p.437 *Fromond* p.130

Turner's English Name or Early Modern Name	Modern English Name	Scientific Name	Reference
Marierum gentle	Wild Marjoram	*Origanum majorana* L.	*Herball* Part I p.228 *Hill* Chapter viii
Maries thystel or Milk thistle	Milk Thistle	*Silybum marianum* L.	*Herball* Part II p.580 *Fromond* p.132
Marigoldes	Marigold	*Calendula officinalis* L.	*Herball* Part I p.260 *Hill* Chapter i *Fromond* p.130
Masterwort or Pillitory of Spain or Great pilletorye of Spayne	Masterwort	*Peucedanum ostruthium* (L.) Koch	*Herball* Part II p.416 *Herball* Part III p.744 *Fromond* p.130
May Lilies	Lily of the valley	*Convallaria majalis* L.	*Names* p.35
Medic fother or Horned claver	Sickle Medick	*Medicago sativa* L., subsp. *falcata* (L.) Arcang.	*Herball* Part II p.447
Medler tree or Open arse tree	Medlar	*Mespilus germanica* L.	*Herball* Part II p.453 *Crafte of Graffynge*
Melone	Melon	*Cucumis melo* L.	*Herball* Part I p.290 *Hill* Chapter viii *Fromond* p.130
Meon or Mew	Spignel	*Meum athamanticum* Jacq.	*Herball* Part II p.453

Turner's English Name or Early Modern Name	Modern English Name	Scientific Name	Reference
Mercury	Mercury, Annual	*Mercurialis annua* L.	*Herball* Part II p.452
Mock chervel	Sweet Cicely	*Myrrhis odorata* (L.) Scop.	*Herball* Part II p.459
Mugwurt or Pontike Wormwod	Mugwort	*Artemesi vulgaris* L.	*Herball* Part I p.217 *Fromond* p.130
Mulbery or Black Mulbery	Black mulberry	*Morus nigra* L.	*Names* p.54 *Herball* Part II p.457
Mullen, Wild or Sage mullen	White Mullein	*Verbascum lychnitis* L.	*Herball* Part II p.595
Mustarde, Black	Black Mustard	*Brassica nigra* (L.) Koch	*Herball* Part II p.571
Mustarde, White	White Mustard	*Sinapis alba* L.	*Herball* Part II p.571
Myrt Tree	Myrtle	*Myrtus communis* L.	*Herball* Part II p.460
Mynte, Garden, or Spere mynte or Baum mynte	Spear Mint	*Mentha spicata* L.	*Herball* Part II pp.449, 575 *Fromond* p.130
Nape or Yellow rape	Rape	*Brassica napus* L.	*Herball* Part II p.540 *Fromond* p.131
Narcissus	Narcissus	*Narcissus* L., Species of	*Names* p.55 *Herball* Part II p.462

Turner's English Name or Early Modern Name	Modern English Name	Scientific Name	Reference
Nettell	Roman Nettle	*Urtica pilulifera* L.	*Names* p.81 *Herball* Part II p.605
Nighteshad, Petemorell	Black Nightshade	*Solanum nigrum* L.	*Herball* Part II p.577
Oke of Hierusalem	Jerusalem Oak or Feather Geranium	*Chenopodium botrys* L.	*Names* p.20 *Herball* Part I p.253
Onyon	Onion	*Allium cepa* L.	*Herball* Part I p.267 *Hill* Chapter viii *Fromond* p.130
Orchanet, Rede bugloshe	Alkanet (Bugloss)	*Anchusa* L., Species of	*Herball* Part I p.233
Organe	Wild Marjoram	*Origanum vulgare* L.	*Herball* Part II p.474 *Fromond* p.130
Otes	Oat	*Avena Sativa* L.	*Herball* Part I p.248
Oxislip or Pagle	Oxlip	*Primula elatior* (L.) Hill	*Herball* Part III p.767
Palma Christi or Ticke sede	Castor Oil Plant	*Ricinus communis* L.	*Names* p.68 *Herball* Part II p.544 *Fromond* p.128
Panike	Foxtail Bristlegrass	*Setaria italica* (L.) P. Beauv.	*Names* p.59 *Herball* Part II p.485
Parietori of the Wall or Pillitorie	Pellitory-of-the-wall	*Parietaria officinalis* L.	*Herball* Part II p.394 *Fromond* p.131

Turner's English Name or Early Modern Name	Modern English Name	Scientific Name	Reference
Patience dock or Herb patience	Patience Dock	*Rumex patentia* L.	*Herball* Part II p.549 *Labyrinth* Part I p.30 *Fromond* p.130
Paulis betony	Heath Speedwell	*Veronica officinalis* L.	*Herball* Part I p.252
Pea or Common gray pease	Garden Pea	*Pisum sativum* L.	*Herball* Part II p.510 Hill Chapter vii
Pear tree	Pear	*Pyrus communis* L.	*Herball* Part II p.534
Peche Tree	Peach	*Prunus persica* (L.) Batsch	*Herball* Part II p.441 *Crafte of Graffynge* *Fromond* p.130
Pennyryal	Pennyroyal	*Mentha pulegium* L.	*Herball* Part II p.532 Hill Chapter viii *Fromond* p.131
Peonye (fem)	Common Peony	*Paeonia officinalis* L.	*Herball* Part II p.496 *Fromond* p.131
Persely	Garden Parsley	*Petroselinum crispum* (Miller) Nyman ex A.W. Hill	*Names* p.15 *Herball* Part I p.239 *Fromond* p.130

Turner's English Name or Early Modern Name	Modern English Name	Scientific Name	Reference
Persnepe	Parsnip	*Pastinaca sativa* L.	*Herball* Part II p.573 *Banckes' Herball Hill* Chapter viii *Fromond* p.130
Perwyncle or Perywyncle	Lesser Periwinkle	*Vinca minor* L.	*Names* p.28 *Herball* Part I p.279
Peti Panik	Canary-grass	*Phalaris canariensis* L.	*Herball* Part II p.497
Plum, Garden	Plum	*Prunus domestica* L., subsp. *domestica*	*Herball* Part II p.527 *Fromond* p.131
Pomgranat tree	Pomegranate	*Punica granatum* L.	*Names* p.52 *Herball* Part II p.442
Poppy, Garden, or White poppy or Chesboule	Opium Poppy	*Papaver somniferum* L.	*Names* p.59 *Herball* Part II p.486 *Fromond* p.131
Popyroyall or Red Cornrose	Common Poppy	*Papaver rhoeas* L. or *Papaver somniferum* L. *paeoniaeflorum?*	*Herball* Part II p.486 *Fromond* p.131
Porcellayn	Common Purslane	*Portulaca oleracea* L.	*Herball* Part II p.526 *Fromond* p.131

Turner's English Name or Early Modern Name	Modern English Name	Scientific Name	Reference
Primrose or Primerose	Primrose	*Primula vulgaris* Huds.	*Herball* Part III p.767 *Tusser* p.152 *Fromond* p.131
Prymprynt or Privet	Wild Privet	*Ligustrum vulgare* L.	*Herball* Part II p.425
Pyne tree	Scots Pine	*Pinus sylvestris* L.	*Names* p.62 *Herball* Part II p.501 *Fromond* p.131
Pyper white	Pepperwort	*Lepidium campestre* (L.) R.Br. (?)	*Fromond* p.131
Quince tree	Quince	*Cydonia oblonga* Miller	*Herball* Part II p.441 *Crafte of Graffynge* *Fromond* p.131
Radice, Garden or Rape radice or Round radice or Almayne radice	Garden Radish	*Raphanus sativus* L.	*Herball* Part II p.538 *Fromond* p.131
Rammes or Ramseyes	Ramsons	*Allium ursinum* L.	*Herball* Part I p.224 *Fromond* p.131
Rapouncez or Rapounses	Rampion Bellflower	*Campanula rapunculus* L.	*Fromond* p.131
Raspis bush or Hindberry bush	Raspberry	*Rubus idaeus* L.	*Names* p.68 *Herball* Part II p.548

Turner's English Name or Early Modern Name	Modern English Name	Scientific Name	Reference
Ribes	Red Currant	*Ribes rubrum* L.	*Herball* Part III p.757
Rocket, Garden	Garden Rocket	*Eruca vesicaria* (L.) Cav. *Eruca vesicaria* subsp. *sativa* (Miller) Thell	*Names* p.35 *Herball* Part I p.309 *Fromond* p.131
Rose, red	Gallic Rose	*Rosa*, L., Species of *Rosa gallica* L.	*Herball* Part II p.545 *Hill* Chapter i. *Fromond* p.131
Rose, white	Sweet Briar or Eglantine Rose	*Rosa x alba* L. (?) *Rosa rubiginosa* L.	*Herball* Part II p.545 *Fromond* p.131
Roses, Damaske	Damask Rose	*Rosa x damascena* Mill.	*Herball* Part II p.545
Roses, Musk	Musk Rose	*Rosa moschata* Herrm.	*Herball* Part II p.545
Rose Campi	Red Campion	*Silene dioica* (L.) Clairv.	*Names* p.79 *Fromond* p.128
Rosmary	Rosemary	*Rosmarinus officinalis* L.	*Names* p.48 *Herball* Part II p.423 *Fromond* p.131
Rubarbe	Rhubarb	*Rheum x hybridum* Murray	*Herball* Part III p.758 *Tusser* p.154

Turner's English Name or Early Modern Name	Modern English Name	Scientific Name	Reference
Rue or Herbe Grace	Rue	*Ruta graveolens* L.	*Herball* Part II p.552 *Fromond* p.131
Saffron	Crocus or Saffron	*Crocus sativus* L.	*Herball* Part I p.289 *Banckes' Herball*
Sage or Sauge	Sage	*Salvia officinalis* L.	*Herball* Part II p.556 *Banckes' Herball* *Fromond* p.131
Sage Mullen	White Mullein	*Verbascum lychnitis* L.	*Herball* Part II p.595
Sage of Hierusalem	Jerusalem Sage or Lungwort	*Pulmonaria officinalis* L.	*Herball* Part I p.248 *Labyrinth* Part I p.30 *Fromond* p.130
Saint Johans grasse or Saint Johans wurt	St John's-wort, Perforate	*Hypericum perforatum* L.	*Herball* Part II p.399
Saucealone or Jack of the Hedge	Garlic Mustard	*Alliaria petiolata* (M.Bieb) Cavara & Grande	*Herball* Part III p.727 *Fromond* p.129
Saverye, Garden	Summer Savory	*Satureja hortensis* L.	*Herball* Part II p.557 *Fromond* p.131
Saverye, Winter	Winter Savory	*Satureja Montana* L.	*Herball* Part II p.557 *Fromond* p.131

Turner's English Name or Early Modern Name	Modern English Name	Scientific Name	Reference
Savin	Savine	*Juniperus Sabina* L.	*Names* p.69 *Herball* Part II p.553
Scorpiones tayle	Heliotrope	*Heliotropium europaeum* L.	*Herball* Part II p.393
Sea Holly or Se hulver	Sea-Holly	*Eryngium maritimum* L.	*Herball* Part I p.311 *Fromond* p.129
Sea Onion or French Onyon or Squyll onyon	Squill Onion	*Drimia maritima* (L.) Stearn	*Names* p.71 *Labyrinth* Part II p.105
Scalyon	Spring Onion (?)	*Allium cepa* L. or *Allium fistulosum* L.	*Herball* Part I p.267
Selfe heale	Selfheal	*Prunella vulgaris* L.	*Herball* Part III p.756 *Labyrinth* Part I p.30
Shepherdes pouche	Shepherd's-purse	*Capsella bursa-pastoris* (L.) medikus	*Herball* Part III p.733
Skirwurte	Skirret	*Sium sisarum* L.	*Herball* Part II p.549 *Tusser* p.151
Smallage or Marche	Wild Celery	*Apium graveolens* L.	*Names* p.35 *Herball* Part I p.308 *Fromond* p.132

Turner's English Name or Early Modern Name	Modern English Name	Scientific Name	Reference
Smilax of the garden or Kidney Bean or Sperage	French Bean	*Phaseolus vulgaris* L.	*Herball* Part II p.576
Sorrell	Sorrell	*Rumex acetosa* L.	*Herball* Part II p.549 *Labyrinth* Part I p.30 *Fromond* p.132
Sothernwod	Southernwood	*Artemesia abrotanum* L.	*Names* p.7 *Herball* Part I p.219 *Fromond* p.132
Sowthystel	Smooth Sow-thistle	*Sonchus oleraceus* L.	*Herball* Part I p.273 *Fromond* p.132
Spikenarde	Valerian	*Valeriana jatamansi* Roxb.	*Herball* Part II p.464 *Labyrinth* Part I p.30
Spinage or Spinech	Spinach	*Spinacea oleracea* L.	*Herball* Part III p.763 *Hill* Chapter i *Fromond* p.132
Spourge, Myrtel	Broad-leaved Spurge	*Euphorbia platyphyllos* L. (?)	*Herball* Part II p.588
Stavis aker	Stavesacre	*Delphinium staphisagria* L.	*Herball* Part II p.583
Stitchwort	Stitchwort	*Stellaria holostea* L.	*Names* p.41 *Tusser* p.154

Turner's English Name or Early Modern Name	Modern English Name	Scientific Name	Reference
Strawberry	Wild Strawberry	*Fragaria vesca* L.	*Names* p.38 *Herball* Part II p.384 *Labyrinth* Part II p.76
Sweet William	Sweet William	*Dianthus barbatus* L.	*Tusser* p.153
Tansy	Tansy	*Tanacetum vulgare* L.	*Herball* Part II p.489 *Tusser* p.152 *Fromond* p.132
Tarrago	Tarragon	*Artemisia dracunculus* L.	*Names* p.77 *Labyrinth* Part II p.71
Tasel, Wylde or Garden	Wild Teasel	*Dipsacus fullonum* L.	*Names* p.34 *Herball* Part I p.305
Thrift	Thrift or Sea Pink	*Armeria maritima* (Mill.) Willd.	*Tusser* p.155
Triacle Mustard or Boures Mustard or Dish Mustard or Thlaspi	Field Penny-Cress or Treacle-Mustard	*Thlaspi arvensis* L. (?) or *Erysimum cheiranthoides* L. (?)	*Herball* Part II p.586
Thyme	Thyme	*Thymus vulgaris* L.	*Herball* Part II p.590 *Hill* Chapter i *Fromond* p.132
Totsan	Tutsan	*Hypericum Androsaemum* L.	*Names* p.12 *Herball* Part I p.234

Turner's English Name or Early Modern Name	Modern English Name	Scientific Name	Reference
Trifolye gentle	Alsike Clover (?)	*Trifolium hybridum* L.	*Herball* Part II p.592
Turnepe or Great round rape	Turnip	*Brassica rapa* L.	*Herball* Part II p.540 *Fromond* p.132
Two Faces in a Hood or Panses	Heartsease or Wild Pansy	*Viola tricolor* L.	*Names* p.87 *Labyrinth* p.37 *Fromond* p.129
Valeriane	Valerian	*Valeriana officinalis* L.	*Herball* Part III p.764 *Labyrinth* Part II p.164 *Fromond* p.132
Vervine	Vervain	*Verbena officinalis* L.	*Herball* Part II p.595 *Fromond* p.132
Violet	Sweet Violet	*Viola odorata* L.	*Herball* Part II p.597 *Hill* Chapter i *Fromond* p.132
Wadde	Woad	*Isatis tinctoria* L.	*Herball* Part II p.391
Wal gelover or hartis ease	Wallflower	*Erysimum cheiri* (L.) Crantz (?)	*Herball* Part II p.597 *Tusser* p.153 *Fromond* p.132

Turner's English Name or Early Modern Name	Modern English Name	Scientific Name	Reference
Walnut tree	Walnut	*Juglans regia* L.	*Herball* Part II p.406 *Crafte of Graffynge*
Water Melon	Water Melon	*Citrullus lanatus* (Thunb.) Matsum & Nakai	*Herball* Part I p.290 *Hill* Chapter viii
White Wurt or Scala caeli	Solomon's Seal	*Polygonatum multiflorum* (L.) All.	*Names* p.64 *Herball* Part II p.517 *Fromond* p.132
Wild Tansy	Silverweed	*Potentilla anserina* L. now *Argentina anserina* (L.) Rydb.	*Herball* Part III p.728 *Fromond* p.132
Wild Thyme or Creeping Thyme	Breckland Thyme	*Thymus serpyllum* L.	*Herball* Part II p.565
Wood Spourge	Mediterranean spurge	*Euphorbia characias* L.	*Herball* Part II p.588
Wormwode	Wormwood	*Artemisia absinthium* L.	*Herball* Part I p.217 *Fromond* p.132
Wylde lote	Yellow Melilot	*Melilotus officinalis* (L.) Pall.	*Names* p.49
Yelowe wolfes bayne	Wolf's-bane	*Aconitum vulparia* Reichb. (?)	*Herball*, Part I, p.221

Bibliography

Primary sources

Maps and plans

Allen, Elias, map of the Manor of Bisham, 1609 (Reading, Berkshire Record Office, D/EX 1128/1).

Anon., plan of Cecil House in the Strand, London, 1562–1565 (Burghley House, Lincolnshire, M 358).

Anon., 'Copperplate' map of London, *c.*1559 (Museum of London).

Anon., plan of the Waterworks to be erected, probably of 'The Dell', Hatfield House, Hertfordshire, 1611 (National Archives SP14/67 1317086).

Anon., map of Titchfield, Hampshire, 1610, in William Page, ed., *A History of the County of Hampshire, Volume III* (London, 1908).

Du Cerceau, Jacques Androuet, plan of the garden of the château of Gaillon, in *Le premier volume des plus excellents bastiments de France* (Paris, 1576).

——, plans of the châteaux of Fontainebleau, Amboise and Blois, in *Le second volume des plus excellents bastiments de France* (Paris, 1579).

Glover, Moses, map of Isleworth, Middlesex, 1617 (Collection of the Duke of Northumberland, Syon House, Middlesex).

Hare, Benjamin, map of Gorhambury House, Hertfordshire, 1634 (Hertford, Hertfordshire Archives D/EV P1).

Norden, John, map of Middlesex, in *Speculum Britanniae. The first parte an historicall, & chorographicall discription of Middlesex [. . .]* (London, 1593).

Saxton, Christopher, *Christopher Saxton's Sixteenth Century Maps* (Shrewsbury, 1992).

Senior, William, estate map of Chatsworth, Derbyshire, 1617 (Devonshire Collection, Chatsworth House, Derbyshire).

Smythe, Lawrence, estate map of Raglan Castle, Gwent, 1652 (Duke of Beaufort, Badminton House).

Smythson, Robert, plan of the house and gardens at Twickenham *c*.1609 (London, Royal Institute of British Architects).

——, plan of the house and gardens at Wimbledon *c*.1609 (London, Royal Institute of British Architects).

Speed, John, map of Surrey, in *The Theatre of the Empire of Great Britaine* (London, 1611).

Thorpe, John, survey of Cheshunt Park, Hertfordshire, 1611 (London, British Library, Cotton MS Aug.I.i.75).

Treswell, Ralph, *The London Surveys of Ralph Treswell*, ed. John Schofield (London, 1987).

——, map of Holdenby, 1587 (Northampton, Northamptonshire Record Office, Finch Hatton 272).

——, map of Petworth, 1610 (Chichester, West Sussex Record Office, PHA 3574).

——, map of Syon, 1607 (Collection of the Duke of Northumberland, Alnwick Castle, Northumberland).

Books

Alberti, Leon Battista, *On the Art of Building in Ten Books*, trans. Joseph Rykwert, Neil Leach and Robert Tavernor (London and Cambridge, MA, 1988).

Anon., *A closet for ladies and gentlewomen [. . .]* (London, 1608).

Anon., *Here begynnyth a newe mater, the whiche sheweth and treateth of ye vertues [and] proprytes of herbes, the whiche is called an herball Cum gratia [and] privilegio a rege indulto* ([London] [1525]).

Anon., *The crafte of graffynge & plantynge of trees* ([London?], [1518?]).

Anon., *The orchard and the garden [. . .]* (London, 1594).

Anon., *A short instruction very profitable and necessary [. . .]* (London, 1592).

Anon., *The Speeches and Honorable Entertainment given to the Queenes Maiestie in Progresse, at Cowdrey in Sussex, by the right Honorable the Lord Montacute. 1591* (London, 1591).

Ariosto, Ludovico, *Orlando Furioso*, trans. David R. Slavitt (Cambridge, MA and London, 2009).

——, *Orlando furioso in English heroical verse by Iohn Haringto[n]* (London, 1591).

Aubrey, John, *Brief Lives* (1680), ed. Richard Barber (Woodbridge, 1975; repr. 1982).

Bacon, Francis, *The Essays* (1625), ed. John Pitcher (London, 1985).

——, *The Works of Francis Bacon*, eds James Spedding, Robert Ellis and Douglas Denon Heath, 14 vols (London, 1868; repr. Cambridge, 2011).

Barnes, Barnabe, *Parthenophil and Parthenophe Sonnettes, madrigals, elegies and odes* (London, 1593).

Bodenham, John, *Bel-vedere, or, The Garden of the Muses* (London, 1600).

Breton, Nicholas, 'A strange description of a rare Garden plot', in R.S. of the Inner Temple, *The Phoenix Nest [. . .]* (London, 1593).

Calendar of the Cecil Papers in Hatfield House, Hertfordshire, eds R.A. Roberts and others, 24 vols (London, 1883-1976).

Calendar of State Papers, Foreign Series, of the Reign of Edward VI: 1547-1553, ed. William Turnbull (London, 1861).

Calendar of State Papers, Foreign Series, of the Reign of Elizabeth, eds Joseph Stevenson and others, 23 vols (London, 1863-1950).

Calendar of State Papers Relating to English Affairs in the Archives of Venice and other Libraries of Northern Italy, eds L. Rawdon Brown and others, 38 vols (London, 1864-1947).

Camden, William, *Annales: The True and Royall History of the famous Empresse Elizabeth Queene of England France and Ireland &c. [. . .]* (London, 1625).

——, *Britannia: The Division of Britaine* (1586), 4 vols (Birmingham, 2009).

——, *Remaines of a Greater Worke, concerning Britaine [. . .]* (London, 1605).

Castiglione, Baldassarre, *The courtyer of Count Baldessar Castilio diuided into foure bookes. [. . .], done into Englyshe by Thomas Hoby* (London, 1561).

Caus, Salomon de, *Les Raisons des forces mouvantes [. . .]* (Frankfurt, 1615).

Charles VIII, *Lettres de Charles VIII, Volume IV*, ed. Paul Pelissier (Paris, 1903).

Churchyard, Thomas, *The worthines of Wales [. . .]* (London, 1587).

Colonna, Francesco (attrib.), *Hypnerotomachia Poliphili: The Strife of Love in a Dream* (1499), trans. by Joscelyn Godwin (London, 1999; repr. 2005).

——, *Hypnerotomachia Poliphili* (Venice, 1499).

——, *Hypnerotomache, ou Discours du Songe de Poliphile [. . .]* (Paris, 1561).

Coryat, Thomas, *Coryat's Crudities [. . .]* (1611), 2 vols (Glasgow, 1905).

Davies, John, *Hymnes of Astraea in acrosticke verse* (London, 1599).

Dekker, Thomas, *The Batchelars banquet [. . .]* (London, 1603).

——, *The Pleasant Comedie of Old Fortunatus [. . .]* (London, 1600).

Dodoens, Rembert, *A nievve herball, or historie of plantes [. . .]*, trans. Henry Lyte (London, 1578).

Drayton, Michael, *Idea the shepheards garland. Fashioned in nine eglogs [. . .]* (London, 1593).

Du Cerceau, Jacques Androuet, *Jacques Androuet du Cerceau: Les Dessins des Plus excellents bâtiments de France*, ed. Françoise Boudon and Claude Mignot (Paris, 2010).

Dudley, Robert, Earl of Leicester, *Household Accounts and Disbursement Books of Robert Dudley, Earl of Leicester, 1558-61, 1584-86*, ed. Simon Adams (Cambridge, 1995).

Fale, Thomas, *Horologiographia The art of dialling [. . .]* (London, 1593).

Feuillerat, Albert, ed., *Documents relating to the Office of Revels in the Time of Queen Elizabeth* (Louvain, 1908).

Gascoigne, George, *The noble arte of venerie or hunting [. . .]* (London, 1575).
——, *The Princely Pleasures [. . .]* (London, 1576).
Gerard, John, *Catalogus arborum [. . .]* (London, 1596).
——, *Catalogus arborum [. . .]* (London, 1599).
——, *The Herball or Generall Historie of Plantes. Gathered by Iohn Gerarde of London Master in Chirurgerie* (London, 1597).
——, *The Herbal or General History of Plants [. . .]* (New York, 1975).
Gorges, Sir Arthur, *The Poems of Sir Arthur Gorges*, ed. Helen Estabrook Sandison (Oxford, 1953).
Harington, Sir John, *An anatomie of the metamorph-sed Aiax [. . .]* (London, 1596).
Harriot, Thomas, *A Briefe and True Report of the New Found Land of Virginia* (Frankfurt, 1590; repr. Mineola, NY, 1972).
——, *A briefe and true report [. . .]* (Frankfurt, 1590).
Harrison, William, *The Description of England* (1577) (Milton Keynes, 2011).
Hentzner, Paul, and Robert Naunton, *Travels in England* (1612) and *Fragmenta Regalia* (1641) (London, 1892; repr. Gloucester, 2010).
Heresbach, Conrad, *Foure bookes of husbandrie [. . .] Newly Englished, and increased by Barnabe Googe, Esquire* (London, 1577).
Hill, Thomas, *The Arte of Gardening [. . .]* (London, 1608).
——, *The Gardeners Labyrinth [. . .]* (London, 1577).
——, *The Gardener's Labyrinth* (1577), ed. Richard Mabey (Oxford, 1988).
——, *A most briefe and pleasaunte treatise [. . .] And nowe englished by Thomas Hyll Londine* (London, [1558?]).
——, *The proffitable arte of gardening [. . .] Englished by Thomas Hill Londiner* (London, 1568).
Hoby, Lady Margaret, *The Private Life of an Elizabethan Lady: The Diary of Lady Margaret Hoby, 1599–1605*, ed. Joanna Moody (Stroud, 1998).
Hoby, Thomas, *The Travels and life of Sir Thomas Hoby, Kt. Of Bisham Abbey, written by Himself: 1547–1564*, ed. Edgar Powell (London, 1902).
Holinshed, Raphael, *The first and second volumes of Chronicles [. . .]* (London, 1587).
——, *The third volume of Chronicles [. . .]* (London, 1587).
Jonson, Ben, *The Complete Poems*, ed. George Parfitt (London, 1996).
Laneham, Robert, *Robert Laneham's Letter: Describing a part of the Entertainment unto Queen Elizabeth at the Castle of Kenilworth in 1575*, ed. F.J. Furnivall (London, 1907).
Lawson, William, *A nevv orchard and garden [. . .]* (London, 1618).
L'Obel, Matthias de, and Petrus Pena, *Stirpium adversaria nova* (London, 1571).
Lyly, John, *Campaspe, played before the Queenes Maiestie on Newyeares day at night by her Maiesties children and the children of Paules* (London, 1584).

——, *The Complete Works of John Lyly*, ed. Richard Warwick Bond, 3 vols (Oxford, 1902).

——, (attrib.) *Queen Elizabeth's Entertainment at Mitcham*, ed. Leslie Hotson (New Haven, CT, 1953).

Markham, Gervase, *Countrey contentments, or The English huswife [. . .]* (London, 1623).

——, *The English Husbandman [. . .]* (London, 1613).

——, *The English huswife [. . .]* (London, 1615).

——, ed. *Maison rustique or The countrey farme* (London, 1616).

Marlowe, Christopher, *The Complete Plays*, eds Frank Romany and Robert Lindsey (London, 2003).

Munday, Anthony, *A banquet of daintie conceits [. . .]* (London, 1588).

Newton, Thomas, *Atropoïon Delion, or, The death of Delia with the teares of her funerall [. . .]* (London, 1603).

Norden, John, *Speculum Britanniae [. . .]* (London, 1593).

Ovid, *The fyrst fower bookes of P. Ouidius Nasos worke, intitled Metamorphosis, translated oute of Latin into Englishe meter by Arthur Golding Gent. [. . .]* (London, 1565).

——, *Metamorphoses*, trans. A.D. Melville (Oxford, 2008).

Palissy, Bernard, *Architecture et ordonnance de la grotte rustique de Mgr le Duc de Montmorancy, connestable de France* (La Rochelle, 1563).

Peele, George, *The Works of George Peele*, ed. A.H. Bullen, 2 vols (London, 1888).

——, *The Works of George Peele: Collected and edited, with some account of his life and writings*, ed. Alexander Dyce, 2 vols (London, 1829).

Petowe, Henry, *Elizabetha quasi vivens Eliza's funeral. A fewe Aprill drops, showred on the hearse of dead Eliza. Or the funeral teares af [sic] a true hearted subject. By H.P.* (London, 1603)

Plat, Sir Hugh, *Delightes for ladies [. . .]* (London, [1600?]).

Platter, Thomas, *Thomas Platter's Travels in England 1599*, trans. and ed. Clare Williams (London, 1937).

Pliny the Younger, *The Letters of the Younger Pliny*, trans. William Melmoth (Cambridge, MA, 1909).

Pontano, Giovanni, *I Trattati delle virtù sociali: De Liberalitate, De Beneficentia, De Magnificentia, De Splendore, De Conviventia* (Naples, 1498).

Puttenham, George, *The arte of English poesie [. . .]* (London, 1589).

Pyott, Lazarus, *The second booke of Amadis de Gaule [. . .]* (London, 1595).

R.S. of the Inner Temple, *The Phoenix Nest [. . .]* (London, 1593).

Serlio, Sebastiano, *Tutte l'opere d'architettura et prospetiva*, 7 vols (1545–57).

Shakespeare, William, *The Complete Works* (New York, 1994).

——, *The Plays of William Shakespeare, Volume the Sixth*, eds Samuel Johnson and George Stevens (London, 1778).

Sidney, Philip, *The Countesse of Pembrokes Arcadia, written by Sir Philippe Sidnei* (London, 1590).

——, *The Countesse of Pembrokes Arcadia. Written by Sir Philip Sidney Knight. Now since the first edition augmented and ended* (London, 1593).

——, *The Countess of Pembroke's Arcadia: (The Old Arcadia)*, ed. Katherine Duncan-Jones (Oxford, 2008).

——, *The Major Works*, ed. Katherine Duncan-Jones (Oxford, 1989; repr. 2008).

Spenser, Edmund, *The Faerie Queene Disposed into twelve books, Fashioning XII. Morall vertues* (London, 1590).

——, *The Shepheardes Calender [. . .]* (London, 1579).

Straton, Charles R., ed., *Survey of Lands of William First Earl of Pembroke*, 2 vols (Oxford, 1909).

Sylvester, Joshua, *Bartas: his devine weekes and works translated [. . .]* (London, 1605).

Taylor, John, *A new discouery by sea, with a vvherry from London to Salisbury. Or, a voyage to the West, the worst, or the best That e're was exprest* (London, 1623).

Turberville, George, *The booke of faulconrie [. . .]* (London, 1575).

Turner, William, *Libellus de Re Herbaria Novus* (1538), ed. by Benjamin Daydon Jackson (London, 1877).

——, *The names of herbes in Greke, Latin, Englishe, Duche [and] Frenche [. . .]* (London, 1548).

——, *The Names of Herbes* (1548), ed. James Britten (London, 1881; repr. Milton Keynes, 2010).

——, *A new herball [. . .]* (London, 1551).

——, *The first and seconde partes of the herbal of William Turner Doctor in Phisick, lately ouersene, corrected and enlarged with the thirde parte, lately gathered, [. . .]* (Cologne, 1568).

——, *The seconde part of William Turners herball [. . .]* (Cologne, 1562).

——, *The thirde parte of William Turners Herball [. . .]* (Cologne, 1568).

——, *A New Herball: Parts I, II, and III* (1551, 1562 and 1568), eds George T.L. Chapman and Marilyn N. Tweddle (Manchester, 1989; repr. Cambridge, 1995).

Tusser, Thomas, *Thomas Tusser: 1557 Floruit. His Good Points of Husbandry*, ed. Dorothy Hartley (London: Country Life, 1931).

Valdštejna, Zdeněk Brtnický z ('Baron Waldstein'), *The Diary of Baron Waldstein: A Traveller in Elizabethan England* (1600), trans. G.W. Groos (London, 1981).

Vigne, Andrê de La and Octavien de Saint-Gelais, *Le Vergier d'honneur [. . .]* (Paris, c.1512).

Virgil, *The Eclogues and the Georgics*, trans. C. Day Lewis (1963 and 1940) and ed. R.O.A.M. Lyne (Oxford, 1983; repr. 2009).

Vredeman de Vries, Hans, *Hortorum Viridariorumque elegantes mutiplices formae, ad architectonicae artis, normam affabre delineatae a Iohanne Vredemanno Frisio* (Antwerp, 1587; repr. Amsterdam, 1980).

Wirtembirg, Frederick Duke of, *A True and Faithfull Narrative of the Bathing Excursion [. . .]* (1602), trans. William Brenchley Rye, in *England as Seen by Foreigners in the days of Elizabeth and James the First* (London, 1865).

Secondary sources

Books

Adams, William Howard, *The French Garden, 1500–1800* (New York, 1979).

Aiton, William, *Hortus Kewensis; or, a Catalogue of the Plants Cultivated in the Royal Botanic Garden at Kew*, 3 vols (London, 1789).

Appleby, Andrew, 'Diet in Sixteenth-Century England: Sources, Problems, Possibilities', in *Health, Medicine and Mortality in the Sixteenth Century*, ed. Charles Webster (Cambridge, 1979).

Arber, Agnes, *Herbals: Their Origin and Evolution* (Cambridge, 1912; repr. 1990).

Archer, Jane Elisabeth, Elizabeth Goldring and Sarah Knight, eds, *The Progresses, Pageants, & Entertainments of Queen Elizabeth I* (Oxford, 2007).

Barkan, Leonard, ed., *Renaissance Drama: New Series*, 40 vols, VIII (Evanston, IL, 1977).

Batey, Mavis, *The Historic Gardens of Oxford and Cambridge* (London, 1989).

Blunt, Anthony, *Art and Architecture in France, 1500–1700*, 4th edn (Harmondsworth, 1980).

Borlik, Todd Andrew, *Ecocriticism and Early Modern English Literature: Green Pastures* (New York and Abingdon, 2011).

Brenchley Rye, William, *England as seen by Foreigners in the days of Elizabeth and James the First* (London, 1865; repr. Boston, MA, 2005).

Burnett, David, *Longleat: The Story of an English Country House* (Wimborne Minster, 1978; repr. 2009).

Butler, Katharine, *Music in Elizabethan Court Politics* (Woodbridge, 2015).

Campbell-Culver, Maggie, *The Origin of Plants: The People and Plants that Shaped Britain's Garden History Since the Year 1000* (London, 2001).

Cerasano, S.P., ed., *Medieval and Renaissance Drama in England, Volume 24*, (Madison, WI, 2011).

Chambers, E.K., *The Elizabethan Stage*, 4 vols (Oxford, 1923; repr. 1961).

Chaney, Edward, *The Evolution of the Grand Tour* (London, 1998).

Chaney, Edward and Peter Mack, eds, *England and the Continental Renaissance: Essays in Honour of J.B. Trapp* (Woodbridge, 1990).

Cloake, John, *Palaces and Parks of Richmond and Kew, Volume I (The Palaces of Shene and Richmond)* (Chichester, 1995).

Colvin, Howard and others, eds, *The History of the King's Works*, 6 vols (London, 1963–82).

Cooper, Helen, 'Location and Meaning in Masque, Morality and Royal Entertainment', in *The Court Masque*, ed. David Linley (Manchester, 1984).

Cox, Montague H. and Philip Norman, eds, *Survey of London, Volume XIII: St Margaret, Westminster, Part II: Whitehall I* (London, 1930).

Cunningham, Andrew, 'The Bartholins, the Platters and Laurentius Gryllus: The *peregrinatio medica* in the Sixteenth and Seventeenth Centuries', in *Centres of Medical Excellence? Medical Travel and Education in Europe, 1500–1789*, eds Ole Peter Grell, Andrew Cunningham and Jon Arrizabalaga (Farnham, 2010).

Davidson, Peter and Jane Stevenson, 'Elizabeth I's Reception at Bisham', in *The Progresses, Pageants, & Entertainments of Queen Elizabeth I*, eds Jane Elisabeth Archer, Elizabeth Goldring and Sarah Knight (Oxford, 2007).

De la Tour, Dominique, *Château d'Amboise* (Paris, 2006).

Dovey, Zillah, *An Elizabethan Progress: The Queen's Journey into East Anglia, 1578* (Stroud, 1996).

Dunlop, Ian, *Palaces and Progresses of Elizabeth I* (London, 1962).

Findlen, Paula, *Possessing Nature: Museums, Collecting and Scientific Culture in Early Modern Italy* (Berkeley and Los Angeles, CA, 1994).

Furdell, Elizabeth Jane, *The Royal Doctors 1485–1714: Medical Personnel at the Tudor and Stuart Courts* (Rochester, NY, 2001).

Girouard, Mark, *Elizabethan Architecture: Its Rise and Fall, 1540–1640* (New Haven, CT and London, 2009).

——, *Life in the English Country House: A Social and Architectural History* (New Haven, CT and London, 1978).

Goldring, Elizabeth, 'Portraiture, Patronage and the Progresses', in *The Progresses, Pageants, & Entertainments of Queen Elizabeth I*, Jane Elisabeth Archer, Elizabeth Goldring and Sarah Knight eds (Oxford, 2007).

Grell, Ole Peter, Andrew Cunningham and Jon Arrizabalaga, eds, *Centres of Medical Excellence? Medical Travel and Education in Europe, 1500–1789* (Farnham, 2010).

Grendler, Paul F., *The Universities of the Italian Renaissance* (Baltimore, MD and London, 2001; repr. 2004).

Harkness, Deborah, *The Jewel House: Elizabethan London and the Scientific Revolution* (New Haven, CT and London, 2007).

Hart, W.H., 'The Parliamentary Surveys of Richmond, Wimbledon and Nonsuch, in the County of Surrey, A.D.1649', *Surrey Archaeological Collections, Volume V* (London, 1871).

Henderson, Paula, *The Tudor House and Garden: Architecture and Landscape in the Sixteenth and Early Seventeenth Centuries* (New Haven, CT and London, 2005).

Hill Cole, Mary, *The Portable Queen: Elizabeth I and the Politics of Ceremony* (Amherst, MA, 1999).

Hodgkins, Christopher, *George Herbert's Pastoral: New Essays on the Poet and Priest of Bemerton* (Cranbury, NJ, 2010).

Howard, Clare, *English Travellers of the Renaissance* (London, 1913; repr. Charleston, SC, 2010).

Hyams, Edward, *A History of Gardens and Gardening* (London, 1971).

Hyams, Edward, and William MacQuitty, *Great Botanical Gardens of the World* (London, 1969).

James, Henry, *Selected Letters*, ed. Leon Edd (Cambridge, MA and London, 1987).

Jones, Whitney, *William Turner, Tudor Naturalist, Physician and Divine* (London and New York, 1988).

Kapelle, Rachel, 'Predicting Elizabeth: Prophecy on Progress', in *Medieval and Renaissance Drama in England, Volume 24*, ed. S.P. Cerasano (Madison, WI, 2011).

Knight, Leah, *Of Books and Botany in Early Modern England: Sixteenth Century Plants and Print Culture* (Farnham and Burlington, VT, 2009).

Leatham, Victoria, Jon Culverhouse and Eric Till, *Burghley* (Ketteringham, 2010).

Lim, Walter S.H., *The Arts of Empire: The Poetics of Colonialism from Ralegh to Milton* (London and Cranbury, NJ, 1998).

Linley, David, ed., *The Court Masque*, (Manchester, 1984).

Lock, Stephen, John M. Last and George Dunea, eds, *The Oxford Illustrated Companion to Medicine* (Oxford, 2001).

Loughlin, Marie, Sandra J. Bell and Patricia Brace, eds, *The Broadview Anthology of Sixteenth Century Poetry and Prose* (Peterborough, ON, 2012).

Malcolmson, Cristina, 'William Herbert's Gardener: Adrian Gilbert', in *George Herbert's Pastoral: New Essays on the Poet and Priest of Bemerton*, ed. Christopher Hodgkins (Cranbury, NJ, 2010).

Malden, H.E., ed., *A History of the County of Surrey*, 4 vols (London, 1902–12).

Miller, Naomi, 'Fountains as Metaphor', in *Fountains Splash and Spectacle: Water and Design from the Renaissance to the Present*, eds Marilyn Symmes and Kenneth Breitch (London, 1998).

Moote, A. Lloyd, and Dorothy C. Moote, *The Great Plague: The Story of London's Most Deadly Year* (Baltimore, MD, 2004).

Mosser, Monique, and Georges Teyssot, eds, *The Architecture of Western Gardens: A Design History from the Renaissance to the Present Day* (Cambridge, MA, 1991).

Mowl, Timothy, *The Historic Gardens of England: Dorset* (Stroud, 2003).

Mowl, Timothy and Clare Hickman, *The Historic Gardens of England: Northamptonshire* (Stroud, 2008).

Nail, Sylvie, *Forest Policies and Social Change in England* (New York, 2008).

Nichols, John, *The Progresses and Public Processions of Queen Elizabeth*, 3 vols (London, 1823).

——, *The Progresses and Public Processions of Queen Elizabeth I*, eds Elizabeth Goldring and others, 5 vols (Oxford, 2014).

Olwig, Kenneth Robert, *Landscape, Nature and the Body Politic: From Britain's Renaissance to America's New World* (Madison, WI, 2002).

Oxford Dictionary of National Biography (Oxford, 2004).

Page, William and P.H. Ditchfield, *A History of the County of Berkshire, Volume 3* (London, 1923).

Parkinson, Anna, *Nature's Alchemist: John Parkinson, Herbalist to Charles I* (London, 2007).

Pelling, Margaret, and Charles Webster, 'Medical Practitioners', in *Health, Medicine and Mortality in the Sixteenth Century*, ed. Charles Webster (Cambridge, 1979).

Prest, John, *The Garden of Eden: The Botanic Garden and the Re-Creation of Paradise* (New Haven, CT and London, 1981).

Raven, Charles, *English Naturalists from Neckham to Ray: A Study of the Making of the Modern World* (Cambridge, 1947; repr. 2010).

St John Hope, Sir William H., *Cowdray and Easebourne Priory* (London, 1919).

Samson, Alexander, ed., *Locus Amoenus: Gardens and Horticulture in the Renaissance* (Chichester, 2012).

Santing, Catrien, 'Pieter van Foreest and the Acquisition and Travelling of Medical Knowledge in the Sixteenth Century', in *Centres of Medical Excellence? Medical Travel and Education in Europe, 1500–1789*, eds Ole Peter Grell, Andrew Cunningham and Jon Arrizabalaga (Farnham, 2010).

Shirley, Evelyn Philip, *Some Account of English Deer Parks: With Notes on the Management of Deer* (London, 1867).

Simpson, Sue, *Sir Henry Lee (1533–1611): Elizabethan Courtier* (Abingdon, 2016).

Slack, Paul, 'Mortality Crises and Epidemic Diseases in England 1485–1610', in *Health, Medicine and Mortality in the Sixteenth Century*, ed. Charles Webster (Cambridge, 1979).

Smith, Bruce R., 'Landscape with Figures', in *Renaissance Drama: New Series VIII*, ed. Leonard Barkan (Evanston, IL, 1977).

Spaeth, Barbette Stanley, *The Roman Goddess Ceres* (Austin, TX, 1996).

Starkey, David, *Elizabeth* (London, 2001).

Stillwell, John, *Mathematics and its History* (New York, 1989).

Strong, Roy, *The Cult of Elizabeth: Elizabethan Portraiture and Pageantry* (London, 1977; repr. 1987).

——, *The English Renaissance Miniature* (London, 1983).

——, *The Renaissance Garden in England* (London, 1979).

——, 'Sir Francis Carew's garden at Beddington', in *England and the Continental Renaissance: Essays in Honour of J.B. Trapp*, eds Edward Chaney and Peter Mack (Woodbridge, 1990).

——, *The Tudor and Stuart Monarchy: Pageantry, Painting, Iconography*, 3 vols (Woodbridge, 1995).

Strutt, Joseph, *The Sports and Pastimes of the People of England from the Earliest Period* (1801), ed. J. Charles Cox (London, 1903).

Strype, John, *Annals of the Reformation [. . .]*, 4 vols (London, 1709–31; repr. Oxford, 1824).

Symmes, Marilyn, and Kenneth Breisch, *Fountains, Splash and Spectacle: Water Designs from the Renaissance to the Present* (London, 1998).

Taylor, Patrick and others, eds, *The Oxford Companion to the Garden* (Oxford, 2006).

Thurley, Simon, *Hampton Court: A Social and Architectural History* (New Haven, CT and London, 2003).

——, *The Royal Palaces of Tudor England: Architecture and Court Life 1460–1547* (New Haven, CT and London, 1993).

——, *Somerset House: The Palace of England's Queens 1551–1692* (London, 2009).

——, *Whitehall Palace: An Architectural History of the Royal Apartments 1240–1690* (New Haven, CT and London, 1999).

Walters, Stuart Max, *The Shaping of Cambridge Botany* (Cambridge, 1981).

Webster, Charles, ed., *Health, Medicine and Mortality in the Sixteenth Century* (Cambridge, 1979).

Whalley, Robin and Anne Jennings, *Knot Gardens and Parterres: A History of the Knot Garden* (London, 1998; repr. 2008).

Willes, Margaret, *The Making of the English Gardener, 1560–1660* (New Haven, CT and London, 2011).

Wilson, Jean, *Entertainments for Elizabeth I,* (Woodbridge, 1980).

Wingfield-Stratford, Esme, *The Lords of Cobham Hall,* (London, 1959).

Woolfson, Jonathan, *Padua and the Tudors: English Students in Italy 1485–1603* (Cambridge, 1998).

Yates, Frances A., *Astraea: The Imperial Theme in the Sixteenth Century* (Harmondsworth, 1975).

Articles

Andrews, Martin, 'Theobalds Palace: The Gardens and Park', *Garden History*, Vol.21, No.2 (Winter 1993), 129–49.

Batho, Gordon, 'The Finances of an Elizabethan Nobleman', *Economic History Review*, Vol.9, No.3 (1957), 433–60.

——, 'The Library of the 'Wizard' Earl: Henry Percy Ninth Earl of Northumberland (1564–1632)', *The Transactions of the Bibliographical Society*: Volume s5-xv, Issue 4 (December 1960), 246–61.

Bettey, Joseph, 'Sir John Young, Dame Joan Young and the Great House in Bristol', *Transactions of the Bristol and Gloucestershire Archaeological Society*, 134 (2016), 221–30.

Biddle, Martin, 'The Gardens of Nonsuch, Sources and Dating', *Garden History*, Vol.27, No.1 Tudor Gardens (Summer 1999), 145–83.

Breight, Curtis Charles, 'Caressing the Great: Viscount Montague's Entertainment of Elizabeth at Cowdray, 1591, *Sussex Archaeological Collections*, 127 (1989), 147–66.

Cunliffe, J.W., 'The Queenes Majesties Entertainment at Woodstocke', *Proceedings of the Modern Languages Association*, Vol.26, No.1 (1911), 92–141.

Eburne, Andrew, 'The Passion of Sir Thomas Tresham: New Light on the Gardens and Lodge at Lyveden', *Garden History*, Vol.36, No.1 (Spring 2008), 114–34.

Everson, Paul and Sandy Kidd, 'Quarrendon: How the Elizabethans Revolutionised Garden Design', *Current Archaeology*, 218 (May 2008), 31–5.

Hanford, J. and S. Watson, 'Personal Allegory in the Arcadia: Philisides and Laelius', *Modern Philology*, XXXII (August, 1934), 1–10.

Harvey, John, 'Garden Plants of Around 1525: The Fromond List', *Garden History*, Vol.17, No.2 (Autumn 1989), 122–34.

Henderson, Paula, 'Sir Francis Bacon's Water Gardens at Gorhambury', *Garden History*, Vol.20, No.2 (Autumn 1992), 116–31.

Husselby, Jill and Paula Henderson, 'Location, Location, Location! Cecil House in the Strand', *Architectural History*, Vol.45 (2002), 159–93.

Jacques, David, 'The Compartment System in Tudor England', *Garden History*, Vol.27, No.1 Tudor Gardens (Summer 1999), 32–53.

Philips, John and Nicholas Burnett, 'The Chronology and Layout of Francis Carew's Garden at Beddington, Surrey', *Garden History*, Vol.33, No.2 (Autumn 2005), 155–88.

Seeber, Karin, 'Ye Making of Ye Mount: Oxford New College's Mount Garden Revised', *Garden History*, Vol.40, No.1 (Summer 2012), 3–16.

Strong, Roy, 'Foreword: The Renaissance Garden in England Reconsidered: A Survey of Two Decades of Research in the Period 1485–1642', *Garden History*, Vol.27, No.1 Tudor Gardens (Summer 1999), 2–9.

——, 'Nicholas Hilliard's Miniature of the 'Wizard Earl', *Bulletin van het Rijksmuseum*, Vol.31, Nr.1 (1983), 54–62.

Till, E.C., 'The Development of the Park and Gardens at Burghley', *Garden History*, Vol.19, No.2 (Autumn 1991), 128–45.

Woodhouse, Elisabeth, 'The Spirit of the Tudor Garden', *Garden History*, Vol.27, No.1 Tudor Gardens (Summer 1999), 10–31.

——, 'Kenilworth, The Earl of Leicester's Pleasure Grounds Following Robert Laneham's Letter', *Garden History*, Vol.27, No.1 Tudor Gardens (Summer 1999), 127–44.

——, 'Propaganda in Paradise: The Symbolic Garden Created by the Earl of Leicester at Kenilworth, Warwickshire', *Garden History*, Vol.36, No.1 (Spring 2008), 94–113.

Electronic sources

https://www.ashmolean.org/
https://britishart.yale.edu/
https://www.college-of-arms.gov.uk/
https://eebo.chadwyck.com/
https://www.folger.edu/
https://gallica.bnf.fr/
https://www.kew.org/
https://www.malmo.se/Kultur-fritid/Kultur-noje/Konst-design/Malmo-Konstmuseum.html
www.mnw.art.pl/
www.museicivicifiorentini.comune.fi.it/
https://www.museodelprado.es/
https://muzeumslaskie.pl/
https://www.oxforddnb.com/
https://www.pastscape.org.uk/
https://www.rijksmuseum.nl/
https://www.rmg.co.uk
https://www.royalcollection.org.uk/
https://www.themorgan.org/
https://www.treeregister.org/
https://wellcomecollection.org
https://www.vam.ac.uk/

Index

Headings in italics are book titles or scientific plant names. Page numbers in italics refer to illustrations.